Intersectional Chicana Feminisms

THE MEXICAN AMERICAN EXPERIENCE

Adela de la Torre, Editor

The Mexican American Experience is a cluster of modular texts designed to provide greater flexibility in undergraduate education. Each book deals with a single topic concerning the Mexican American population. Instructors can create a semester-long course from any combination of volumes, or may choose to use one or two volumes to complement other texts. For more information, please visit http://www.uapress.arizona.edu/textbooks/latino.htm.

Other books in the series:

Mexican Americans and Health, by Adela de la Torre and Antonio Estrada

Chicano Popular Culture, by Charles M. Tatum

Mexican Americans and the U.S. Economy, by Arturo González

Mexican Americans and the Law, by Reynaldo Anaya Valencia, Sonia R. García, Henry Flores, and José Roberto Juárez Jr.

Chicana/o Identity in a Changing U.S. Society, by Aída Hurtado and Patricia Gurin

Mexican Americans and the Environment, by Devon G. Peña

Mexican Americans and the Politics of Diversity, by Lisa Magaña

Mexican Americans and Language, by Glenn A. Martínez

Chicano and Chicana Literature, by Charles M. Tatum

Chicana and Chicano Art, by Carlos Francisco Jackson

Immigration Law and the U.S.-Mexico Border, by Kevin R. Johnson and Bernard Trujillo

Chicana and Chicano Mental Health, by Yvette G. Flores

Mexican Americans and Education, by Estela Godinez Ballón

Intersectional Chicana Feminisms

Sitios y Lenguas

Aída Hurtado

THE UNIVERSITY OF
ARIZONA PRESS
TUCSON

The University of Arizona Press
www.uapress.arizona.edu

ISBN-13: 978-0-8165-3761-7 (paper)

Cover design by Leigh McDonald
Cover art: *La Nopalera* by Irene Juárez O'Connell
Typset by Sara Thaxton in Granjon LT Std and Gill Sans MT Std

Library of Congress Cataloging-in-Publication Data are available at
 https://lccn.loc.gov/2019036754.

Printed in the United States of America
♾ This paper meets the requirements of ANSI/NISO Z39.48-1992 (Permanence of Paper).

Dedico este libro a las siguientes mujeres:
Gloria E. Anzaldúa
Martha Cotera
Norma E. Cantú
Alicia Gaspar de Alba

These are the women who have carried the field of Chicana feminisms on the back of their plumas. Escribiendo, always escribiendo against all odds— whether there are children to raise, biological or not, familia to support, or brothers who have died. When no one thinks that what they write is of worth, deep into the night—double duty, triple duty—because no one will get less from them than their very best. Estas son las soldaderas, pistoleras, women warriors, fierce women, who never give up, who dispense love, support, and wisdom instead of bullets, and, above all, who write, always write.

Y para las mujeres pistoleras del Valle de Tejas que luchan todos los dias against the wall, against child-family separations, who feed the minds of the young ones, who write about the Valley with urgency, who organize picket lines, and who above all love the Valley y su gente. I name only a few: Stephanie Alvarez,[1] Emmy Pérez,[2] Sister Norma Pimentel,[3] Juanita Valdez-Cox,[4] and Angry Tias y Abuelas (Rio Grande Valley).[5]

CONTENTS

ILLUSTRATIONS

ACKNOWLEDGMENTS

Finishing a book entails many magical connections. Some are by design and others are like Russian dolls—one opens up a connection and many others follow. I have been lucky to have many fortuitous associations that have guided me down the path of writing this book. Of particular significance is my good fortune of spending most of my professional career at the University of California, Santa Cruz (UCSC). I was hired as an assistant professor and left the campus as a full professor to join the University of California, Santa Barbara (UCSB)—just far enough that I could still manage to commute from Santa Cruz to Santa Barbara on a weekly basis but not so far as to make it impossible for me to become part of the Department of Chicana and Chicano Studies at UCSB. I have been blessed to have had magnificent professional and personal connections on both campuses.

I began my career at UCSC after I finished graduate school at the University of Michigan. UCSC put me in touch with a community of feminists on and off campus that nurtured my feminist consciousness at a young age when I was beginning my journey as a writer. Among the many faculty members who guided me to become a feminist were Bettina Aptheker, Helene Moglen, Candace West, and Valerie Simmons. There were also community members, UCSC graduate students, and staff who were critical to increasing my gender consciousness—folks like Ciel Benedetto, Sophia García, Beatríz López Flores, Rosie Cabrera, and Hale Bolak, among many others. The UCSC Chicano/Latino Research Center provided the intellectual home for the Chicana Feminist Research Cluster that worked collaboratively for ten years and produced the Chicana Feminist Colloquium Series covered in chapter 2 of this book and the edited volume *A Critical Reader: Chicana Feminisms*, published by Duke University Press in 2003. The core members of the research cluster were Professors Gabriela Arredondo, Norma Klahn, Olga Nájera Ramírez, and Patricia Zavella. Estas mujeres fueron fuente de inspiración, a source of intellectual growth and mentorship—sin ellas, my accomplishments would be minimal.

UCSC also allowed me to have the intellectual and physical space to mentor and train a long line of undergraduate research assistants who worked with me on a daily basis. The research assistants' youthful eagerness to learn, insightful questioning, and companionship helped create a community of collaborators, many of whom have moved on to build careers of

their own—among them are Virginia Espino, Francie Cordova, Christina Santana, and Mindy Nabor. For this book I extend my deepest gratitude to undergraduate research assistants Luz Estrada, Xarah Golden, and Xochitl Avitia. In particular, I'd like to thank research assistants Chieun (Gloria) Kim and Iliana Aldana—both brilliant young scholars whose skills, dedication, and enthusiasm for research makes me feel blessed to have chosen this profession.

My graduate students, past and present, were also part of our collaborative research lab at UCSC. Graduate students Karina Cervantez and Aracely Garcia and former graduate students (now colegas) Jessica López Lyman and Ruby Hernández will always be an integral part of my work.

In Santa Cruz I also met my editor of many years, Kim Loretucci. Her superb editing skills and deep reading of my work established a connection that I cherish and that thankfully turned into friendship.

My connection to Adela de la Torre, the editor of the Mexican American Experience series and the first Latina to serve as the president of San Diego State University, formed many years ago when we were both graduate students attending the various meetings of the National Association of Chicana and Chicano Studies. Adela's brilliant idea of creating an accessible book series was prescient, now that these modular volumes can be used to teach Chicana and Chicano studies in K–12. I'm deeply grateful for her vision and dedication to creating avenues for the dispersion of our discipline.

My sincerest appreciation to the University of Arizona Press staff and to the anonymous reviewers, whose close reading of the manuscript made it so much better.

My deepest gratitude goes to the Department of Chicana and Chicano Studies at the University of California, Santa Barbara. I especially thank my colleagues, who make me happy to come to work. I am appreciative of the department's staff, who are part of our community dedicated to excellence and to serving students.

I am fortunate to live in two of the most beautiful cities in the world—Santa Barbara and Santa Cruz. Both offer communities of women who provide support in my day-to-day activities. I'd like to thank the "Fly Girls" from my Zumba class in Santa Cruz. Under the direction of dance teacher extraordinaire Carolyn Cord-Wormhoudt, they create a woman-space where we can forget our obligations for an hour and simply enjoy our bodies as we move to the sounds of salsa, hip-hop, and bachata. We gather to giggle like schoolgirls, to praise each other for our commitment to keeping

our bodies healthy, to commiserate when things are not going well, and to cheer each other on in our endeavors. We are a motley crew of women of all ages, ethnicities, races, and class backgrounds, who exemplify the diversity in this beautiful beach town, with its hippie inclinations, feminist promise, and attempt to live in kindness. I will forever be grateful for having gone to class the morning after the 2016 presidential election, when we danced our hearts out to Beyoncé's song "Run the World (Girls)" (with the echoing chorus, "Who run the world? Girls!"), as we silently swallowed our disappointment over the loss of the election and the opportunity to see the first woman president within our lifetime. I left sad but hopeful.

I also have my pistolera crew at both ends of my commute and beyond: from Santa Barbara, Micaela Díaz-Sánchez, D. Inés Casillas, Laura Romo, Cherríe Moraga, Celia Herrera Cruz, Joann Erving, Eileen Boris, Lea Longley, and Rebeca Mireles-Rios; from the Bay Area, Arcelia and Maria Hurtado, Chanelita Trevino, Erin and Lynne Haney, Olga Talamante, Sandra Pacheco, Patricia Quijada, Julie Figueroa, Joan Pinkvoss, and Rosa-Linda Fregoso; and from beyond, Pat Gurin, Abby Stewart, Michelle Fine, Laura Rendón, Norma Cantú, Gloria Cuádraz, Antonia Castañeda, Angela Valenzuela, Tina Atkins, and Graciela Rubalcava. My pistoleras guard over me with care and tenderness. In my back-and-forth commute between Santa Cruz and Santa Barbara, they say goodbye with a hug and depth of caring: "Text me when you get home." They send me random texts: "I'm checking in to see how's it going," "Hey, want some coffee?," "Missing you, hope to see you soon." They send unexpected gifts, birthday wishes, congratulatory notes, and read much of what I write. They are my connection to a worthwhile life.

I am also blessed by the kind masculinities of the men in my family— Craig, Jose, Matt, Tristan, Joaquin, and Sisto. They love and learn from the women's world we have created in our family—they all make my life worth living.

Santa Cruz also gave me the connection to find the artist for the cover of this book. In the early stages of production, the art director from the University of Arizona Press requested samples of prospective cover images. Of the ones I sent, which were picked at random with no knowledge of the artists who created them, the art director selected an image painted by Irene Juárez O'Connell, a Santa Cruz resident and recent graduate from UCSC. I contacted Irene, and she was delighted that we had selected her painting *La Nopalera*. As Irene described the painting:

La Nopalera is the third installment in a series of three paintings depicting La Nopalera in her various stages of life. I painted this with tears in my eyes, thinking of all the generations of women in my lineage and beyond who have endured so much, carried so much burden, have pressed on with so much resistance to oppression. Yet, they continue to rise with strong spines filled with courage, bearing fruit in even the harshest of conditions. *La Nopalera* is a prayer and a tribute to the matriarchs of borderlands everywhere—from Mexico to Palestine—los nopales are symbols of self-sufficiency, self-determination, and resilience. (Personal email, July 9, 2019)

Here Irene is describing the women in my family: las nopaleras/nepantleras of my/her lineage on both sides of the border (mi bisabuela Agustina; mis abuelas Lázara y Inocencia; mis tias Aída, Guillermina, Rosenda, Tomasa; y mi madre Magdalena). My feminisms are like the headdress of nopales on the woman on the cover—many connections, many different paths, many different versions of the same values that Irene so wisely identifies in her description: "who have endured so much, carried so much burden, have pressed on with so much resistance to oppression. Yet, they continue to rise with strong spines filled with courage, bearing fruit in even the harshest of conditions." I am blessed to have sprung my own headdress made of nopales from the women in my life.

Yes, I live in a woman-world protected by the principles I try to describe in this book—Chicana feminisms are indeed a "Chicana living theory" (Trujillo 1998).

Intersectional Chicana Feminisms

Intersectional Chicana Feminisms

Introduction

The Legacy of Martha Cotera's
The Chicana Feminist

If you're a woman it just doesn't make any sense not to be a feminist. . . .
People ask me, "How long have you been a feminist?" and I say, "Well,
when I realized I was a woman."

We [Chicanas] were very interested in issues of domestic violence and
rape. We were very interested in reproductive issues, the availability of
choice in abortions because a lot of us had been raised on the border where
women were tragically dying from back alley abortions. We don't think
about that. Because of the work that we did, abortion became legalized.

— Martha Cotera, "Women within the La Raza Unida Party"

An important marker for the field of Chicana feminisms occurred in 1977,
with the publication of Martha Cotera's book aptly titled *The Chicana Feminist* (box 1, figure 1). This book contains many of the major theoretical and
philosophical tenants of Chicana feminisms. One can consider *The Chicana Feminist* as a manifesto, when *manifesto* is defined as a written statement
of the beliefs and aims of a political movement. Cotera's book had several
aims: It reminded us that mexicanas had a long feminist history in Mexico
and that that history should be recognized in the contemporary Chicano
movement, which had reverted to privileging men and relegating women
to a subservient position. In addition, it identified the feminist issues that
affect Chicanas differently from middle-class white feminists, and it advocated for creating policy that addresses Chicanas' class origins directly. *The
Chicana Feminist* was a call for women to reclaim their rightful place in the
political mobilization taking place at the time of its publication.

This call for action took place again in 2018 with the publication of the
volume *Movidas*, co-edited by Martha Cotera's daughter Maria Cotera, a
professor of American Studies at the University of Michigan (box 2, figure 2). *Movidas* is also about reclaiming the Chicana history of political
involvement en defensa de la mujer (in defense of women).[1]

Box 1. Biography of Martha P. Cotera

Martha Cotera is a writer, librarian, and community activist living in Texas. She was born Marta Piña in 1938 in Chihuahua, Mexico, where her grandfather taught her to read at a very young age. Her grandparents were very interested in Mexican politics, a passion Cotera inherited as part of her upbringing. In 1946 she and her mother immigrated to El Paso, Texas. The racist and discriminatory policies in the Texas public school system did not deter Cotera from involvement in her school. She was an active member of the writing club and English club, working as editor of the school newspaper.

In 1962 Cotera earned her BA in English with a minor in history from Texas Western College (which is now the University of Texas at El Paso). That same year she became a U.S. citizen, and she cites this event as the beginning of her political awakening. Soon after, she married fellow student Juan Cotera, and they moved to Austin, Texas. There, Martha was hired as director of federal documents at the Texas State Library in Austin.

In 1964 Martha and other Texas educators formed the Texans for Educational Advancement for Mexican Americans (TEAM). This network of educators supported the student walkouts organized by the Mexican American Youth Organization (MAYO). Later, Martha and her husband also provided support for students during the Crystal City walkouts. They volunteered as tutors and provided curriculum materials and instruction.

In 1968 Martha became the director of Southwest educational development, which placed her in charge of twenty-eight libraries across Texas. The next year she and her husband moved their family to Mercedes, Texas, and founded the Colegio Jacinto Treviño. The college was developed for Mexican Americans and was designed to prepare teachers for bilingual and bicultural education programs through the Antioch Graduate School of Education and its University Without Walls program. The college was the first of its kind in a geographical area not known for its leftist politics. Martha served as an instructor and librarian for the college until the late 1970s, when she began teaching at Juarez-Lincoln University, which split from the Colegio Jacinto Treviño. She received her master's in education from Antioch College in 1971.

In 1972 Martha ran for a seat on the State Board of Education under the newly formed Raza Unida Party (RUP). The RUP was a third political party dedicated to addressing the needs of Chicanos, primarily in Texas. Martha and her husband were actively involved in the founding and structuring of the RUP. However, Martha and other women in the RUP felt marginalized by the male leadership of the organization and established the Mujeres de La Raza Unida Party. This new entity advocated for the recruitment of women into the RUP, created opportunities for women's political involvement, and added women's issues to the party's agenda. Mujeres de La Raza

Unida Party also established a Chicana caucus within the Texas Women's Political Caucus to advocate for the election and appointment of more women into office.

In 1974 Martha Evey Chapa founded the Chicana Research and Learning Center in Austin. This organization applied for research grants and sought funding for community projects addressing the needs of women of Color. Martha went on to form the independent research and publishing company called Information Systems Development. The organization was dedicated to publishing materials by and about Chicanas/os.

In 1975 Martha was hired as a consultant and community liaison for the Benson Latin American Collection at the University of Texas. Her duties included locating, preserving, and raising awareness of Mexican American archives. The goal was to address the underrepresentation of Latina/o perspectives and contributions to U.S. history. After thirty-four years in this position, successfully locating and preserving the work of many writers, artists, scholars, and community activists, her position was cut because of budgetary concerns.

In 1976 Martha published *Diosa Y Hembra: The History and Heritage of Chicanas in the U.S.*, the first survey of Chicana history and an important contribution to the recovery of Chicana histories. The following year, she

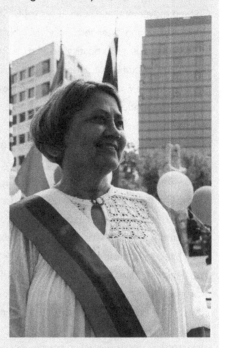

Figure 1. Photo of Martha Cotera. Courtesy of Martha Cotera's personal archive.

published *The Chicana Feminist*, a collection of essays addressing her experiences with gender issues in the Chicano movement and her experiences with racism and classism in the white women's movement. Martha's analysis of these two social movements demonstrated the nascent notion of intersectionality developed later in many of the writings of Chicana feminists and other feminists of Color.

Martha Cotera has had a distinguished career as a writer, activist, and archivist. She has continued to write essays, articles, and book chapters on feminism, civil rights, activism, Chicanas in politics, and Chicana/o history. Martha continues her activist involvement and works as an independent translator and community consultant. She continues to be active in local politics and community initiatives, and her passion for social justice fuels her work on behalf of Chicanas and feminist issues.

Box 2. Biography of Maria E. Cotera

Maria Eugenia Cotera is a Chicana feminist, author, researcher, activist, and professor. She was born in Austin, Texas, in 1964 to Chicana activist Martha Cotera and architect Juan Cotera. She spent most of her childhood in Austin and El Paso, because of her parents' work and political involvement. Her parents were active in various social movements during the 1960s and 1970s, such as the farm workers' movement, the Chicano movement, and student walkouts. She also spent many summers in Mexico visiting friends and extended family in Chihuahua and Juárez.

Maria's exposure to political activism led to her becoming conscious of the issues faced by most Latinas/os, Hispanics, and Chicanas/os in the 1960s and 1970s. From an early age, she was aware of the inequitable treatment Latinas/os suffered, resulting in inferior education and high levels of violence, poverty, and police brutality in the barrios.

Maria also witnessed discrimination in school, where teachers punished students for speaking Spanish. A school lunch lady once demanded that Maria pronounce her name with an English intonation instead of a Spanish one. At that time, Proposition 63 (the California language amendment that attacked bilingual education, the Spanish-language ballot, and more) had passed and contributed to the discriminatory policies and attitudes against Spanish-speaking children in the school system.

As the daughter of first-generation college graduates (both parents obtained graduate degrees), Maria understood the value of education and had a strong affinity for academics. In high school she became interested in the issues of homelessness and poverty, and in college she focused her attention on Chicana feminisms, Chicana/o histories, and identity.

In 1986 Maria earned her BA in liberal arts, and in 1994 she completed her master's in English, with both degrees from the University of Texas in Austin. She earned her PhD in modern thought and literature from Stanford University in 2000.

While pursuing her master's at the University of Texas in Austin, Maria worked with Dr. José Limón on a recovery project. Maria found a lost co-authored manuscript by one of the first Mexican American folklorists, Jovita González, and writer Eve Raleigh. Both women challenged the gender norms of their time. The recovered manuscript was published as *Caballero: A Historical Novel*, with an epilogue written by Maria. The manuscript was largely written in the 1930s and 1940s, and has become a foundational piece of scholarship in Texas history. Maria recovered other works by Jovita González. Among these were Jovita's master's thesis, "Life Along the Border," which was written in 1929 at the University of Texas, Austin. Her thesis is one of the foundational documents of Mexican American history in Texas. Jovita's work offers a vision of history and culture that competes with that promoted by the "founding fathers" of Texas folklore. Her complex analysis de-emphasizes the role of the Texas

Revolution as a foundational moment of Texas history and explores the ways in which Anglos and Mexicans developed tense ties through intermarriage and political alliance in the fifty years following the U.S.-Mexico War. Maria has continued to publish multiple essays on Jovita González.

In addition to her scholarly written work, in 1989 Maria coproduced the documentary *Crystal City: A Twenty-Year Reflection*, centered on the role of young women in the 1969 Chicano student walkouts in Crystal City.

After obtaining her doctorate, Maria attended the University of Michigan to complete postdoctoral research in the American Culture program. In 2008 Maria published *Native Speakers*, a comparative analysis of the works of Ella Deloria, Zora Neale Hurston, and Jovita González, three intellectuals and women of Color who pursued ethnographic studies in the early twentieth

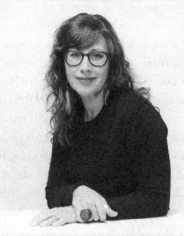

Figure 2. Photo of Maria E. Cotera. Courtesy of Chris Stranad.

century. Maria received the Gloria E. Anzaldúa book prize from the National Women's Studies Association for this work of "groundbreaking scholarship in women's studies that makes significant contributions to women of color/transnational scholarship."

Maria is currently an associate professor of American culture and women's studies and the director of the American Culture Latina/o Studies program at the University of Michigan. Her research initiatives include the Chicana por Mi Raza project and the community-based El Museo Del Norte project. Chicana por Mi Raza is a digital archive project dedicated to collecting, digitizing, and displaying archival materials and oral histories about the development of Chicana feminist praxis from 1965 to 1985. It is one of the largest repositories of Chicana feminisms in the world, holding more than one hundred oral histories and five thousand archival documents by and about Chicana feminists. Still, many more documents and materials related to the history of Chicana feminisms remain stored away in the homes of women who were active during this civil rights era. This project seeks to create a single, digital access point for Chicana feminist scholars and activists dispersed throughout the United States, from Chicago to Texas to California and beyond, to reconnect with each other and their works in a network like the one that once existed among Chicana feminist activists. El Museo del Norte is a collaboration with the Fronteras Norteñas organization to educate the public about the history of Latinas/os in the Midwest and to build a museum and cultural center dedicated to preserving community stories.

The rich history represented by the Coteras is seminal in the field of Chicana feminisms. Chicana feminisms as a field of study address the inequalities in power and privilege experienced by Chicanas as well as other women in U.S. society and worldwide. Chicana feminisms are committed to social action to address these inequalities. Unlike other feminisms, Chicana feminisms have an added emphasis on Mexican and Chicana/o cultures and histories, the importance of the Spanish language, and the examination of structural variables that affect power and privilege. Chicana feminisms have been a fluid field of study that evolved as new social categories of oppression were analyzed and highlighted through political mobilizations and pressure from previously ignored constituencies. For Chicanas, the current relevant social categories that affect inequality in U.S. society are gender, ethnicity, race, class, sexuality, and physical ableness (Hurtado 2018). Chicana feminisms are concerned with exploring the consequences for women's lives when these categories intersect (Hurtado and Cervantez 2009, 171).

I base this introduction to Chicana feminisms primarily on Cotera's (1977) influential monograph and more recent, contemporary feminist writings. I begin with a discussion of the diversity in ethnic labeling in defining U.S. feminisms, followed by the historical background of this field of study, then discuss the theoretical paradigm proposed by Chicana feminisms, and conclude with overview of this book.

Diversity of Ethnic Labeling in the United States

Octavio Paz is the *Labyrinth of Solitude* man who wrote about "los hijos de la chingada."[2] (I like to respect the opinion of those who dislike obscenity, but that's the title.) Paz used to live in a penthouse suite near U.T. when he was teaching there, and many times we were invited by him to parties I did not attend. It's just that I like to be as correct as possible, and I didn't trust myself not to walk up to him and say, "If you think that Mejicanos are hijos de la chingada, please don't include us—Chicanos and Chicanas." There are those of us who just don't relate to Mexican history that way. Some of us don't think that our Mexican mothers had any choice but to open up when the time came. I challenge the notion that we have to castigate ourselves for being what we are. I think it's very beautiful to accept yourself and to go on from there. So I will never go through the agonies of, "Oh, if I could tear

out my Indian blood," or my Chicano blood. I think that our identity is a
growing process that we can go through very comfortably.

—Martha Cotera, *The Chicana Feminist*

Latinas/os in the United States have many ethnic labels available to them
for representing their different histories and the complexities of their social,
cultural, economic, and political existence in this country. For Puerto Ri-
cans, the relationship between Puerto Rico as a protectorate of the United
States with no official representation within the U.S. government has in-
fluenced the group's social identity formations. Puerto Rican migration in
large numbers from the island mainly to New York City has disrupted
Puerto Rican cultural patterns and social norms developed in the native
country. Other national groups of Latina/os, such as Salvadorians, Guate-
malans, and Colombians, who have emigrated from their home countries
because of economic pressures or political, sexual, and gender-based perse-
cution have a different set of influences that affect their definition of what
constitutes their social identities. Many Latinas are forced to leave family
and country behind and readjust their beliefs about gender relations as they
struggle economically in the United States (Zavella 2011). The varied na-
tional histories of Latinas, however, do not deter them from having shared
concerns and experiences based on their common oppressions that influence
the development of their intersectional identities, which are based on gen-
der, race, sexuality, ethnicity, and physical ableness.

The Historical Origins of a Chicana Identity

The so-called "changing role" is actually a continuing growth process orig-
inating within our ancient Indian heritage and moving always toward a
stronger position for the woman within our culture. The entire process is
consistent with our legacy of Mejicano/Chicano feminism influenced by
technological and sociological changes in Chicano areas in the United States
and in Mexico. Anglo feminism has had little to do with the development
of the Chicana.

—Martha Cotera, *The Chicana Feminist*

Mexican-descent Latinas are subject to the same complexities as Latinas
originating in Latin America and use a multiplicity of labels to refer to

themselves—from Chicana, Latina, Mexican American, and Hispanic to, most recently, Latinx and Chicanx. However, a Chicano and Chicana identity has historical colonization as the origin of its creation. The end of the Mexican-American War in 1848 codified in the Treaty of Guadalupe Hidalgo the colonized status of Mexico's former citizens in what became part of the U.S. southwestern states of Arizona, California, Colorado, New Mexico, and Texas. Mexicans residing in these regions lost their citizen rights and saw their language and culture displaced overnight. The treaty formalized Mexico's defeat and the loss of more than 50 percent of Mexico's territory to the United States (Almaguer 1974; García 1973). This act of colonization is central to making Chicanos in general, and Chicana feminists in particular, distinct from other immigrant groups in claiming a unique social and economic position in the United States. This initial act of colonization influences even recent Mexican immigrants as they join Chicano communities in the United States that are treated differently from mainstream white communities.

Chicana feminist literature self-consciously labels itself *Chicana* as a political statement to highlight its "in-between" position, situated in the interstices of multiple social, economic, and cultural systems. *Chicana* has come to signify the celebration of hybridity and the claiming of what the social activist and writer Gloria Anzaldúa called *El Mundo Zurdo*—the queer world that hybrids inhabit because they offend purists on all sides. The label *Chicana* therefore became a political assertion through the restitution of self—a self that is constructed in the interstices of two countries, two national cultures, two geographical areas, two languages, and two systems of patriarchal (or male-dominated) oppression. Chicana feminists "feel" the rejection from the purists on both sides of these divides, as they are not fully Mexican nor fully from the United States—what many Mexicans on both sides of the border derisively refer to as *pochas*. Chicana feminists acknowledge that they are violating cultural expectations by not marrying young, by leaving home before marriage, or by having premarital sex, but they also are not accepted in the "white" world they live in. To paraphrase Lani Guanier (1998, 66), Chicanas are "border people," fully accepted by few. At the same time, Chicana feminists become the "bridge called their back" (Moraga and Anzaldúa 1981) between all the different social worlds they belong to. Chicana feminists therefore fully and proudly claim the label *Chicana* through their lives and through the cultural, intellectual, and political spaces created by Chicana feminist scholarship.

Chicana feminists have been in solidarity with other progressive movements in the United States and worldwide. They align themselves with movements that seek social justice and question the political status quo of regressive governments in Latin America as well as places like South Africa before Mandela's revolution. Their internationalist views, however, have not prevented them from joining the struggles of people of Color in the United States. In this book (and within Chicana feminisms), *people of Color* refers to Chicanos, Asians, Native Americans, and Blacks, all of whom are domestic minorities. Therefore, *Color* is capitalized because it refers to specific ethnic groups. *Black* is also capitalized, following the argument that it refers not merely to skin pigmentation but to a "heritage, an experience, a cultural and personal identity, the meaning of which becomes specifically stigmatic and/or glorious and/or ordinary under specific social conditions. It is socially created as, and at least in American context no less specifically meaningful or definitive than, any linguistic, tribal, or religious ethnicity, all of which are conventionally recognized by capitalization" (MacKinnon 1982, 516). *Indigenous* is also capitalized because it refers to the First Nations people. On the other hand, *white* is lowercased because it refers not to a single specified ethnic group but to many.

A central feminist struggle was to decolonize the use of the masculine pronoun as the acceptable style for formal writing. The debates were long and hard around using the pronouns *he* as well as *she* in all public documents. For Chicana feminists, the fight was a bilingual one—that is, to push for the Spanish-language use of the *a* to indicate female gender. One marker of major success was to expand the titles of Chicano studies departments to include Chicana and Chicano studies. Another solution to decolonize the Spanish language was to use *Chicana/o* as an inclusive and political move. The latest discourse development is to use *x* as an *all-inclusive* indicator of gender. However, the use of *x*, in effect, erases the hard-won feminist struggle to use the *a* to indicate female gender. In this book I chose to honor the feminist efforts and use *Chicana/o*. For me, the "/" indicates patriarchy's imposition of the gender binary. Until patriarchy no longer exists, it is important to honor the *a*. Another inclusive move used by some writers is to use *Chicana/x* to indicate all genders and also honor the feminist struggle. I agree with this move but decided against using this option in this book because the binary is still alive and dominant. The *a* and *o* remind us that we still have not achieved inclusiveness in recognizing all sexualities and genders.

The Historical Background of Chicana Feminisms

In the 1960s the historical cycle was completed and Chicanas picked up the feminist threads introduced by the radical Club Liberal de San Antonio and the autonomous Liga Mexicanista Femenil of the 1910s. Both organizations, unlike GI Forum, Ladies LULAC, and Chicana groups working within predominantly male groups, were feminist and autonomous. Chicanas had come of age. They have been willing in the seventies, as before, to participate in community ahd [*sic*] male-dominated organizations. But in addition, they recalled part of themselves, part of their energies, to participate in newly formed all-women caucuses and organizations.

—Martha Cotera, *The Chicana Feminist*

Contemporary Chicana feminisms are truly the offspring of the U.S. progressive political movements of the 1960s (Cotera 1977; Espinoza, Cotera, and Blackwell 2018). Chicana activism on behalf of women's issues has a long and mostly undocumented history. Contemporary writings by Chicana feminists largely began in the late 1960s, contemporaneous with the Chicano movement, free speech movement, Black Power movement, Asian American movement, civil rights movement, and other progressive movements of the era. Many Chicana feminists simultaneously participated in more than one of these movements (Cotera 1977; Martínez 1989), challenging stigmatization on the bases of sexuality, race and ethnicity, class, and gender. Chicana scholarship also benefited from developments made by other groups in deciphering their oppression as well as their liberation.

An integral part of the recuperation of Chicano/a history was to revise the official narrative of the historical events surrounding the colonization of mexicanos on their own land in what is now the Southwest United States. A central project for many Chicana feminists has been to document the history of Chicanas and to debunk the stereotypes that portrayed them as nonagents in political struggles (Córdova 1994; Ruiz 1998). Chicana historians and social scientists are particularly interested in documenting women's struggles in the workplace—for example, in maquiladoras and the garment industry (Mora and Del Castillo 1980), canneries (Ruíz 1987; Zavella 1987), and agricultural fields (Guerin-González 1994). They record not only the struggles of women workers but also the efforts of women leaders (Méndez-Negrete 1995; Pesquera and Segura 1993, 97). The emphasis on labor issues (Pesquera 1991; Romero 1992; Segura 1994; Zavella 1987)

stems not only from the intense participation of Chicanas in this sphere but also from the linkage between almost all Chicana feminist scholars and the Chicano movement (Segura and Pesquera 1992). Many of the Chicana feminist foundational writings were produced by individuals who participated in the Chicano movement of the 1960s and 1970s (Córdova 1994, 175, 188–89; Cotera 1977; Segura and Pesquera 1992). Ramón Gutiérrez (1993) describes the Chicano movement as encompassing the unionizing efforts of César Chávez with the farmworkers, the militant efforts of Reies López Tijerina to recapture the lands taken from Chicanos in the southwestern United States during the Mexican American War of 1848, and the political mobilization of Chicano students on university campuses across the country. It was a movement that included students, labor organizers, agricultural workers, and cultural workers—mostly poets, singers, and actors in regional Chicano theater. Many of the writers of Chicana feminisms, regardless of their disciplinary affiliation, refer frequently to their participation in the Chicano movement.

Historically the Chicana/mexicana communities on both sides of the border have always had strong women leaders. Chicanas have also been subject to brutality that was mostly reserved for men at the time. Cotera (1976) documents that among the victims of social injustice were such women as Juanita, of Downieville, California, who was lynched in 1852; Chipita Rodriguez, who was the only woman ever to be executed in Texas; and countless other Chicanas who were killed by Texas Rangers during the raids on communities in the 1900s. The emphasis on historical context and events in the field of Chicana feminisms deeply influences the overall paradigm— from recuperating history, to revising existing stereotypes about Chicanas and the Chicano/a community, to making a deep commitment to alleviating the conditions of poverty faced by many Chicanas/os in the United States.

Chicana Feminisms as a Field of Study

The Mexican American woman as a human being, as a topic for research, or as the object of a project or curricula is an elusive being. Myths and stereotypes abound because very few resources have been allocated to objective research and to documenting historical fact. A popular myth and often-used excuse for not producing curricula relevant to Mexican American women is that "there is no literature available." Literature and information abound, undiscovered and unculled in archives (church, University of Texas, Bexar,

Santa Fe State Library Archives, etc.), obscure university publications, theses and dissertations, in the writings of women themselves, in period community newspapers, and in government publications.

—Martha Cotera, *Diosa Y Hembra*

There are four distinctive features that distinguish Chicana feminisms from other forms of feminism: history, culture, intersectionality, and political coalitions. There are also many definitions of feminism, and scholars now assert that the word should be used in its plural form to encompass women's various social locations. Chicana feminisms address the specific historical, economic, and social experiences of women of Mexican descent in the United States. The field of Chicana feminisms developed within the context of feminist movements in the United States, including the feminist writings of African American, Asian American, Native American, and white scholars. Although Chicana feminist analyses focus specifically on the condition of Chicanas, writers claim allegiance to U.S.-based as well as internationally based politically progressive movements (Saldívar-Hull 1991).

The Importance of History

The position of Chicanas within our culture may be traditional but it is not conservative. The so-called "changing role" is actually a continuing growth process originating within our ancient Indian heritage and moving always toward a stronger position for the woman within our culture. The entire process is consistent with our legacy of Mejicano/Chicano feminism influenced by technological and sociological changes in Chicano areas in the United States and in Mexico. Anglo feminism has had little to do with the development of the Chicana.

—Martha Cotera, *The Chicana Feminist*

During the Chicano civil rights movement of the 1960s, many Chicano writers sought to expose the suppressed history of Mexicans in the United States. Chicana feminist writers focused on highlighting the political resistance and "underground" feminisms (Hurtado 2003b) of everyday women fighting for their families and communities, as well as the invisibility of many important women leaders since 1848 (Castañeda 1990). Women of Mexican descent in the United States have a long history of resistance and political mobilization, as demonstrated by strong women leaders such as

Emma Tenayuca, who was a labor leader in Texas, and las soldaderas (women soldiers), who fought in the Mexican Revolution of 1910. Soldaderas joined the predominantly male army to democratize Mexico from a feudal country to one where land was distributed among peasants. Dolores Huerta (b. 1930) followed this tradition of political leadership as she fought side by side with César Chávez (1927–93) to unionize California farmworkers and continued carrying out Chávez's important political work into the twenty-first century after his untimely death in 1993.

The political underpinnings of the Chicano movement were Marxist/socialist, infused with Chicano culture (Gutiérrez 1993, 46). They included a kind of secular Catholicism that was more cultural than religious in nature. The feminisms exposed by Chicanas are deeply rooted in the material conditions of Chicanos/as as a whole. As Saldívar-Hull (1991) states, "Chicana feminism, both in its theory and method, is tied to the material world" (220). Chicana feminisms proclaim the primacy of material conditions and advocate for good working conditions, childcare, health care, and public safety for all workers. The emphasis that Chicana feminisms place on these issues is somewhat different from other feminisms. For example, even though reproductive rights have been central to the white feminist agenda, white feminists emphasize the right to their bodies through birth control and abortion. While for Chicana feminists these two issues have also been central, of equal concern (and more egregious) has been the forced sterilization and forced birth control that some Chicanas have suffered through state intervention (Espino 2015; Gutiérrez 2008; Nieto 1974). Chicana scholars and reporters were writing about forced sterilization as early as the 1960s (Córdova 1994). For white women, forced sterilization has not been a central concern in their writing or in the white feminist political agenda—certainly not as central as abortion rights. Even those Chicana feminist writers who make incursions into more abstract topics like psychoanalysis (Pérez 1993) and cultural studies (Alarcón 1990; Chabram-Dinersesian 2007; Fregoso 1993a; Sandoval 1991) always proclaim the importance of material conditions in the liberation of Chicanas and the Chicano community as a whole.

Debunking History: Reclaiming Malinchismo and Rejecting Marianismo

We must always end our spiel with the cop-out catch-all, that depite [sic] all this we, Chicanas, will never change our "traditional ways"; that we will always remember what and where our role is; that above all we must

remember we are "good women." Not what *we consider* a "good woman: [*sic*] to be, but what someone else, who does not even know what being a woman is, considers a "good woman" to be.

—Martha Cotera, "Women within the La Raza Unida Party"

Many Chicana feminists see links between the history of Chicanas in the United States and Mexico as a centerpiece of their theorizing about the condition of women. The colonization of Chicanas/os in 1848 by the United States was not the first experience of conquest. For Chicana theoreticians, the conquest of the Americas includes an Indigenous woman, La Malinche, a pivotal figure who has been cast as the ultimate traitor of Mexico. La Malinche supposedly facilitated Hernán Cortés's conquest of the Aztec empire by serving as translator and go-between in the negotiations between the Spanish and the Mixteca tribes. Hernán Cortés (1485–1547) ultimately defeated the Aztec leader Montezuma in 1519. Cultural critic Norma Alarcón (1989) notes, "Malintzín [La Malinche] comes to be known as *la lengua*, literally meaning the tongue. La lengua was the metaphor used, by Cortés and the chroniclers of the conquest, to refer to Malintzín the translator" (59). From this betrayal, modern Mexico was born both figuratively and literally, because La Malinche converted to Catholicism and bore the children of Hernán Cortés's soldier Jaramillo. As historian Emma Pérez (1993) points out, Cortés did not feel Malintzín (or Malinche) was worthy of marriage because she was the "other, the inferior, disdained female"; when he was finished with her, he passed her on to his soldier (61).

Chicana feminists did not choose La Malinche as the defining figure of their feminisms. Yet because "the betrayal" was committed by a woman, many male writers have saddled all women with Mexico's initial colonization (see Paz [1985] as a prime example of this tendency). Skepticism about women has its origins in the cultural and sexual violation of La Malinche. Many feminists have engaged the polemics around La Malinche to redeem her, to commiserate with her, or to appropriate her as a feminist hero (Alarcón 1989). But La Malinche is not the only historical figure to be engaged. Other female historical figures have been embraced for their potential to illustrate a mapping for what can constitute a feminist consciousness that is specific to Chicanas. Examples are La Virgen de Guadalupe (Castillo 1997), Sor Juana Inés de la Cruz (Gaspar de Alba 1998; González 1990), La Llorona (Anzaldúa 1995; Cisneros 1991; Mora 1996, 91; Pérez 2008), and Frida Kahlo, among others (Córdova 1994, 193). These

historical figures also share an engagement with struggles that go beyond gender—mostly struggles around labor and social revolutions against repressive governments.

The other side of Malinchismo is Marianismo, or the veneration of the Virgin Mary. The Virgin Mary, especially her Mexican version, La Virgen de Guadalupe, is the role model for Chicana womanhood: she is the mother, the nurturer; she has endured pain and sorrow; and she is willing to serve (Nieto 1974, 37). Traditionally Chicanas are supposed to emulate these same values and apply them in serving their husbands and children (Córdova 1994, 175). Although the root of these values is the Catholic Church, they are nonetheless similar to the ideals of womanhood held by other ethnic and racial groups, including some whites, in U.S. society (members of the Christian Right come readily to mind). For many Chicanos/as, however, these same values have been a source of solace and strength to fight racism and resist oppression by the dominant group. The dedication that many women have to their families—and many men's commitment to uphold their side of the bargain by hard work in the agricultural fields, brutal work in factories, and low-paid, unskilled labor—posed a challenge for Chicana feminists to question these values. Consequently, the challenge for Chicana feminists has been simultaneously to critique the inherent sexism in dichotomizing their womanhood between Malinchismo and Marianismo and to recognize the courageous work of many women and men who have fought to preserve their families against violent, racist state intervention. Chicana feminists have not always been successful in keeping all these issues in balance, nor have their challenges been met with open arms by most members of Chicano/a communities. Some Chicanas have not seen the advantages of challenging patriarchy, and others have been afraid to betray their communities and culture by joining any feminist cause (García 1989, 225).

The fight to avoid dichotomizing Chicana womanhood into either Malinchismo or Marianismo hit full force during the Chicano movement (Cotera 1977), when Chicana feminists questioned their roles in the political mobilization of the times. Chicana feminists were perceived by both men and some women in the movement as undermining the Catholic underpinnings of all Chicano culture. Consequently, a Chicana feminist consciousness was characterized as a betrayal and Chicana feminists were labeled as "anti-family, anti-cultural, anti-man and therefore anti-Chicano movement" (Nieto-Gómez 1974, 35). Ironically, they were called *Malinchistas* by the men in the movement, signifying them as traitors to their communities

and as sellouts to white feminism; they were also called lesbians because they supposedly were privileging their sex above the unity of the Chicano movement in its struggle for social justice (Cotera 1977; García 1989, 225–26). The accusation of lesbianism by homophobic Chicano nationalists of both genders was used to intimidate Chicana feminists into relinquishing their struggles on behalf of women's issues. In an effort to build solidarity, many contemporary Chicana theorists, be they lesbian, queer, trans, or heterosexual, define their feminisms in allegiance with one another.

The Importance of Culture

U.S. sociologists who study our communities from the outside looking [in]. . . . They've always said that the Mexican American community has a lot of machismo . . . but they don't understand the definition of machismo. There are two definitions: A man that is very sexist and the real definition which is a man of strength and responsibility and who is nurturing. There is a nurturing side of machismo that the sociologists don't talk about. These [college] kids just believed a lot of the sociology and jargon although the reality was very different. Their mothers and sisters didn't pass it onto them. They got it out of textbooks.

—Martha Cotera

Chicana feminist writers agree with other feminists that patriarchy exists in most societies. However, patriarchy is manifested in culturally specific ways, and as such, Chicanas' culture and history are central to their analysis of gender in their communities. Chicana feminists have identified several cultural elements that define proper Chicana womanhoods in Chicano/mexicano communities. As mentioned previously, among them are the veneration of La Virgen de Guadalupe (the Virgin of Guadalupe, the national saint of Mexico) and La Malinche; both women are iconic figures of what is desirable and undesirable for Mexican women in Mexico, as well as in Chicanas in the United States. The desirable aspects of Mexicana/Chicana womanhood based on La Virgen de Guadalupe are piety, humility, selflessness, dedication to family, and virginity. The undesirable traits, as embodied in La Malinche, are treachery, lying, deceitfulness, and sexual promiscuity. Although other cultures often describe the distinction between women as a "virgin-whore" dichotomy, in Mexican and Chicano culture, the dichotomy is tied specifically to these two figures rather than to general

descriptors with no cultural or historical referent. These culturally appropriate and inappropriate ways of expressing Chicana womanhood do not apply to non-Chicana women and therefore merit a different feminist analysis from those developed by other cultural groups.

The Construction of Chicana Sexualities

La Malinche is the woman that the men have always picked on. La Malinche fue, supuestamente [supposedly], la primera india que se fue con los españoles [the first Indigenous woman who ran away with the Spaniards]. There's some very good research that's been done on the politics of the conquest and the reasons why she [La Malinche] went ahead with the Spaniards. Encouraged by the Octavio Paz mentality, men have used her [La Malinche] as a club for us, to keep us down. "You stupid broads! You see what you did?" What we are is what we decide we are. And what we do with our identity is also our own decision, not the decision of men, the universities, "herstories," "his-stories," or anyone else. That goes for Malinche and for us today!

 —Martha Cotera, *The Chicana Feminist*

Marianismo and Malinchismo dichotomize Chicanas' womanhood into "good woman" versus "bad woman," depending on how women exercise their sexuality (Hurtado 1998). As Vásquez and González (1981) ask, "They say we are sometimes passionate, sexy, voluptuous, dark-eyed, hot-tempered beauties; other times we are chaste and sexually pure; we are 'mamacitas': fat women surrounded by five or six little brown-skinned children, always cooking. This is what they say we are. Is that who we really are?" (50). Marianismo and Malinchismo are cultural concepts whose content change over time and historical moment but whose underlying values and logic remain. There is little doubt that the manifestations in Chicanas' lives of Marianismo and Malinchismo in the 1950s differed in content from Marianismo and Malinchismo in the 1960s at the height of the Chicano movement. However, the notion that women should support and undergird men's activities was all too evident in the political mobilizations of the time. Martha Cotera provides a powerful narrative of the gender bias among progressive Chicano men in the political circles she worked in. The expectation was that women should be the caretakers, the ones who cleaned after political gatherings, typed political writings, provided cooking and other housekeeping tasks—a type of political Marianismo. To refuse

the role assigned to them, women then joined the ranks of Malinchistas—traitors to the movement and to the betterment of La Raza.

According to Marianismo, to be a "good woman" is to remain a virgin until marriage and to invest devotion, loyalty, and nurturance in the family. Chicanos' definition of family, moreover, extends beyond the nuclear family to include extended networks of related kin, as well as friends (Baca Zinn 1975). As in all patriarchies, there are rewards for women who comply and punishments for those who rebel. As Anzaldúa laments, "Every bit of self-faith I'd painstakingly gathered took a beating daily. Nothing in my culture approved of me. Habia agarrado malos pasos [I had taken the wrong path]. Something was 'wrong' with me. Estaba mas alla de la tradición [I was beyond the tradition]" (Anzaldúa 1987, 38). But even among those who comply, patriarchal power, as in white mainstream culture, has its prerogative of violence at the *discretion* of the father/husband, with little or no accountability. Women who openly rebel pay the price. Again, as Anzaldúa (1987) declares: "Repele, Hable pa' 'tras. Fuí muy hociona. Era indiferente a muchos valores de mi cultura. No me deje de los hombres. No fui buena ni obediente" (15).[3] As a result of her rebellion, Anzaldúa was considered not a "real woman."

Because of Malinche's betrayal of the nation, all women are suspect. It is similar to the Judeo-Christian construction of Eve as the traitor who tempted Adam with forbidden fruit and thus provoked the banishment of all humans from paradise. La Malinche as the traitor to the nation then sets the stage for all women to be potential traitors. Women's loyalty can only be ensured under the supervision of men. In most instances, it is the guardianship of girls by their fathers, which is later transferred to their husbands, although brothers and male relatives also play a role in "guarding" women's "honor." Within this patriarchal guardianship, there are very few subject positions women can occupy that are congruent with the Chicano communities' cultural definitions of appropriate womanhoods.[4] The acceptable subject positions are girlfriend, wife, sister, daughter, mother, grandmother. The unacceptable subject positions are single woman, single mother, whore, lesbian, queer, and transgender. For mexicanos there is also a culturally specific, ambivalent subject position: the femme-macho, which is a woman who is attractive to men because she is strong and powerful but not promiscuous like a whore or meek like a wife. In fact, her psychological characteristics are grotesquely exaggerated, so much so that none of them are human. The femme-macho's sexuality, in particular, is so accentuated and objectified that she is in effect neutered.

The femme-macho, unlike the virgin or the whore, can either be physically attractive or unattractive. A strong personality is what characterizes her. The strength of the femme-macho does not lie in her racial/physical appearance but, rather, on remaining emotionally uninvolved though sexually active—a cynical, detached, derisive view of love, tenderness, or any "soft emotion" associated with femininity. The man's challenge is to deflower the femme-macho emotionally; the power of the femme-macho is to remain an emotional virgin. The Achilles' heel of the femme-macho is her emotions. Yet she will only be punished for showing particular emotions. The femme-macho can be sarcastic, funny, outrageous, aggressive, mean, or belligerent, but she cannot be tender, loving (except in a political or abstract sense), frightened, or insecure. In fact, femme-machos are always in mortal combat with men to emasculate them and overpower them. Although femme-machos are able to express a wider range of emotions than other kinds of women and therefore obtain some sense of freedom, they are still emotionally trapped because they are never allowed to show weakness.

Many Chicanas, struggling to escape the narrow confines of the whore-virgin dichotomy, embrace the femme-macho characteristics as a form of liberation. A prototype of this adaptation is the persona cultivated by the popular Mexican movie star María Félix. Whereas María Félix came from a working-class background, had no education, was not very talented, but was decidedly beautiful, she was able to forge a career in Mexican cinema and reached international acclaim and wealth. There were many beautiful actors in the 1940s and 1950s when María Félix was at the height of her popularity, but few who were femme-machos. In fact, most of María Félix's movies rested on a formula in which she was an arrogant, indomitable, and belligerent woman who eventually was subjugated by a strong man, akin to Katherine in Shakespeare's comedy *The Taming of the Shrew*. Yet, although most of her movies ended with her submission, in public life she never surrendered. Instead she flaunted her freedom, her economic independence, and her shrewd sense for business (Taibo 1985). The femme-macho also plays with the notion of bisexuality—her taunting is attractive to heterosexual men out of the morbid curiosity about watching women make love to each other. Félix, as a femme-macho, is reported to have had an affair with Frida Kahlo, which further enhanced her power by demonstrating her defiance of established sexual conventions (Herrera 1983). Félix even committed the ultimate sin of keeping emotional distance from her only son and did not exalt her motherhood (Fuentes 1967). Carlos Fuentes,

considered one of Mexico's most celebrated novelists, dramatized this relationship in his novel *Zona Sagrada* (Sacred Zone; 1967). In his novel, loosely based on Félix's life and her relationship with her son, he details the characteristics of the femme-macho. In the novel, the mother emasculates her son by denying him her approval (usually the relationship depicted between a powerful father and his son). The main character of *Zona Sagrada* also teases about her potential bisexuality, further threatening heterosexual men.

Chicana writer and feminist Sandra Cisneros, in her poem "Loose Woman," exalts the characteristics of the femme-macho as a form liberation:

Loose Woman
They say I'm a beast.
And feast on it. When all along
I thought that's what a woman was.

They say I'm a bitch.
Or witch. I've claimed
the same and never winced.

They say I'm a *macha*, hell on wheels,
Viva-la-vulva, fire and brimstone,
man-hating, devastating,
boogey-woman lesbian.
Not necessarily,
but I like the compliment.

The mob arrives with stones and sticks
to maim and lame and do me in.
All the same, when I open my mouth, they wobble like gin.

Diamonds and pearls
tumble from my tongue.
Or toads and serpents.
Depending on the mood I'm in.

I like the itch I provoke.
The rustle of rumor
like crinoline.

I am the woman of myth and bullshit.
(True, I authored some of it.)
I built my little house of ill repute.
Brick by brick. Labored,
loved and masoned it.

I live like so,
Heart as sail, ballast, rudder, bow.
Rowdy. Indulgent to excess.
My sin and success—
I think of me to gluttony.

By all accounts I am
a danger to society.
I'm Pancha Villa.
I break laws,
upset the natural order,
anguish the Pope and make fathers cry,
I am beyond the jaw of the law.
I'm *la desperada*, most-wanted public enemy.
My happy picture grinning from the wall.

I strike terror among the men.
I can't be bothered what they think.
¡Que se vayan a la ching chang chong!
For this, the cross, the calvary.
In other words, I'm anarchy.

I'm an aim-well,
shoot-sharp,
sharp-tongued,
sharp-thinking,
fast-speaking,
foot-loose,
loose-tongued,
let-loose,
woman-on-the-loose
loose woman.

Beware, honey.

I'm Bitch. Beast. *Macha.*
¡*Wachale!*
Ping! Ping! Ping!
I break things.

The poet uses hyperbole to exalt the appropriation of the femme-macho gender adaptation. Every single characteristic of the femme-macho is covered in this poem. If women are thought of as less human then men, the poet outright claims her bestiality ("I'm a beast; I'm a bitch"). If women are thought of as dangerous because they cannot control their passions (as animals often cannot) and they devour men, the poet "feasts" on the notion and claims herself a "danger to society," a "*desperada,*" who "breaks laws," all while her "happy picture grinning from the wall." She defies patriarchal power and usurps a male identity for herself by becoming "Pancha Villa"— after the only Mexican hero to openly defy the U.S. Army at the turn of the century—furthering her transgression by feminizing the name Pancho. She rebels against all authority and violates all sacred boundaries, including that of heterosexuality ("*viva-la-vulva*") and defies the Holy Father by "anguishing the Pope" as well as "mak[ing] fathers cry." She has fashioned herself into a crime of nature and rejoices in her transgression ("man-hating, devastating / boogey-woman lesbian"). She does not regret, apologize, or otherwise feel anything but passion and power ("I like the itch I provoke"). Her emotion is not tempered by sympathetic response to anybody, but instead she thinks of no one but herself "to gluttony." She relishes her selfishness and laughs out loud at how she is the creator of her own image (not real but made out of bullshit through the appropriation and mockery of hegemonic masculinity). She laughs deep, and she laughs hard, and at the end only she is left standing because all of her accusers have run away in fear ("The mob arrives with stones and sticks . . . All the same, when I open my mouth, they wobble like gin"). And all the while she claims, sarcastically, with an implied wicked smile, that this is what she thought "a woman was."

Whereas the femme-macho has her will, her source of strength, whores have no volition. As Emma Pérez indicates, "For Paz, *la india* personifies the passive whore, who acquiesced to the Spaniard, the conqueror, his symbolic father—the father he despises for choosing an inferior woman who begot an inferior race and the father he fears for his powerful phallus" (1993, 61).

From this perspective, whores are not women who give themselves willingly in exchange for a predetermined amount of goods. Instead, they are fallen women and, by definition, damaged merchandise. Most important, Chicana putas are traitors—traitors to the essence of la cultura. As putas, Chicanas betray all that is sacred to Chicano/mexicano culture. At the root of the image of the puta is Chicanos' dread of the symbolic meaning of sexual penetration, especially the equation of penetration and the Spanish conquest of Mexico (Del Castillo 1974; Alarcón 1981; Paz 1985; Pérez 1991, 67).

The construction of Chicanas' womanhood around the virgin, whore, and femme-macho are not meant to be *types* but social locations that are given cultural space to exist (Hurtado 1996a). These subject positions are largely determined by women's virginity or loss of it in culturally appropriate ways.

In Chicano communities, as in many other cultures, there is what might be called a *cult of virginity*. That is, a woman's value as a woman is largely dependent on whether they have restrained from having sexual intercourse. Only under the sanction of heterosexual marriage can a woman "lose" her virginity. Wives and mothers are respected subject positions within Chicano communities, and becoming an elder, an abuelita, is one of the most revered positions. The stigmatized subject positions for women are reserved for those who lose their virginity and practice their sexuality outside the sanctions of heterosexual marriage—again, the single mother, whore, lesbian, queer, and transgender.

The punishment and banishment from Chicano communities have been especially harsh for women who openly claim their lesbianism, queerness, and other sexualities. To sexually prefer women is the ultimate rejection of patriarchy; the strong Catholic underpinnings of Chicano culture make non-heterosexual sexualities a mortal sin (Trujillo 1991, 191). Many Chicanas have found refuge in lesbian, gay, and queer communities and in activism on behalf of sexuality issues. Most Chicana lesbian, queer, transgender, and gay activists, however, have not completely disengaged from their Chicano/a communities or from activism on behalf of Chicano/a issues (Trujillo 1998, 274). The political and theoretical sophistication gained from participation in this broader political base has infused much of the theorizing about Chicanas' gender and sexuality issues.

Some of the most prolific Chicana feminist writers openly claim their lesbianism and queerness. They also are among the most read and cited authors in mainstream circles. Writers like Cherríe Moraga, Gloria Anzaldúa, Alicia

Gaspar de Alba, and Emma Pérez have accomplished a great deal in making sexuality a central part of Chicana feminist theorizing. Chicano communities can be as homophobic and transphobic as white mainstream communities, and Chicana feminists who expose and defend lesbianism and queerness have profoundly challenged the status quo (Saldívar-Hull 1991, 214; Peréz 1996). It is important to acknowledge that progressive politics in Chicano communities are practiced by individuals who are deeply committed to maintaining the cultural integrity of Chicano/a culture and to challenging the dominant hegemony of cultural, linguistic, and economic assimilation (Segura and Pesquera 1992). In that context, to propose that homosexuality and transsexuality be accepted even among working-class Chicanos is a courageous act. At the same time, most of the lesbian, queer Chicana writers have an intense loyalty to their communities of origin, to Chicano/a culture, to the Spanish language, and to working-class issues.

The simplistic subject positions assigned to Chicanas deny the complexity of women's experiences. Chicana feminists have challenged these subject positions by documenting the strengths and agency of the women placed in these narrow categorizations. Chicana feminisms provide the details of women's lives to gain understanding of women's strengths, gifts, agency, and wisdom. Take the subject position of "mother." Instead of characterizing mothers as "madres sufridas (suffering mothers)," who give all to their children with no sense of self, Chicana feminists have written about mothers with admirable characteristics who are also complicated human beings with desires and dreams of their own (Castillo 2016; Caballero et al. 2019). Many Chicana feminists have written eloquently about their loyalty to their mothers (Cantú 1995, 16–17; Cervantes 1981, 11–14; Córdova 1994, 193; Mora 1996; Moraga 1983, 2019). The relationship they highlight in these writings is that of the intimacy, love, and care provided by their mothers, grandmothers, and other mother figures such as aunts. Loyalty is born out of their shared condition as women, but also out of the writers' recognition of these women's class struggles to survive against all odds. Many Chicana writers speak of their mothers' fortitude and resilience on behalf of their families. For instance, Cantú (1995) describes the hardships experienced by her grandmother, or "mamagrande:"

> She holds her dreams in her heart. . . . The work, endless. From cooking daily meals—*sopa de arroz, guisados, postres* for lunch—to keeping the linens whiter than white, fighting the dust and the grime of life on a ranch

of a town. The keeping of appearances, of dignity, of what is right is even more tiring. . . . Her pains and her joys buried in her heart, her hands ever busy crocheting, embroidering, knitting, quilting. The work never stops, her handkerchief *a la mano* in her apron pocket ever ready for the tears of joy or of pain. Mamagrande. (17)

Creative writer and poet Pat Mora (1993) passionately describes the strength her mother gave her. Although her mother was one of the fortunate few of her generation to finish high school in the 1930s, she was unable to attend college. Nonetheless, her lack of higher education did not mean lack of assertiveness.

I've never seen anyone intimidate my mother, who is about five feet tall. Without cheating and resorting to physical violence, I can't imagine anyone who could—not a president, prime minister, or pope. . . . When she's angry, I think her eyes can melt metal. She is assertively articulate in English or Spanish and has never hesitated to state her displeasure, whether at poor service, rude behavior, or injustice. She can be bilingually fierce. . . . Articulate fire is wealth. . . . Ultimately, of course, she was showing us the importance of expecting justice and of clearly and forcefully stating objections to unfairness. (82–83)

Chicana feminists see their mothers as unnamed feminists and unclaimed heroes who, through their daily lives, map what Chicana feminists want to capture in their writings. Although not without tension, the relationship between mothers and daughters in Chicana feminisms is overwhelming in its solidarity to political struggle. Lesbian and queer writers also speak of how the relationships with their mothers flourished, even when they disapproved of or did not understand their daughters' commitment to lesbianism and queerness (Moraga 1983; 2019).

The Importance of Intersectionality

Many Anglo women, including feminists, simply cannot accept the fact that there are minority women with brains and status. They seem unable to realize, possibly because of gross ignorance of minority history, that we have a strong history of involvement, achievement and guts, since we've had to fight no [*sic*] only the issue of sexism but the issue of racism. In terms

of human dynamics, we're usually knowledgeable and aware since we are operating on two planes: the racism inherent in White-Brown relations and sexism. Later on, I'll discuss classism.

—Martha Cotera, *The Chicana Feminist*

Like many Chicana feminist theoretical contributions, intersectionality, which I discuss in depth in chapter 4, was birthed from the necessity to address inequality based on sex, gender, sexuality, race, class, and ethnicity. Most recently, physical ableness has been added as another axis of inequality. Chicana feminist organizing is committed to fighting for equality for all, not eliding difficult issues of representation. The commitment to social justice has pushed Chicana feminist writers and activists to extend the boundaries of the conceptualization of the intersections that contribute to inequality by including nonconforming gender behavior and expanding to understand and fight for the rights of trans individuals, for example.

Chicana feminists' experiences of participating in multiple political struggles alerted them to the exclusion of social class, race, and ethnicity in feminist mobilizations. In response to feeling only partially understood, Chicana feminists developed, in conjunction with other feminists of Color, the concept of intersectionality (Crenshaw 1989; Collins 1991; Hurtado 2003c; 2018). Chicana feminisms ascribe to the notion that women belong to more than one oppressed group and that through understanding the intersection of how these different social categories (sexuality, class, race, ethnicity, gender, physical ableness) intersect in contextually specific situations, Chicanas' multiple oppressions can be understood. For example, a poor, lesbian, immigrant, Mexican farmworker will experience patriarchy and gender subordination differently than a middle-class, heterosexual, third-generation U.S.-born Chicana professor. Intersectionality immediately recognizes that not all women are the same and that social locations identified through group membership can elucidate women's multiple sources of oppression.

A corollary to intersectionality is that the experience of multiple sources of oppression facilitates Chicanas' experience of a multilayered social reality—that is, the knowledge of more than one language and one culture allows the potential for realizing the arbitrary nature of social categories. Chicana feminist writers have identified the ability to perceive and translate different social realities as mestiza consciousness (Anzaldúa 1987), concientización (Castillo 1995), shifting consciousness (Sandoval 2000), and

multiple subjectivities (Hurtado 2005). These writers have capitalized on this intellectual dexterity to capture fully the internal diversity of Chicanas in the United States and to avoid essentializing the "Chicana experience." Furthermore, the ability to communicate multiple realities has facilitated Chicana feminist writers speaking to different constituencies through their intellectual production and addressing different sources of oppression, depending on whom they are addressing (Arredondo et al. 2003).

Intersectionality has always been present in Chicana feminist writings, although it was not explicitly named as such. The development of Chicana feminist theory has continued to evolve since 1977, with the pathbreaking publication of Cotera's book, and has continued to grow and make its mark inside and outside the academy (Zavella 2020). Chicana feminist writings are provocative, incendiary, and a call to action, not only to dismantle the masculinist and racist scholarship on ethnic minorities but also to challenge the stronghold white feminists have had on the production of feminist theory. The writings in this area have been produced by Chicanas as well as non-Chicana writers, providing a variety of perspectives from within the group as well as outside of it. The writers of Chicana feminisms have differences in terms of race, class, ethnicity, age, academic disciplines, and writers outside the academy. However, they have an overarching commitment to analyzing gender as an integral part of other stigmatized social categories.

Intersectionality as proposed by Chicana feminisms takes the social categorizations used to impose inequalities and examines them from the perspective of the history and culture of Chicanas and other women of Color to propose specific avenues for social change and recommit feminisms to a social justice agenda (Zavella 2020). Chicana feminist writings have squarely situated themselves as coming from working-class perspectives and in solidarity with economically oppressed groups. As the largest organization of Chicana/Latina/Indigenous and gender nonconforming organization states in its 1983 founding statement:

> We are the daughters of Chicano working class families involved in higher education. We were raised in labor camps and barrios, where sharing our resources was the basis of survival. Our values, our strength derive from where we came. Our history is the story of the working class people–their struggles, commitments, strengths, and the Chicano/Mexicano experience in the United States. We are particularly concerned with the conditions women face at work, in and out of the home. We continue our mothers'

struggle for economic and social justice. The scarcity of Chicanas in institutions of higher education requires that we join together to identify our common problems, to support each other and to define collective solutions. Our purpose is to fight the race, class, and gender oppression we have experienced in the universities. Further, we reject the separation of academic scholarship and community involvement. Our research strives to bridge the gap between intellectual work and active commitment to our communities. We draw upon a tradition of political struggle. We see ourselves developing strategies for social change–a change emanating from our communities. We declare the commitment to seek social, economic, and political change throughout our work and collective action. We welcome Chicanas who share these goals and invite them to join us. (Mujeres Activas en Letras y Cambio Social n.d.)

Clearly stated in this founding statement is the steadfastness Chicanas feminisms have to "bridge the gap between intellectual work and active commitment to our communities" (Mujeres Activas en Letras y Cambio Social n.d.).

Chicana feminist writers were deeply influenced by the political movements of the 1960s and have strong Marxist leanings. Most Chicana college students, even those entering college today, come from predominantly working-class backgrounds, have parents who did not finish high school, and are oftentimes the first generation in the United States. In reviewing Chicana feminist writings from the 1970s and 1980s, Córdova (1994) includes the following issues: "welfare rights, childcare, health, birth control, sterilization, legal rights, prison experience of Chicanas, sex roles, images of Chicanas, heroines of history, labor struggles (mostly historically), and organizing themselves as Chicanas" (178). Sosa Ridell (1993) makes a plea for Chicanas to address the political and cultural issues raised by the new reproductive technologies, such as in vitro fertilization, surrogate motherhood, and artificial insemination. She perceives Chicanas and other women of Color to be particularly vulnerable to abuses of these technologies because "the lack of control Chicanas/Latinas may experience over their reproductive lives must be linked to their material conditions. These material conditions include a socioeconomic status that places them in a high-risk category for continued reproductive victimization, increased health risks due to their occupational segregation, and exclusion from access to information,

services, and decision-making in the area of reproductive technology policy making" (190).

The Importance of Political Coalitions

> Racism, classism, and sexism will disappear when we accept differences and if we continue to resist loudly and clearly all racist, classist, and sexist efforts on the part of other persons to enslave us. We should resist this whether they are Brown, Black, White, lesbian, heterosexual, male, or female. Maybe then the level of consciousness will be raised, if not through goodness, at least through our resistance and unity.
>
> —Martha Cotera, *The Chicana Feminist*

Many Chicana feminists extend their work beyond differences, finding dimensions of similarity through "strategic suspensions" (Hurtado 1996b) and producing feminisms that defy "geopolitical borders" (Saldívar-Hull 1991, 211). Chicana feminists have also made enormous contributions to theorizing nonhierarchical relationships with Third World feminists worldwide and with other U.S. feminists of Color (208–29). Their theorizing averts the obstacle of race privilege inherent in white feminisms. The working-class commitments observed by Chicana feminists, however fraught with tensions, have also been a bridge to women of Color in the United States and in Third World countries. Many of the cornerstones of Chicano/a culture based on Catholicism and on a rural, working-class culture find their echo in Third World feminisms, especially in those from Latin America (Sternbach et al. 1992). Moreover, Chicana feminists' commitment to the liberation of their communities as a whole is a much more common goal among Third World feminists. This perspective is in opposition to the Western view of freedom based on *individual* rights, which has been highly influenced by white feminists' relationships to white men as fathers, lovers, husbands, and brothers (Hurtado 1996a). White privilege interferes with Third World feminists' trust of white feminists as individuals or as producers of feminist knowledge. White feminist privilege is a significant barrier for many Chicana feminists who view themselves as members of a politically colonized group within the United States (Saldívar-Hull 1991). They cannot ignore the history of conquest and labor exploitation their group has suffered at the hands of the dominant white group. The exploitation, moreover, has

benefitted white women directly and indirectly because of their race (Fine 1997; Frankenberg 1993; Hurtado 1998; McIntosh 1992; Ostrander 1984) and because of their familial relationship to white men (Hurtado 1996a).

The frameworks proposed by Chicana feminisms for liberation are reflexive in nature—there is a constant self-scrutiny to avoid oppressing others. As Pérez (1991) contends, "Within capitalist patriarchal ideology, there is no place for the sensitive human being who is willing to transform the world . . . each member of the collective taking responsibility for hers/his contradictions within the collective, willing to grapple with the question, 'Who am I exploiting?'" (173). Regardless of their colonized status and the risks involved, especially for lesbians and queers, Chicanas nonetheless assume agency (Trujillo 1998). They know that within specified, restrictive contexts they too can act in prejudicial and racist ways. As a whole, Chicana feminisms are theories about liberation for all.

From the beginning, many Chicana feminists have not been concerned with reaching consensus or avoiding disruption (García 1989) in order to voice their conditions as women, lesbians, transgender, members of ethnic and racial groups, or their predominantly working-class status (Sandoval 1991). They confronted their internal diversity earlier than many other groups, including the white women's movement. In other words, they readily ascribed to many feminisms and, in fact, expect there to be more than one. According to Arredondo and co-authors (2003):

> [an apt] metaphor for capturing the multiple engagements of Chicana feminists is of women living and working in an intellectual *glorieta* (a roundabout), a space that centers on the Chicana experience and is a standpoint from which to engage in dialogue with different audiences and participants. The *avenidas* that we face in the glorieta allow Chicana feminists to make assessments of power in relation to our varied locations. Like a Mexico city glorieta, the dialogue is fast-paced, fluid, and flexible, at times unnerving; it forces intellectual dexterity. Such agility is foundational to the Chicana feminist political project, which intervenes in important ways to raise consciousness and further the struggle for decolonization against multiple oppressions. (2–3)

Chicana feminists have raised their disruptive voices, calling for solidarity and political coalition vis-à-vis various progressive movements like Third World feminism; the white women's movement; decolonial femi-

nisms (Lugones 2003; Sandoval 2000); the Chicano movement; socialist and Marxist movements; revolutionary movements, primarily in Latin America; and most recently, the development of Latina feminism (Ortega 2016).

Chicana feminisms do not situate the sources of women's oppression exclusively in gender or in class, race, ethnicity, or sexuality. Their commitment to examine women's disadvantages through the lens of intersectionality allows them to actively seek political coalitions with other oppressed groups, including men of Color. Chicana feminisms refuse to "rank the oppressions" (Moraga and Anzaldúa 1981) and are committed to being self-reflexive about how everybody, regardless of their apparent powerlessness, can contribute to oppression within restricted contexts (Pérez 1991). At the same time, Chicana feminisms see class struggles as fundamental to worldwide liberation (Saldívar-Hull 2000).

Concluding Thoughts on Chicana Feminisms

Martha Cotera's book published in 1977 has produced four generations of Chicana feminist scholars and writers in several disciplines: American studies, anthropology, art, ethnic studies, film studies, literature, psychology, sociology, and feminist studies. Among the scholars is Martha Cotera's daughter Maria, who, together with other writers, is expanding and elaborating on the tenets of Chicana feminisms. Furthermore, young, educated Chicanas are embracing the political goals set by the first generation of Chicana feminist writers and using their various professions to implement many of the ideas written about forty years earlier. These developments, coupled with the flexibility and self-reflexivity inherent in the paradigms proposed by Chicana feminisms, make it a promising and expanding field of study. Chicana feminisms are also being used as a potential framework for political action. Saldívar-Hull (1991) summarizes the premises on which Chicana feminisms currently exist:

> From Anzaldúa's important revision of Texas history to the theoretical proclamations by the collective voices of Moraga, Gómez, and Romo-Carmona to Viramonte's questioning the constitution of family, Chicana feminism challenges boundaries defied by the hegemony. . . . Chicana feminism, both in its theory and method, is tied to the material world. When feminist anthologizers . . . cannot recognize Chicana theory, it is because Chicanas ask different questions which in turn ask for reconstruction of the very premise

of "theory." Because the history of the Chicana experience in the United States defines our particular *mestizaje* of feminism, our theory cannot be a replicate of white feminism nor can it be only an academic abstraction. The Chicana feminist looks to her history (to paraphrase Bourne's plea for feminist praxis) to learn how to transform the present. For the Chicana feminist it is through our affiliation with the struggles of the other Third World people that we find our theories and our methods. (220)

It is on these lived experiences that the next phase of Chicana feminisms resides and on which future writers will build.

Overview of This Book

In addition to the introduction, this book consists of four chapters. The chapters are designed to provide an overview of the scholarship in the area of Chicana feminisms. In chapter 1, "Sitios y Lenguas / Spaces and Languaging: Creating Chicana Feminisms," I explore the use of the phrase "un sitio y una lengua" (space and language),[5] first introduced by Chicana feminist Emma Peréz in the 1990s, to capture the essence of the Chicana feminist project. Both parts of the phrase—space and language—have multiple layers of meaning (some overt, some less so) that were fundamental to the development of Chicana feminisms. Chapter 2, "'Me Siento Continente' / I Feel Myself Continent: Chicana Feminist Methodologies," focuses on four of the several innovative and pathbreaking methodologies developed within the field of Chicana feminisms: (1) writing as method, (2) language as method, (3) collaboration as method, and (4) testimonio as method. These four methods center gender in the analysis of Chicanas' existence. Chapter 3, "'Mi Lucha Es Mi Arte' / My Struggle Is My Art: Chicana Feminisms and Art," covers Chicana art and activism, focusing on four areas of artistic activity: the visual arts, music, spoken word, and dance. The final chapter, "'Por La Raza Habla Mi Espiritu' / Through My People Speaks My Spirit: Intersectional Chicana Feminisms and the Women's March," is a case study of the use of Chicana feminisms' intersectional frameworks by discussing the women's marches that took place on January 2017 in Washington, D.C., and January 2018 in Las Vegas, Nevada. Both events were co-organized by Carmen Pérez, a young Chicana feminist and political organizer who took my college course on Chicana feminisms. Pérez's experience in my class

influenced her thinking about political organizing and led to the largest demonstrations in U.S. history.

As is customary in the Mexican American series, there are additional suggested readings listed at the end of each chapter and a series of class exercises to encourage readers to further explore the topics presented in each chapter. Each chapter includes short biographies of distinguished Chicana feminists relevant to the topics covered. Each chapter also includes multiple epigraphs taken from the writings of prominent Chicana feminist writers, to provide a sampling of their writing with the hope that the reader will be enticed to seek further reading.

Chapter 1

Sitios y Lenguas /
Spaces and Languaging

Creating Chicana Feminisms

Our works emerge from un sitio y una lengua [a space and language] that rejects colonial ideology and the by-products of colonialism and capitalist patriarchy—sexism, racism, homophobia . . . Chicanas seize sociosexual power [to create] our own sitio y lengua. So I move from deconstructing male centrist theory about women to reconstructing and affirming a Chicana space and language in an antagonistic society.

—Emma Pérez, *Sexuality and Discourse*

I will no longer be made to feel ashamed of existing. I will have my serpent's tongue—my woman's voice, my sexual voice, my poet's voice. I will overcome the tradition of silence.

—Gloria Anzaldua, *Borderlands / La Frontera*

In 1991 Emma Pérez wrote the above quotation about Chicana feminist production (box 3, figure 3). She placed an emphasis on creating "the space and language" that are "rooted in both the words and silence of Third-World-Identified-Third-World-Women who create a place apart from white men and women and men of color" (161–62). As mentioned in the introduction to this book, Chicana feminisms as an area of study was first brought to light in 1977 with the publication of Martha Cotera's book aptly entitled *The Chicana Feminist*. In Cotera's book, the seeds that had accumulated from many years of action and writing by Chicanas in various fields are presented and theorized upon. In her incisive analyses, Cotera lays out the experiential basis (or sitios) for developing new discourses (or lenguas) that encapsulate the feminisms developing on the ground as Chicanas articulate their oppression at the intersections of race, class, gender, sexuality, and ethnicity. This powerful new theory was later termed *intersectionality* by legal scholar Kimberlee Crenshaw (1991).

Box 3. Biography of Emma Pérez

Born in El Campo, Texas, Emma Pérez has published essays in history and feminist theory, as well as *The Decolonial Imaginary: Writing Chicanas into History*. Her novel *Gulf Dreams* was first published in 1996 and was considered to be one of the first Chicana lesbian novels in print. Pérez earned her PhD in history at the University of California, Los Angeles. She taught in the Department of History at the University of Texas, El Paso, from 1990 to 2003, where she also served as chair. From 2003 to 2017, Pérez taught in the Department of Ethnic Studies at the University of Colorado, Boulder. As chair, she led the development of the department's doctoral program in comparative ethnic studies.

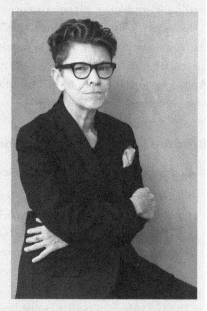

Her second novel, *Forgetting the Alamo, Or, Blood Memory* (University of Texas Press, 2009) is a Chicana lesbian western that challenges white-male-centric domination of this genre. The novel was awarded the Christopher Isherwood Fiction Writing Grant in December 2009, as well as the National Association for Chicana/Chicano Studies Regional Book Award for fiction (2011). Her most recent novel, *Electra's Complex*, is an erotic, academic mystery published in spring 2015 (Bella Books).

Pérez continues to research and write about LGBT Chicanx/Mexicanx in the borderlands in her two latest projects:

Figure 3. Photo of Emma Pérez. Photo courtesy of Alma López.

"The Will to Feel: Decolonial Methods, Queer and Otherwise," which promises to be a brief study that interrogates the coloniality of feelings, and *I, Ben Espinoza*, a dystopic novel that probes a colonial global order run by the wealthy 1 percent.

Since 2017 Pérez has been a research social scientist in the Southwest Center at the University of Arizona. As part of her research appointment, she also teaches in Gender and Women's Studies.

In this chapter, I bring Cotera's early analyses up to date by using Emma Pérez's proposal that the creation of un sitio y una lengua is integral to Chicana feminisms. I provide several interpretations of the words *sitio* and *lengua*, as these two words inherently have multiple meanings. The plural forms of *sitio* and *lengua* convey the multiple meanings that demonstrate how Chicana feminisms fit within Pérez's paradigm. For instance, *sitios* can refer to a geographical location, a historical racial origin, or a philosophical space, while *lenguas* can refer to a specific language, a discourse, or literally a tongue that boldly asserts sexuality. These diverse spatial and linguistic attributes are central to the existence of Chicanas.

Similarly, Gloria Anzaldúa's (1987) metaphors of la frontera (the borderlands) and la lengua (tongue) aptly apply to the field of Chicana feminisms (box 4, figure 4). In this chapter, I use the insights of Pérez and Anzaldúa to elaborate on the multiple meanings of *la lengua(s) para crear sitios fronterizos*.[1]

Buscando Sitios / Searching for Spaces

Claiming a Geographical Location

El *Río Bravo* was once a life-giving stream that my ancestors crossed to travel north or to journey south. Back and forth, completing cycles. The river was not a boundary. *Gringos/as* built boundaries, fences, for themselves while they invaded our space, our boundaries.

—Emma Pérez, *Sexuality and Discourse*

The U.S.-Mexican border es una herida abierta where the Third World grates against the first and bleeds. And before a scab forms it hemorrhages again, the lifeblood of two worlds merging to form a third country—a border culture. —Gloria Anzaldúa, *Borderlands / La Frontera*

The site of colonization for Chicanas has geographical specificity—the U.S.-Mexico border. It was in la frontera (the borderlands) that Chicanas situated their feminisms to highlight a particular border culture and language that stood between two nation-states, Mexico and the United States; they did not belong fully to either. Chicana feminists have been at the forefront of theorizing from the borderlands—la frontera is their sitio, their space (Anzaldúa 1987). The geographical area represented by la frontera has become the guiding metaphor for the border crossings Chicanas do on

Box 4. Biography of Gloria E. Anzaldúa

Gloria Evangelina Anzaldúa was a cultural theorist, writer, and scholar. She was born in 1942 in Raymondville, Texas, and spent her early years on Jesus María Ranch in the Rio Grande Valley. When she was eleven years old, her family moved to Hargill, Texas, to provide the children with greater educational opportunities. She was an avid reader as a child, and during high school she experimented with poetry, fiction, and journaling. From her experiences working on farms and ranches across South Texas, Gloria gained an intimate knowledge of the Rio Grande Valley's racist legacy and history of Tejano land dispossession—a knowledge that had a profound influence on her work.

In 1962 Anzaldúa graduated from Edinburg High School and enrolled in the Texas Women's University. Unable to meet the cost of tuition, she withdrew after her first year and worked for several years. She earned her bachelor's degree in English, art, and secondary education from Pan American University in 1969.

During summer breaks from graduate classes at the University of Texas in Austin, Anzaldúa taught preschool, special education classes, and high school in the Valley. She received her master's in English and education in 1972 and worked as a liaison between migrant camps and school officials in Indiana for two years before returning to the University of Texas in Austin to continue her graduate studies in literature. While attending UTA, she worked with various political groups, including the Movimiento Estudiantil Chicanx de Aztlán (MEChA), farmworker protesters, and feminist groups.

Figure 4. Photo of Gloria E. Anzaldúa. Photo courtesy of Annie Valva.

Anzaldúa discovered a deep absence of works by and about women of Color in the United States while teaching at UTA. This glaring lack of scholarship (and a pivotal experience of discrimination at a writing workshop in San Francisco) propelled her to put out a call to women of Color for their papers; eventually this collection of essays became the anthology *This Bridge Called My Back: Writings by Radical Women of Color*. In 1981 she and Cherríe

(*continued*)

Box 4. (continued)

Moraga published this co-edited anthology, which provided important contributions to feminist theorizing and catalyzed the development of Third World feminisms in the United States. In 1986 Anzaldúa and Moraga received the Before Columbus Foundation American Book Award for outstanding contributions to American literature.

The eighties were a time of prolific writing for Anzaldúa. She moved from San Francisco to New York and developed her craft while attending writing retreats and workshops. In 1987 she published her essays and poems in *Borderlands / La Frontera: The New Mestiza*, a semi-autobiographical book that explores the invisible borders that exist between groups and identities—men and women, Latinas/os and non-Latinas/os, and other groups.

In 1988 Anzaldúa enrolled in a PhD program in literature at the University of California, Santa Cruz, and assembled a course reader for a women's studies class that would become the basis for *Making Face, Making Soul / Haciendo Caras*, an anthology of essays, research papers, poetry, and storytelling by women of Color. The book was published in 1990 and won the Lambda Literary Award for Best Lesbian Debut. After a brief respite from her graduate work, she pursued her professional writing and speaking career. At this time Anzaldúa was diagnosed with diabetes. She returned to her previous dissertation project with new chapters and essays. With AnaLouise Keating, she published the edited collection *This Bridge We Call Home: Radical Visions for Transformation* in 2002. This anthology followed the work of *This Bridge Called My Back* with new examinations of social issues by women and men, both of Color and white, in the United States.

Throughout her life as a writer, theorist, and activist, Anzaldúa dedicated herself to teaching and bringing women of Color writers together. She taught at Vermont College's Adult Degree Program in the eighties and in several writer-in-residence and visiting-professor appointments. She received many awards and honors in her lifetime, including the previously mentioned Before Columbus Foundation American Book Award (1986) and Lambda Lesbian Small Book Press Award (1991) and a National Endowment for the Arts Fiction Award (1991), the Lesbian Rights Award (1991), the Sappho Award of Distinction (1992), and the American Studies Association Lifetime Achievement Award (2001).

In 2004 Anzaldúa passed away in her home in Santa Cruz, California, from complications due to diabetes. At the time, she was working toward the completion of her PhD dissertation. UC Santa Cruz posthumously awarded Anzaldúa a doctoral degree in literature in 2005.

a daily basis as they encounter multiple boundaries in class, race, ethnicity, and sexuality. Maintaining a coherent sense of self and preventing others from invading their boundaries to define them is a constant battle. As Pérez (1991) points out: "The boundaries that I draw sustain my sanity. We cannot be friends as long as you think you know every part of who I am, as long as you think you can invade my space and silence my language, my thoughts, my words, my rage. *Mi sitio y mi lengua.* Invasion, a deceitful intimacy. The Perpetrator wields power over the victim. The colonizer over the colonized. Sexual-racial violence mired in language, in words. A speculum of conquest to 'penetrate' further" (175).

A pivotal theoretical addition to Chicana feminisms has been the work of Gloria Anzaldúa—writer, public intellectual, and one of the first Chicanas to publicly claim her lesbianism (Moraga and Anzaldúa 1981). Anzaldúa (1987) declares the border as the geographical location (sitio) that created the aperture for theorizing about subordination from an ethnically specific Chicana/mestiza consciousness. From her perspective, the history of conquest, which layered the new country (the United States) over a preexisting one (Mexico), is evidence of the temporality of nation-states (Klahn 1994).

The political line dividing the United States from Mexico does not correspond to the experiential existence on the border, where families of Mexican descent live on both sides of the Rio Grande and where shopping, entertainment, and cultural expression are not determined by the legal line that separates both nations (Cantú 1995). On the border, many individuals live, work, and socialize in both countries without experiencing contradiction (Anzaldúa 1987). Living in the borderlands creates a third space between the two cultures and social systems, where embracing ambiguity and holding contradictory perceptions without conflict lead to coherence. Thus la frontera is a geographical area characterized by la mezcla (mixture), because it is neither fully of Mexico nor fully of the United States. La frontera is where you "put chile in the borscht/eat whole-wheat tortillas/speak Tex-Mex with a Brooklyn accent" (195). The borderlands provide the space for antithetical elements to mix, not to become homogenized or incorporated into a larger whole, but to become combined in unique and unexpected ways (Hurtado 2003b).

Borderlands theory was born out of Anzaldúa's experiences as the daughter of farmworkers living in extreme poverty in South Texas. However, the theory can be applied to many types of social, economic, sexual, and political dislocations. Anzaldúa's insights help us theorize the experiences

of individuals who are exposed to contradictory social systems and, as a result, develop a mestiza consciousness—the notion that individuals (primarily women) who are exposed to multiple social worlds (as defined by cultures, languages, social classes, sexualities, nation-states, and colonization) are able to perceive and challenge linear conceptions of social reality. A mestiza consciousness simultaneously embraces and rejects contradictory realities to avoid excluding what it critically assesses. Individuals living in many liminal spaces (Lugones 2003) are the most likely to develop a mestiza consciousness, which permits them to perceive multiple realities at once (Barvosa 2011). Anzaldúa's work integrates Indigenous Aztec beliefs and epistemologies that circumvent linear, positivist thinking, which does not readily allow for hybridity, contradiction, and ultimately liberation from existing social arrangements (Hurtado 2003b).

It was at the border that Chicanas/mestizas learned the socially constructed nature of all categories. Standing on the U.S. side of the river, they saw Mexico and they saw home; standing on the Mexican side of the border, they saw the United States and they saw home. Yet they were not really accepted on either side. Their ability to "see" the arbitrary nature of all categories but still take a stand challenged Chicana feminists to construct paradigms that exclude while including, to reject while consenting, to struggle while accepting. The basic concept involves the ability to hold multiple social perspectives while simultaneously maintaining a center that revolves around concrete material forms of oppression. In this way, borderlands theory expands on W. E. B. Du Bois's idea of double consciousness;[2] by examining the experiences of Chicanas on the border, borderland theory identifies their multiple subjectivities.

Regardless of multiple border crossings through sitios and lenguas, Chicana feminisms are situated within a U.S. experience. The connection to Mexico is an ancestral one, as well as a political one, but Chicana feminisms are a U.S. phenomenon and proclaim their U.S.-based "Americanness." Chicana feminist writers did not claim a foreign status but rather inserted themselves into the U.S. national debates around gender, while still expressing solidarity with working class Mexican women and the rest of Latin America. They fully acknowledged their Mexican backgrounds, but claimed their rights and privileges as U.S. citizens.

Anzaldúa presages the concept of intersectionality by attributing Chicanas' subordination to patriarchy and to the intersection of multiple systems of oppression. Borderlands theory does not rank oppressions, nor does it

conceptualize them as static; rather, oppressions are fluid systems that take on different forms and nuances depending on the context. Individuals can experience multiple oppressions and forms of resistance that are not easily accessible through traditional methods of analysis and measurement (Torre and Ayala 2009). The inspiration for Anzaldua's view of intersectionality, and the source of her continuous theorizing, was derived from the geographical border between the United States and Mexico. The border between these two countries becomes a metaphor for the many crossings that exist within multiple linguistic and cultural contexts, all of which are also the products of the racial intermixing of the Spanish, African, and Indian peoples. Thus intersectionality must account for multiple axes of oppression and multiple cultural, linguistic, political, and economic systems.

Claiming Racial Historical Origins

Here [the conquest of Mexico], the sexual, political, social, and psychological violence against *la india*—the core of the Chicana—is born. This core has been plundered from us through conquest and colonization. We reclaim the core for our woman-tempered *sitio y lengua*.

—Emma Pérez, *Sexuality and Discourse*

The struggle of the mestiza is above all a feminist one.

—Gloria Anzaldúa, *Borderlands / La Frontera*

Chicana feminist writers are deeply aware of their history of racial colonization. Emma Pérez advocates Chicanas' reacquisition of that part of themselves that is india and that has been "plundered ... through conquest and colonization" (1991, 168); she declares, "we reclaim the core for our women-tempered sitios y lenguas" (1993, 62). The combination of experiencing racialization and situating their feminisms in la frontera has encouraged Chicana feminists to embrace their racial mixture—their mestizaje. The borderlands are a space of all mezclas (mixtures, hybridity), including racial. Exposed were the negative racist judgments of darker-skinned, Indian-looking women and the derogation of their womanhood, even by otherwise progressive Chicano men (Anzaldúa 1987; Broyles 1986). As Norma Alarcón (1990a) states: "It is worthwhile to remember that the historical founding moment of the construction of mestiza(o) subjectivity entails the rejection and denial of the dark Indian Mothers as Indian which have compelled women to often collude in silence against themselves, and

to actually deny the Indian position even as that position is visually stylized and represented in the making of the fatherland" (252). Chicana feminisms have addressed the problematic of colorism and anti-indigenismo head on to expose it and to claim the "india within" (Hurtado and Cantú 2020).

Chicana feminists address issues of racism within their communities based on skin color and Indian heritage as determined by phenotype (Anzaldúa 1987, 21; Broyles 1986; Castañeda 1990, 228). Chicana feminists specifically analyze how racialized physical features are used to define desirable standards of beauty and womanhood (Anzaldúa 1981) within their communities. They reclaimed mestizaje—the mixture of European, African, and Indian "races"—to resist the racist standards existing in U.S. society and adopted in Chicano communities in preferring lighter skin and European features, especially for women (Saldívar-Hull 1991, 214–15; Hurtado 2003b). Zavella (1994) notes: "skin color in particular is commented on, with *las gueras* (light-skinned ones) receiving appreciation, while *las prietas* (dark-skinned ones) are devalued and admonished to stay out of the sunlight so they won't get darker" (205). By speaking to the internal racism of Chicano communities and of progressive Chicano men, Chicana feminists turned the critical lens inward. Their use of standpoint theory reveals how the dynamics of prejudice influence relations in Chicano/a as well as other communities (Ochoa and Teaiwa 1994, ix). By including issues of beauty, sexual desirability, and construction of womanhoods, the analysis of mestizaje is woman-centered rather than dependent on the paradigms developed by male scholars for studying racism (Arce, Murguía, and Frisbie 1987; Forbes 1968; Telles and Murguía 1990, 1992).

Claiming a Philosophical Space

Ya no me van a robar mi sitio y mi lengua.[3] They live inside my soul, with my mother, my sisters, *mis hermanas del tercer mundo.*[4]

—Emma Perez, *Sexuality and Discourse*

Living on borders and in margins, keeping intact one's shifting and multiple identity and integrity, is like trying to swim in a new element, an "alien" element.　　　　—Gloria Anzaldúa, *Borderlands / La Frontera*

Chicana feminists agree with white feminists that patriarchy oppresses them. They diverge, however, from white feminisms because philosophically their analysis of patriarchy does not stem from claiming *individual*

rights denied them by men. Instead, Chicana feminisms propose that their subordination is the result of the intersection of multiple systems of oppression; these systems include gender, but also race, ethnicity, class, and sexuality. It is from this bocacalle (intersection) that Chicana theorists situate their feminisms (Arredondo et al. 2003). The interlocking systems of oppression stem from the historical specificity of colonization of Indigenous peoples by Spain and of the conquest of Mexico by the United States. Chicana feminisms take the history of the Americas as the bedrock on which they theorize their condition as mestizas (hybrids or mixed-race women). Unlike Virginia Woolf's quest for "a room of one's own" as the means to liberation, Chicanas seek a liberatory space to congregate with others like them. The space envisioned is a nurturant space where cultural and language differences do not have to be repeatedly explained. It is also a space of replenishment and shelter from the daily interactions in which Chicanas negotiate a fragmented self. Chicana feminisms theorize about *collective* liberation against all kinds of oppressions. Chicana feminisms not only see men as potential oppressors but rather identify systems of oppression that triangulate into what Pérez (1991) calls the "subject" who holds "sociosexual-racial power" over marginalized others, who include her and others like her: "I see you, who hold sociosexual-racial power, as the subject who objectifies the marginal other—me. . . . I sense you as invasive, conquering and colonizing my space and my language. You attempt to 'penetrate' the place I speak from with my Chicana/Latina *hermanas*" (178). The "subject" oppressing Chicanas is sometimes white men, other times white women, and still other times men of Color and other members of their communities.

Regardless of this *relational* analysis of power, Chicana feminists still put Chicanas and Third World women at the center of their analysis. As Pérez states:

> I prefer to think of myself as one who places women, especially Third World women and lesbians, in the forefront of my priorities. I am committed to women's organizations because in those spaces we revitalize, we laugh, we mock the oppressor, we mock each other's seriousness and we take each other seriously. This is a process of support, this is living the ideal, if only momentarily, to give, to nurture, to support each other in a racist, sexist, homophobic Western society. I speak at this moment of historical consciousness as a Chicana survivor who has survived much more than I speak of here, just as we, women of color survive daily. (178)

Chicanas feminists think of themselves as multiply positioned because of the interlocking nature of their oppression. It is from this philosophical space that they develop political proposals for coalitions to accomplish social justice. The coalition politics Chicana feminisms ascribe to stem theoretically from their knowledge that "women of Color," or "African American women," or "Chicana women" are racialized subjects that have been constructed through historical events and material conditions (46). Rather than adhering to an essentialist notion of racial or gender identity, Chicana feminisms are dedicated to documenting different cultural versions and workings of patriarchy to more effectively mobilize different groups to fight it.

The literature produced by Chicana feminists is as diverse as the women they are attempting to describe and theorize about. They ascribe to interdisciplinary perspectives to encompass the diversity of Chicano communities, making claim to "lived experience" as their philosophical sitio for obtaining knowledge. As Anzaldúa (2002) states, "Personal experiences—revised in other ways redrawn—become a lens with which to reread and rewrite the cultural stories into which we are born" (6). It was on women's flesh that Chicana feminists found history, love, politics, and liberation. Abstract theory was suspect because it often appeared irrelevant to the daily experience of traversing borders and its consequences (Anzaldúa 1987). Chicana feminisms basically posed the challenge, as some other feminisms did, to seek truth not only in abstract categories but also in what women lived and "told in their stories." As Sonia Saldívar-Hull (1991) advocates, "We have to look in nontraditional places for our theories: in the prefaces to anthologies, in the interstices of autobiographies, in our cultural artifacts, our cuentos [stories], and if we are fortunate to have access to a good library, in the essays published in marginalized journals not widely distributed by the dominant institutions" (206).

The intellectual and philosophical project of Chicana feminisms is to bring to light women's lived experiences and to document a different social, economic, and cultural reality than that found in mainstream academia and cultural production.

Reclamando Lenguas / Reclaiming Languages

Claiming a Language

[Jacques] Lacan imparted to us the "symbolic law of the father" entrenched in language. Language, he argues, is ensconced with symbols that dictate

patriarchal power. But in his discussion he, like Freud, dismisses women, and exalts the phallus, again because women do not have "one."

—Emma Perez, *Sexuality and Discourse*

Attacks on one's form of expression with the intent to censor are a violation of the First Amendment. El Anglo con cara de inocente nos arrancó la lengua [The Anglo putting on an "innocent face" ripped out our tongue]. Wild tongues can't be tamed, they can only be cut out.

—Gloria Anzaldúa, *Borderlands / La Frontera*

Chicanas reclaim their native Spanish language as an act of resistance to the dominant U.S. ideologies of English language assimilation (Hurtado 2016). The claim of Spanish is not for the version of the language imposed on Mexico by Spanish conquistadores, but rather the Spanish developed in Mexico and the various hybridized versions of the language that unfolded in the United States among Chicano/a communities. Reclaiming Spanish is a public acknowledgment of the linguistic limbo many experience as they are socialized in Spanish at home and then confront language repression when they enter school (Hurtado 1989). Learning the "colonizer's language" (Hurtado and Rodriguez 1989) was a traumatic event for many Chicana feminist writers and one that deeply influenced their thinking about the meaning of having their own lengua (language). As Pérez (1991) relates:

> Like many tejanas/os [Texans] who attended Anglo schools through grade school, I too was punished for speaking my parent's tongue on playgrounds and classrooms. Spanish set my brother and me apart. Anglo teachers peered at us when we spoke Spanish, the way white women peer at me now when they try to interfere in a circle of Chicanas speaking together in *Spanglish*, reaffirming our *mestizaje*. As a child in Anglo schools, I realized quickly that I had to learn English, to pronounce it accurately, precisely. I was ridiculed for my accent, I was pushed into dark closets, disciplined for calling a student *gringo*. I practiced at night, staring up at the ceiling in my bedroom, reciting the alphabet. In English. Forgetting *la lengua de mi gente* [the language of my people]. Not knowing that the loss of language is loss of memory. (174)

The loss of their native lengua and the shame among those who retained it propelled Chicana feminists' understanding of the political nature of all discourse. Sonia Saldívar-Hull (2000), in her book *Feminism on the Border*,

refused to translate, italicize, or otherwise mark the shift between English and Spanish in the first few chapters of her book. She wanted non-Spanish readers to experience the disjuncture felt by many monolingual Spanish speakers, especially children, as they are thrust into mainstream circles not understanding English:

> In a consciously political act, what Gloria Anzaldúa calls "linguistic terrorism," I will not italicize Spanish words or phrases unless they are italicized in direct quotations. I invite readers not fluent in Spanish to experience a sense of life on the border as we switch from English to Spanish. Sometimes we translate, at other times we assume the nonnative speaker will understand from the context. Many Chicanas/os speak only English. Reading Chicana texts puts several demands on the reader, including the expectation that the reader will be knowledgeable in multiple Chicana and Chicano linguistic, cultural, and historical contexts. While most contemporary Chicana writers and critics have been formally educated in the United States and are fluent in English and Spanish, many of the writers code-switch between the two languages in a conscious act of identity politics. . . . My political practice as a transfrontera border feminista informs my linguistic acts of "identitarian collectivities." Once I have given the non-Spanish-literate reader a sense of "alien" disorientation in the text, I move toward more inclusionary tactics and offer translations in [later chapters]. (173)

Professor Sonia Saldívar-Hull is not the only Chicana feminist advocating the reinscription of Spanish as a U.S.-based language. As noted previously, Professor D. Inés Casillas (2014) expresses her solidarity with Chicana feminist writers by refusing to italicize the Spanish phrases in her book *Sounds of Belonging*. From her perspective, Spanish is not a foreign language, given Chicanos/as' history of colonization.

Having access to multiple discourses in two languages—from formal English, to Spanglish, to Caló—provides insight into the political nature of how intellectual "merit" is defined. Many Chicana feminists who came from working-class backgrounds experienced the derogation of their parents by schools and other institutions because their parents did not speak English. As Pérez (1991) relates:

> When I entered the first grade, I cried each day after school. I lay my head on my mother's lap, a woman who was denied the right to read and write

the language of the colonizer in a land that belonged to her ancestors. She brushed my hair back, comforting me. I couldn't articulate what I say so easily now. I couldn't say that the woman who comforted me, the woman who held power, beauty, and strength in my eyes, that Anglos dismissed her because she couldn't fill out their damn forms. I couldn't say that the school was infested with white students, so alien to me. And that day the white teacher shoved me against a wall because I didn't recite the "Pledge of Allegiance." I didn't know it. But I knew "El Rancho Grande." (177–78)

Chicana feminists did not bend to the academic tyranny that insisted that English be the sole language of scholars in the United States. The use of Spanish by Chicana feminists in intellectual production became a signifier of political assertion of the value of their heritage and the means by which to create a feminist discourse directly tied to a Chicana experience.

Claiming a Discourse

[Michel] Foucault transcribes historical documents to ventilate "the power of discourse." He argues that "through discourse power-knowledge is realized." Language, after all, is power. Third World people know that to learn the colonizer's language gives one access to power and privilege, albeit controlled, qualified power.

—Emma Pérez, *Sexuality and Discourse*

We are robbed of our female being by the masculine plural. Language is male discourse.

—Gloria Anzaldúa, *Borderlands / La Frontera*

Discourse is yet another meaning for lengua (language); it is the formal expression of thought on a subject. Chicana feminisms proclaim that creating and controlling their discourse is essential to decolonization. Passive silence has been the enemy that allowed others to construct who Chicanas are, what they can and cannot do, and what they are capable of becoming. Claiming discourse is claiming power for Chicanas to construct themselves. As Pérez states: "If discourse reveals the history of sexuality, then women of color face an obstacle. We have not had our own language and voice in history. We have been spoken about, written about, spoken at but never spoken with or listened to. Language comes from above to inflict us with western-white-colonizer ideology." (175–76).

In the 1970s the lack of access to academic writing nullified Chicanas from the white feminist intellectual landscape. They did not exist as intellectuals because, from a dominant white hegemonic feminist perspective, women-of-Color feminists in general, and Chicana feminists in particular, had not developed a distinctive and comprehensive theory of liberation; their existing writings were considered to be "mainly at the level of description" (Jaggar 1983, 11). However, there is now a critical mass of Chicana feminist writers who have created an alternative discourse that dovetails with and outside of academic writing; they have used multiple tools to write in a complex fashion about Chicanas' experiences and subjectivities. Most recently, Chicana feminist writers have expanded the Chicana discourse by incorporating other forms of communication such as dance and performance (Díaz Sánchez 2012; González 2014).

Chicana feminists have also recuperated the wisdom of their foremothers by reconstituting what is traditionally considered valid discourse in the academy. Instead of rejecting the discourses of their working class communities, Chicana feminists privilege the oral communications received in the home, particularly from the women in their families. As Lorna Dee Cervantes (1981) claims, "I come from a long line of eloquent illiterates / whose history reveals what words don't say" (45); Sonia Saldívar-Hull (2000) exhorts us to go beyond the "dominant discourse" and look in "non-traditional places for our theories" (46); and Alvina Quintana (1989) advocates the use of literary texts to see Chicanas as "their own ethnographers" (189).

Chicana feminists struggled to decolonize language, to burst open discourses and allow for the possibility of a liberatory consciousness (Sandoval 2000). They reject the dichotomization of discourse between "high" theory and everyday discourse. As stated by Pérez (1991): "We speak our history to each other now just as our ancestors used oral tradition. A tradition which is minimized. We must write in accomplished English to legitimize our work. We must master the language of the colonizer before our studies are read. *Gringos y gringas* censure our real language which is often born from rage" (175–76).

Chicana feminists claimed the women's discourse found within their communities. Women's shared stories of defeat and resistance within their families were validated as worthy of recording, reporting, and analyzing (Hurtado 2003b). No longer was women's gossip outside the privy of academic theorizing. It is through the sharing inherent in "gossip" that women subvert the silence around abuse by husbands, lovers, parents, and

other authority figures. If it was spoken about, it existed in the memory of others—accountability was at least possible, if not viable.

To explicate the content and form of their discourse, Chicana feminists have self-consciously fashioned a rhetoric that integrates many genres—poetry (Cervantes 1981; Cisneros 1994), spoken-word (Gonzalez and Habell-Pallán 1994), teatro (theater; Broyles 1994; Yarbro-Bejarano 1986), declamación (Cantú 1995), short stories (Viramontes 1995; Serros 1993), and performance art (Habell-Pallan 2005). Many Chicana feminist writers align themselves with cultural theorists who examine discourse to uncover the dynamics of power (Sandoval 2000).

The Chicana feminist discourse talks back to white hegemonic feminism, to the colonizing discourses of the academy, and to some of the cultural practices in their own communities that are politically regressive. The targets of their defiance include the progressive men in the Chicano movement who did not acknowledge women's issues. Because silent, passive women who are willing to sacrifice everything on behalf of their families has been the ideal form of womanhood in Chicano communities (the notion of Marianismo, as discussed in the introduction), there was a backlash when Chicanas claimed their right to speak out against the men in their communities. As poet Elba Sánchez proclaims, Chicanos want their women "mute" because "asi eres mas bonita" (you are prettier that way). Consider her 2003 poem "Woman's Word":

woman
her story
I sustain in my memory
the want you want
to erase
to domesticate
with your alphabet

you have wanted me mute
since childhood

once
my silence
carved the place
you call smile as

your frothing words
spilled out
your eyes sternly
warned
—don't think
you're prettier that way

once
I would hide
my forbidden voice
in the pleats of my conscience
cities trapped in my throat

that was then

now
my tongue
has birthed the words
challenging
what is
no longer accepted

Since its earliest formation, Chicana feminisms have appropriated a dis-course that challenges multiple constituencies—the hegemonic academy, white feminism, anti-feminist Chicanos, and to some extent, Chicano tradi-tion and culture. Instead, Chicana feminists have consciously aligned them-selves with progressive political causes in the United States and internation-ally, including social and political movements aimed at sexual liberation.

Claiming a Lengua

Memory as history, as social construction, as politics, as culture, race—all are inscribed upon the body. Inscription upon the body are memory and history. The body is historically and socially constructed. It is written upon by the environment, by clothes, diet, exercise, illness, accidents. It is written upon by the kind of sex that is practiced upon the body and the body practices.

—Emma Pérez, *Sexuality and Discourse*

Su cuerpo es una bocacalle (her body is an intersection).
—Gloria Anzaldúa, *Borderlands / La Frontera*

Yet another translation for *lengua* is *tongue*, which captures the sexual component implicit in the word. Claiming sexuality has also been central to the Chicana feminist project. The focus on sexuality in Chicana feminisms pushed all theoreticians to expand their frameworks beyond race, ethnicity, gender, and class. The understanding of sexuality has not developed separately from other Chicana feminist concerns. Sexuality, however, was not as dominant in Chicana feminists' earliest writings as it has become since the publication of *This Bridge Called My Back* (Moraga and Anzaldúa 1981). Engaging the polemics around lesbianism was the gateway to questions of sexuality and questions of sexual pleasure and desire. Although the explicit treatment of sexuality has not been easy, Chicana feminist writers nonetheless have taken risks and exposed women's desires regardless of the normative sanctions against women speaking about, much the less experiencing, pleasure through sex (Castillo 1992; Cisneros 1994; Pérez 1991; Sánchez 2003; Zavella 1997).

Chicana feminists highlight sexual pleasure to counteract the silence and repression around sex in Chicano communities. The field fully acknowledges that Chicanas experience sexual repression in their communities and that virginity is highly valued (Hurtado 1996a, 2003b); however, within these spaces of restriction, women also seek pleasure. As Patricia Zavella (2003) concludes from analyzing her interviews with mexicana/Chicana respondents on their sexual practices:

> Catholic-based repressive ideology should be seen as only a cultural template. Women's cultural poetics (the social meaning of sexuality) entails struggling with the contradictions of repressive discourses and social practices of control that are often violent towards women and their desires. Women contest or incorporate repressive notions into their sense of sexual selves and they use metaphors of "play" and "fire" to express bodily pleasure. That is, in discussing their intimate relationships, playing was a recurring metaphor which signified women's experiences of teasing, testing or pushing the boundaries of social convention. In women's discourse, fire had dual meanings: the repression of desire, where sanctions were "too hot," and the uncontrollable force of the erotic where passion consumed them. Women, then, sometimes "got burned" in transgressing social conventions, even as they sought sensations and experiences of the body enflamed. (229)

Chicana feminist creative writers have been at the forefront of writing about sexual pleasure explicitly. As Elba Sanchez (1997) explains, she titled her poem "A Gift of Tongues" because "I do believe that our tongues are a gift, and I do believe that to make them a really powerful gift, we need to use them and unleash them." Her poem highlights the sensual aspects of women using their tongues as power, weapon, and sensor to savor los sabores del cuerpo (the tastes of the body):

this tongue of mine sets fires
licking hot all in its path
scorches the old
announces the new
this tongue of mine
breaks through walls
setting free
imagery of feelings
odors of dreams
tasting the bitter
the rancid
quenching the thirst
this tongue of mine
invents the words
creating familiar signs
draws my days in bold hues
celebrates
affirming my world
this tongue of mine
opens wounds
heals the hurt
with warm breath savors
the other
the you
that is also me
this tongue of mine

Similarly, Sandra Cisneros (1996) centers the feminine power en la Virgen de Guadalupe, not as a saint or a representative of the purity of womanhood as embodied in the mother of Jesus Christ, but rather converted into

a "sex goddess" (49). Cisneros' version of la Virgen is one that makes her "feel good about her sexual power" and inspires her to "write from my panocha [cunt]" (49).

From the beginning of Chicana feminisms as a field, writers have addressed issues of sexuality that were centered on lesbianism, bisexuality, gayness, and queerness. They opened up sitios for the exploration and writing about sexualities. Most recently, estos sitios have been deployed by Chicana feminisms to address the range of sexualities and their relationship to patriarchy in Chicano communities, including transsexuality. Some gay male scholars have used Chicana feminisms y sus lenguadidades (their languaging) to deconstruct their own oppressions based on their sexuality. Chicano gay men have subverted the power of patriarchy in Chicano communities (Almaguer 1991) by openly engaging their sexual orientation, expanding los sitios y lenguas created by Chicana feminist writings.

Exposing the range of LGBTQ issues in Chicano communities is an especially delicate subject for exactly the same reasons that exposing women's sexual desires was delicate in the early 1980s. There exists a risk that these issues could divide the political struggle to gain some basic necessities of life. Another concern is that addressing sexuality could potentially subvert the Catholic underpinnings of Chicano culture. Regardless of these risks, LGBTQ writers have expanded the paradigmatic spaces/sitios of gender issues from a feminist perspective and have embraced and analyzed their issues as they are transformed and expanded to address the full range of sexualities. Sexuality will continue to be a prominent sitio as Chicana feminist writers develop new lengualidades to study the range of sexualities and their relationship to the deconstruction of patriarchy within and outside their Chicano/a communities. Scholars writing about sexuality issues confront the next frontier in Chicana and Chicano studies; they will be especially important in furthering our paradigms of how we address gender issues from a feminist perspective. Chicana feminisms, as a body of work, offer an impressive theoretical framework from which to enhance feminist analysis by claiming and creating new sitios and new lenguas.

Discussion Exercise

Writing Your Autohistoria

Chicana feminisms is about reclaiming the self to counteract the fragmentation imposed on Chicanas because of their intersectional identities (their

gender, class, race, ethnicity, sexuality, and physical ableness). Chicana feminist writer Gloria Anzaldúa states that the fragmentation of self can be alleviated by constructing an autohistoria. According to Anzaldúa, an *autohistoria* is an individual's efforts to construct her/his/their own life and make sense of their life events, feelings, personal history, and intersectional identities. The process of writing an autohistoria involves using an individual's skills, abilities, imagination, creativity, knowledge, feelings, and perceptions about the self.

The purpose of the autohistoria is to gather and acknowledge different aspects of the self to gain a sense of balance, peace, and happiness. The autohistoria requires reflection on and review of important life events that might have caused pain and trauma, as well as events that brought a person happiness and fulfillment. In writing one's autohistoria, a person can become more aware of their assets as well as those aspects of self that might need to be changed.

An autohistoria can entail poetic verse, journal writing, or other means that will facilitate a person's self-knowledge and reflection. According to Anzaldúa, one purpose of writing an autohistoria is for an individual to eventually engage in the process of "auto-teoria"—that is, a theory about the world around them based on a deep self-knowledge that combines everything an individual has lived, read, processed, and integrated into the self. Anzaldúa believed that this deep knowledge (or conocimiento) would lead to the transformation of self.

Personal narrative is constructed to insert meaning into individuals' lives through the process of theorizing their existence. Building an autohistoria begins by describing honestly and fully a person's life, with all its complications, contradictions, and traumas. When a person honestly faces themselves, then they can begin exploring various explanations for how they arrived to their current position in life. An autohistoria permits individuals to theorize their own lives, healing of past injuries and traumas may follow. This exercise can be the beginning of that journey toward self-discovery and healing. As Anzaldúa (2015) writes: "I define healing as taking back the scattered energy and soul loss wrought by woundings. Healing means using the life force and strength that comes with el ánimo to act positively on one's own behalf and on others' behalf. Often a wound provokes an urgent yearning for wholeness and provides the ground to achieve it. In shadow work the problem is part of the cure—you don't heal the wound, the wound heals you" (89).

Once individuals reach a state of healing, they are able to help their communities. By constructing an autohistoria, a person can gather strength and wisdom to engage spiritual activism. In other words, the healing of self is deeply tied to the healing of the world by doing work that matters and contributes to the betterment of humanity. Writing this exercise may also lead an individual at some point in time to join a wider circle of folks engaged in the same goals of making this world a better place for everyone. If an individual is already engaged in social justice work, this exercise may be a space of reflection and growth.

Preliminary Reading for the Construction of an Autohistoria

A biography that might help in writing your autohistoria is Ana Castillo's book *Black Dove: Mamá, Mi'jo, and Me* (2016). *Black Dove* addresses the importance of the author's intersectional identities (her race, class, ethnicity, sexuality, physical ableness, and gender) in affecting her life course— from her upbringing, to her educational trajectory, to the incarceration of her son, and ultimately to the profession she chooses as a writer. Similar to the author Ana Castillo, in writing your own autohistoria, think about how your intersectional identities (race, class, ethnicity, sexuality, physical ableness, and gender) have affected your life course. Relate your trajectory to Castillo's biography and any other writings, films, media, and art that have influenced you to articulate your inner self (Castillo uses all of these to explain her life trajectory and her son's life outcomes).

If you are not ready to write your own autohistoria, an alternative to this exercise is to select a family member, a close friend, or someone you know well to analyze their intersectional trajectory—that is, how has his/her/their life been affected by the social identities represented by the intersections of race, class, ethnicity, sexuality, physical ableness, and gender? Relate the person's experiences to the previous discussion. This initial effort is not as intimate as your own autohistoria, and it may be an effective aid to beginning your process of self-reflection.

Writing Tips for Your Autohistoria

1. Tell your story. You should include the people, places, and events that have made a difference in your life. Be detailed so your readers feel like they are watching the actual events unfold. Be sure to convey a story worth telling. *Do not tell your entire story*; rather, pick something that *dovetails* with important

insights you have learned and what critical events or discoveries led to the insights.

2. Create a purpose. Just telling a story is not enough for a true narrative essay. Indicate whether you have learned something from the experiences, places, and people. Share your unique point of view, which makes essays interesting to read and more than just a story.

3. Organize the autohistoria in chronological order, if appropriate. Since life moves in chronological order, your essay can too, unless you choose another way to organize the structure of your autohistoria. The only parts of the essay that do not have to be in chronological order are the introduction and conclusion because of the nature of these paragraphs.

4. Create a thesis or claim. Almost all essays are persuasive in nature, so write a clear thesis statement. This claim should be at or near the end of the introduction. Your claim will present the purpose of the essay and the life events that made this realization occur. Your readers will appreciate having an idea of why you chose to write about a particular time in your life.

5. Share your autohistoria with significant people in your life. Chicana feminisms advocate the sharing of lived experiences to dismantle stereotypes and to create a circle of support to enhance growth.

Further Reading

Anzaldúa, Gloria E. *Borderlands / La Frontera. The New Mestiza*. San Francisco: Spinster/Aunt Lute, 1987.

Cotera, Martha. *The Chicana Feminist*. Austin: Information Systems Development, 1977.

Espinoza, Dionne, María E. Cotera, and Maylei Blackwell. *Chicana Movidas: New Narratives of Activism and Feminism in the Movement Era*. Austin: University of Texas Press, 2018.

Pérez, Emma. *The Decolonial Imaginary: Writing Chicanas into History*. Bloomington: Indiana University Press, 1991.

Chapter 2

"Me Siento Continente" /
I Feel Myself Continent

Chicana Feminist Methodologies

Introduction

During the 1997 spring quarter at the University of California, Santa Cruz, a group of faculty under the auspices of the Chicano/Latino Research Center organized the first ten-week colloquium series dedicated to the field of Chicana feminisms. The colloquium series was the result of the work of the Chicana Feminisms Research Cluster that was established in 1996. The goal of the colloquium was to hold a series of presentations delivered by eight invited scholars who at that time were writing in the burgeoning field of Chicana feminisms. As Literature Professor Norma Klahn stated in her introduction to the first presentation: "We want to welcome you to our first colloquia on Chicana feminisms. If you come to all the series you will be witnessing an historic event. Their [the speakers'] work locates a site for engaging issues of class, race, sexuality, and gender; contesting discourses of power no matter when, where, and how they are located. Their work is at the cutting edge of theory."

The series of presentations culminated in the edited volume *A Critical Reader: Chicana Feminisms*, published by Duke University Press in 2003. One of the presentations and subsequent book chapters ("Me Siento Continente")[1] was by Elba Sánchez (box 5, figure 5), a lecturer for one of the first Spanish for Spanish Speakers Programs at the university level in the state of California.[2] She was also a poet, creative writer, and community activist. I had the honor of introducing Sánchez at the colloquium and situating her work within the field of Chicana feminisms. She exemplifies what is

advocated by these writers—that we not cut off any avenue of knowledge. That we not center ourselves only in one discipline, but that we use everything; that we use poetry; that we use art; that we use history; that we use social science; whatever it takes to voice a reality that has never been

Box 5. Biography of Elba R. Sánchez

Elba Rosario Sánchez is an educator, writer, and activist living in the Latino community of the Bay Area. She was born in Atemajac, Jalisco, Mexico, and came to San Francisco when she was eleven years old. Growing up in the sixties when political and social movements were rising up and growing everywhere, she was very soon a young supporter of the United Farm Workers movement. Her activism grew alongside her love for writing.

Sánchez graduated with a bachelor's degree in Latin American studies and obtained her master's in literature, both degrees from the University of California, Santa Cruz (UCSC). In 1979 she started working as a tutor in the Spanish for Spanish Speakers Program (SPSS) at UCSC. Sánchez spent the next fifteen years teaching in and coordinating the multidisciplinary SPSS. This program provided an extraordinary opportunity for incorporating poetry and performance, encouraging

Latin American writers and artists to visit UCSC classrooms, and organizing special events.

Sánchez was one of the founders and co-editors of *Revista Mujeres* (1984–93), a bilingual literary and visual arts journal published at UC Santa Cruz for more than eleven years. *Revista Mujeres* was produced by Chicana and Latina faculty, staff, and undergraduate and graduate students. This journal brought access to many women in the UC community and beyond who had not published before, in addition to including well-published writers. Elba has left a powerful legacy at UCSC, honoring the Spanish language and promoting the art, writing, and culture of Latin America, Chicanos/as, and Latinos/as in the United States.

Figure 5. Elba R. Sánchez. Photo courtesy of Annie Valva.

In the late 1980s, Elba was essential in the efforts to release the Salvadorian artist Isaías Mata from political imprisonment. Mata had previously been in the Bay Area organizing a Salvadorian art exhibit and working on many other cultural events. Through the activism of Sánchez and other Chicano/a writers, Bay Area churches, and other

organizations, Isaías was released, returned to San Francisco, and continued contributing to the beauty of this city with his artwork.

Sánchez also participated in the bilingual writer's workshop in San Francisco with several other Chicana/o and Latina/o writers who met at Codices, the Salvadorian center, every other Saturday and provided advice on each other's writing. Sánchez drove from Santa Cruz to the Bay Area to collaborate with this group of writers.

During this time, Sánchez's own creativity was developing and flourishing. She is the author of *Tallos de luna / Moon Shots* (Moving Parts Press, 1992) and *From Silence to Howl* (Moving Parts Press, 1993). She is a contributor to many anthologies, including *Chicana Feminisms: A Critical Reader* (Duke University Press, 2003) and Anzaldúa's *Making Face, Making Soul / Haciendo Caras: Creative and Critical Perspectives by Feminists of Color* (Aunt Lute Books, 1990).

Her bicultural experience is the essence of her poetry. Many university classes use her poems as an effective tool to educate students in Chicana/o and Latina/o issues. One poem that has become a standard in my classes is titled "Hispanics." The piece makes explicit the artificial nature of the imposed label on Latinos/as by a government that still does not understand the nature of the Latino/a experience in the United States.

Elba Sánchez has contributed to the definition of the Chicana/Latina experience through her poetry, has generously promoted other women's creativity, and through her activism, has helped many Chicana/o and Latina/o causes. Her voice and dynamism are part of the proud tradition of the Chicana/o and Latina/o legacy to this country.

properly addressed. Elba's presentation is a wonderful introduction to the multiple methods that Chicana feminists use to articulate Chicana feminisms. . . . Each subsequent presentation [demonstrates] how uniquely every scholar addresses the field even though there is a coherent paradigm they are trying to build, how they get there is just as interesting as what they're producing—Chicana feminisms. (Hurtado 1997b)

Indeed, Sánchez's colloquium presentation captured Sonia Saldívar-Hull's description (1991) of Gloria Anzaldúa's book on the borderlands in that "the text is itself mestizaje; a postmodernist mixture of autobiography, historical document, and poetry collection. Like the people whose lives it chronicles, *Borderlands* resists boundaries as well as geopolitical borders"

(211). Sánchez's presentation was a combination of poetry, theoretical lecture, biography, and social commentary that also outlined many of the methodological concerns addressed in the area of Chicana feminisms. In this chapter, I quote at length from Sánchez's lecture and subsequent book chapter "Cartohistografía: Continente de una Voz, Cartohistography: One Voice's Continent" (Sánchez 1997, 2003)[3] to provide an analytical framework for the search and creation of methods in the field of Chicana feminisms.

Mapping the Chicana Body: Una Cartohistografía

> This cartohistographical frame fits the expression of my work, theory, and my Chicana feminist framework.
>
> —Elba Sánchez, "Cartohistografía"

Sánchez (2003) begins her "Cartohistografía" chapter by acknowledging that her body is "una bocacalle" (an intersection), to quote Gloria Anzaldúa. Her "intersectional identity constellation" (Hurtado and Sinha 2016) represents multiple constituencies: "The aim of this essay is to set a framework that looks at Chicanas' work and, more specifically, my own Chicana work. I want to see, for example, how the development of my identities as Mexican, immigrant, Chicana, Latina, mujer, ser natural y espíritu, and so on reflect in that work" (26). The dilemma for Sánchez, however, is the same dilemma that other Chicana feminist writers encountered at the beginning of their careers—how to conceptualize gender within the confines of their multilayered social, economic, and historical experience. The Chicana feminist project was to open up paradigms, allowing the complexities of their cross-border existence to be fully legible to their readers. In other words, how does one reconceptualize gender unanchored from the conventional understandings largely moored to a Western hegemonic view of the self? Sánchez made this her major task in the colloquium lecture and subsequent book chapter (1997, 2003).

In preparation for this rethinking, Sánchez (2003) engages in a deep reflection of self that explores multiple avenues of knowledge to emerge. She states that her reconceptualization of gender "began with a dream where I was physically transformed. I was no longer body and flesh, eyes, hair, and teeth, but hills, valleys, orchards, forests. I had metamorphosed into a mountain range with caves and volcanoes and bodies of water surging through me. As I extended my arms, I was a whole coast, and then I

stretched into a continent. I was my own continent with many geographies. I could see lush forests, fields of abundance, the sands of desert terrain that were me. This was my physical landscape" (19). By transforming herself into a landscape and eventually into a continent, Sánchez can more freely speak her truths, unencumbered by the restrictions of her female gender. In verse she informs how it feels to be a "continent" (29–30):

"I Feel Myself a Continent"
In my dream
I see myself
a continent
tierra firme[4]
lush and leafy

geographic mass
of curves and caves

braids of rivers
draping across my back
I hear myself
simmering song
volcanic core
and epicenter
breasts bursting
white-hot lava
nipples swelling
as they caress the sky
I taste myself
salty continent
of ocean foam
waves of a tongue
in seaweed beds tangled
between the undertow
and blush red corals
I stroke
a piel de flor[5]
emerald carpets of feelings
thirsty daughters

of waters flowing
within me
soaking
dense jungles
all this
is me
sweet smell
of cocoa fills the air
as my arms and legs
fleshed mountains
and canyons
stretch
weaving and tugging
meaning and reason
tierra segura[6]
in a storm
I trace the lines
defining the map
of my geography
territory of still
unknown spaces
I am naming
claiming
I am a continent.

By metamorphosizing into a continent, Sánchez is able to speak freely about herself as a woman, a device also used by Chicana actors in the early years of El Teatro Campesino; these actors used genderless characters like la calavera (the skeleton) to escape the narrow conceptions of women (Broyles-Gonzalez 1994; Hurtado 1996a). As a continent, Sánchez can express passion, expansion, almost any emotion or thought she desires. She does not project herself as Mother Earth, which would restrict her conceptualizations of self. A continent is powerful and not gender specific.

Sánchez claims that the continent metaphor "began with a dream where I was physically transformed" (19). This assertion is important; "a dream" implies the nonprimacy of linear thinking in which Sánchez can reclaim the sensual, the sexual, the unpredictable, the chaotic, and the erotic as legitimate sources of knowledge: "volcanic core / and epicenter / breasts

bursting / white-hot lava / nipples swelling / as they caress the sky / I taste myself." In fact, a continent cannot be contained—it has a "mind" of its own that linear thinking has yet to decipher. The rumblings of a continent are not predictable, even with the aid of the most sensitive scientific instruments. A continent "puede rugir": it can roar at will, and volcanoes can explode without warning. All of these emotions are governed by larger forces that we do not fully understand at this time. These are the sources of knowledge that Chicana feminisms attempt to charter.

Sánchez's meditation on averting the pitfalls of framing her work and that of other Chicanas is at the core of creating new methods of knowledge production for the field. Chicana feminisms are steadfast in avoiding the Western, masculinist commitment to linear and binary thinking that allocates power to "experts" versus "subjects" of study (Latina Feminist Group 2001). The methods of Chicana feminisms seek to avert objectifying human beings, especially women, in the process of producing knowledge (Hurtado 2003a). In addition, Chicana feminisms seek to center the experiences of poor, working class Chicanas as valid in informing all knowledge production and creating new theory and methods (Delgado Bernal et al. 2018).

Once Sánchez has set up her nongendered body of a continent with no referent to impose restrictions, she can fully articulate her intellectual, emotional, social, and political journey.

> Because my writing has been a way of mapping a life, necesitaba tomar de varias palabras y conceptos para nombrar este proceso.[7] The first word I began to take apart was cartography. From cartography I borrowed cartoas the art or technique of making maps or charts—el arte de trazar mapas geográficos. I then took histo- from history / historia: (del griego historia), en su sentido de relato de los acontecimientos y de los hechos dignos de memoria.[8] In other words, a narrative of events, a story, a chronicle. También reclamo histo de historia en el sentido de desarrollo de la humanidad. En este caso, desarrollo de mi propia humanidad.[9] I wanted to utilize a distinct meaning of histo-: as a chronological record of events of the life or development of an individual, a people. In this case, my own chronological development as a woman, a Chicana, the development of my political conscience, and my humanity. (26)

Sánchez is making legible her identities and multiple purposes in life; she is identifying her various talents, clarifying her political and social

commitments, and making herself worthy of remembrance—quite a tall order for a Chicana, who is typically made invisible except when serving others, or even degraded to not much more than a beast of burden. She can only see her grandiosity if she steps outside of gender (and other intersections of disempowerment like race, class, ethnicity, sexuality). When she dreams of being a continent, she is unrestricted from all of these categorizations that are used by others to box her in and reduce her. She charters her course using the different components of the word "cartohistografia"— carto, the contours of her geography; histo, the history of lineage as well as her personal history; and grafia, the actual mapping of her consciousness and her life. She considers herself to be part of "hechos dignos de memoria," part of the events worthy of memory and, as she asserts, worthy of being recorded to make visible "mi propia humanidad" (my own humanity).

In concluding this passage, Sánchez adds that for her, writing becomes her preferred weapon for making herself legible: "The last part of this constructed term consiste de la palabra: grafía, del griego, graphé, acción de escribir. Significa un sistema de escritura, o el empleo de signos determinados para expresar las ideas.[10] In English, -graphy: a process or method of writing or other graphic representation" (26).

Sánchez summarizes the purpose of Chicana feminist production as the recorder of the complexities embodied in a continent: "It is through the reconstruction of these terms that I arrived at the term cartohistografía or cartohistography. Its definition follows: Documentación de una historia o experiencia individual por medio de escritos, dibujos, u otra representación cuyos signos y significados son compartidos; amplía la geografía del espacio individual al espacio comunal.[11] The historiography of an experience is chronicled and shaped through the writer's use of language, metaphor, cultural signifiers, the content of the work, the sociopolitical, historical, and cultural context in which the work is produced" (26). In her words, "The instant the cartohistographer's experience or vision is documented, it creates a physical, material space with its own geography, ecology, and cosmology" (26).

However, Sánchez's writing is not solely for herself. As she explores her own trajectory, inevitably the journey involves other women, a community, and other peoples—a "collective biography." As Sánchez states, "My work is a part of history. Yet, by nature, it is herstory, one that seeks to encompass other women's stories and, further, might possibly encompass the story of a community. When it is recorded, herstory has the potential of being both

individual and collective biography" (8). Her-story becomes an us-story leading to our-story.

Sánchez concludes that the purpose of Chicana feminist production is both to explore the individual self but also to document the explorations of Chicanas and their communities as a whole—both for the benefit of framing her work as well as for the benefit of larger communities. Chicana feminists are cartohistographers—another word for researcher and writer.

Chicana Feminist Methods

Sánchez's discussion of her writing process and the framing of her work suggests four Chicana feminist methods that have emerged in the field: (1) writing as method, (2) language as method, (3) collaboration as method, and (4) testimonio as method. While Chicana feminists have used many other methods, mostly deriving from the academic disciplines of the writers, in this chapter I focus on these four methods that emerged from Sánchez's intellectual and poetic framing of the Chicana feminist project.

Writing as Method

We all start someplace.

—Elba Sánchez, "Me Siento Continente"

Chicana feminists had to climb an almost insurmountable wall from non-writer to writer. In the 1970s when Martha Cotera penned her first book *Diosa y Hembra* (1976), she was one of the few Chicanas ever to have been published and one of the few Chicanas who had published on Chicanas. To become a writer under these circumstances has to begin as a "dream," something out of the ordinary because of the barriers that Chicanas have to overcome. As Sánchez (2003) states: "I began to think about that continent in my dream, that self, and about how my writing and poetry have been a discovery, an ongoing exploration of that self-territory. My writing has been a way to name the landscapes of emotions, to recognize those layers of experiences that have sculpted my ecosystem and have chiseled my herstory. As well, writing has been a path to forging my spiritual cosmology" (19). The challenge for Chicana writers is to create a discourse to make their experiences legible to self and others.

Chicana feminisms are built on the passion to write—to record "hechos dignos de memoria" (events worth remembering). The passion to write is

fueled by the presence of an absence. Chicanas know they are materially present but invisible to most, or only partially seen. As Sánchez describes as follows, her motivation for writing is the presence of the absence of Chicanas on the written page when she was growing up:

> I began to write because I love to read, and because I remember vividly as a young reader scanning library shelves and listings, looking for authors with Latino-sounding names who might come close to describing and feeling my reality, who might connect me with my own identity. Octavio Paz could never do that for me, but he was guaranteed to be in almost every library I checked out. I wanted to read about the everyday life of other young Mexicanas, Chicanas—others like me who live between, entre culturas, languages y lenguas, friends, families, worlds. I wanted and needed to write as a way to fill the void of voices that didn't speak to my experience. I wanted to write porque en mi familia, yo no hablaba, unless I was spoken to.[12] And what was I going to do with all my feelings, ideas, dreams, and turmoil? I wanted to chronicle biographical and fictional relatos [stories], to make real, to give flesh to the word, to my and our story. I had to write because clearly, for our voices to be heard through time, they need to be passed from mouth to mouth, and they also need to be written. That is why our Chicana writings are vital. Because they enter into the realm of historical and creative documentation of who we are and have been, all at the same time. Our writings, en nuestros idiomas [in our languages], are the testament of our vibrant resistance, as our metaphors, code switching, theories, visions, and worlds—real and imagined—give shape, texture, and human depth to the history of our very presence and resistance. (19–20)

Writing and publishing in whatever venues available had become the aperture to have Chicanas' subjectivities matter politically, socially, and personally. Chicana feminists sought to become agents in the world through their writing.

A central theme of Sánchez's presentation and chapter is the recuperation of self—that is, to value who one is. If she is not of importance, neither are her thoughts, actions, words, and life. Only those individuals who are valuable and worthwhile have rights, which include the right to determine their own destiny and, equally importantly, to create. A person cannot be a writer unless that person believes that what they have to say is of worth. However, in Sánchez's recuperation of self, she not only includes herself as

an individual; she explicitly states that in her path to discovering herself, she encountered other women (and men) who were also seeking themselves. Through these encounters, she found a connection with a larger group or groups. She found community in the process of self-discovery. She wants not only her individual poetic and artistic production to be taken seriously but also the production of an entire community. In fact, she wants to "take the work seriously as we would a science" (1997) because knowledge production makes Chicana bodies visible: "I have linked various poems and stories in this essay to illustrate my own cartohistography. Espero que este trabajo muestre más que todo, una conciencia y voz desenvolviéndose. Como cartohistógrafa me esfuerzo para unir territorios antes separados, ésos que engendran potencial de convertirse en territorios comunes, tierras hermanas a través de nuestra literatura. Por medio de éste y de nuestros otros escritos, reflexionamos, analizamos, creamos conciencia y proseguimos a la siguiente etapa de nuestro desarrollo. Como escritoras y cartohistógrafas trazamos lazos comunes en nuestro continente de mujer"[13] (27).

The goal of developing her cartohistografia is to, through the exposure of different geographies, define and ultimately unite territories that were previously separate and unconnected. Sánchez wants to create "tierras hermanas"—a sisterhood, brotherhood, humanhood of lands through the process of writing ("a través de nuestra literatura"). The process of writing itself provides the analysis to collectively produce "la siguiente etapa de nuestro desarrollo"—the next stage of our collective development. Women writers and cartohistógrafas map the commonalities of their mutual women's continent—"continente de mujer." Sánchez invites others to join the process of self-discovery but centers women and their experiences in mapping the continent that is her body and the body of other women.

Sánchez follows the tradition of Chicana feminisms that were born out of acts of disruption, especially in the Chicano movement, to create spaces of resistance to patriarchy in general and to patriarchy within their own ethnic and racial groups (García 1989). Disruption (that is, head-on confrontation) is one of the most powerful methods used by Chicana feminists to bring their issues to the political agenda. Many Chicana feminists disrupted the social movements they participated in: when working within the Chicano movement, they argued for women's issues (Blackwell, 2011; García 1989; Segura and Pesquera 1992); when working with white feminists, they argued for inclusion of ethnicity and race (Sandoval 1990); when working with Chicana women organizations, they argued for inclusion of lesbian

and gay issues (Pesquera and Segura 1993, 107; Trujillo 1991). As Córdova (1994) summarizes: "Chicanas write in opposition to the symbolic representations of the Chicano movement that did not include them. Chicanas write in opposition to a hegemonic feminist discourse that places gender as a variable separate from that of race and class. Chicanas write in opposition to academics, whether mainstream or postmodern, who have never fully recognized them as subjects, as active agents" (194). In other words, Chicana feminists are characterized by finding absences and exclusions and arguing from that standpoint (Arredondo et al. 2003). In sum, Chicana feminist knowledge production is historical, intersectional, and interdisciplinary.

Like a continent that appears fixed until it is not, the disruption is many times unexpected but has been boiling beneath the surface: the volcano explodes and spews lava, the tectonic plates shift, and the earthquake breaches the surface, disrupting everything in its path. Chicana feminist methods have to be flexible and nimble enough to capture the constant fluidity of its continent. As Sánchez (2003) explains:

> Como cartohistógrafa, estoy observando y definiendo científica y sensiblemente todo eso que llena mi espacio.[14] I am making real herstory by placing my voice, mis escritos, in the context of a timeline of the cartohistography of the Mexicano Chicano and polycultural peoples or pueblos to which I belong. Digo pueblos o comunidades porque mi geografía se mueve, se expande, es flexible.[15] My borders are fluid and I am an active member of many comunidades. Por ejemplo, pertenezco a las comunidades Chicana y Latina, soy de familia trabajadora, mujer, educadora, madre, trabajadora cultural, y agrego a éstas, varias otras comunidades.[16] As Chicana artists and writers, our work and expression become a physical mediation of our herstory. Nuestros escritos consideran, miden y explican experiencias individuales que forman parte del rompecabezas de nuestra comunidad. Al publicar estos escritos exigimos reconocimiento de esa realidad.[17] (27)

Knowledge production is un "rompecabezas"—a puzzle. However, the literal translation of *rompe* means to break open heads—cabezas. The knowledge production process that Chicana feminists engage in is puzzle solving: Why and how do Chicanas thrive even in the worst of circumstances? How are these skills of survival manifested in others? What do we learn from the neglected stories that contradict our existing knowledge? Equally important is to produce knowledge que rompe cabezas—that splits

open individuals' perceptions of the Other. Knowledge that literally shifts the internal geographic layers of the self and the selves of others. For instance, the dual feelings that many readers express when they first encounter Anzaldúa's work are a sense of profound recognition and, at the same time, profound dread for the unknown or of the already known in nonconscious channels. Such emotion is expressed by Marcos Andrés Flores, who wrote this poem in response to Anzaldúa's passing in May of 2004 (cited in Hurtado 2011):

In dark corners
we huddle en masse
holding each other
mourning the loss
of yet another elder
as we sit in circle
singing songs
of remembrance
asking questions like
where do we go from here
who will be left
will life ever be the same
but tearstained letters
and storied words and deeds
indeed
sustain the flame of flickering candles
velas of freedom
as la Gloria shouts out
at shadows
reflecting our own bodies
smashed against the wall of liberation
beaten and battered
we are still whole
forever healing
as we put pieces
of memory together
collectively
fighting the real enemy
and what it means to forget

on this day and everyday
we remember you Gloria
Mother
Grandmother
To us all.

For the Chicana feminist, the act and product of writing is multilayered: a method of knowledge production, a means of discovery of self and others, a documentation of the unknown, a reclamation of history, an existential claim of survival. Anzaldúa (1981) reflects on the merits of writing as method for Chicana feminists:

> Why am I compelled to write? Because the writing saves me from this complacency I fear … Because the world I create in the writing compensates for what the real world does not give me. By writing I put order in the world, give it a handle so I can grasp it. I write because life does not appease my appetites and hunger. I write to record what others erase when I speak, to rewrite the stories others have miswritten about me, about you. To become more intimate with myself and you. … To dispel the myths that I am a mad prophet or a poor suffering soul. To convince myself that I am worthy and that what I have to say is not a pile of shit. … Finally I write because I'm scared of writing, but I'm more scared of not writing. (168–69)

Anzaldúa's sentiments that "not writing" in many ways feels to Chicana feminists as a death that is difficult to put into words because, as they write, they are birthing themselves and others.

Language as Method

Spanish is the language of my cognitive self, of my dreams y recuerdos [memories]. Aprendí a cantar en español, to play adivinanzas and other games.[18]
—Elba Sánchez, "Cartohistografía"

As discussed in the introduction and in chapter 1 of this book, the use of Spanish and its multiple variations and speech styles—formal Spanish to Spanglish, Tex Mex, regional U.S. Spanish, everyday Spanish—are Chicana/o communities in the United States.

Like all feminist scholars, Chicana feminists have struggled to develop methods that avoid erasing women's voices. Many of the methods they

have developed are similar to those of other feminist scholars. However, unlike white and African American feminists, Chicana feminists strongly advocate and use different varieties of Spanish to increase the inclusion of all women. For many Chicanas, Spanish still remains the home language, which is critical in maintaining Chicano culture and which can, at times, serve as a barrier to keep the harshness of the outside world at bay. As Sánchez (2003) writes: "My first day of school, that September in 1960, was a garbled memory of sensory perceptions. Emerson Elementary School on Pine Street was a segregated school, only half a block from my house. When I first walked into Mrs. Anderson's fifth-grade class, I noticed that she, like all the children in the class, was Black. Smiles and gestures were the extent of our communication. En mi mente, mi voz gritaba en español, mientras yo trataba de controlar la multitud de sonidos que me parecían garabatos, por primera vez muda, sin lengua"[19] (31–32). Many Chicana writers began their schooling feeling "muda, sin lengua (mute, without a language)" as monolingual Spanish speakers. The experience of being without a language that others can understand informed their insights of the complexities inherent in cross-cultural, cross-language communication, especially when one language is valued over another.

Languages, including English, Spanish, and some Indigenous languages, are used as a method to express the complications of communities with a history of colonization in the United States.

"Cuando desaparezcan los libros, las lenguas recontarán las historias." Eso es lo que me dijo mi "agüelita" una vez. He cargado sus palabras y consejos tucked in my rebozo, desde que las sentí, es decir, desde que las entendí. Español es y ha sido mi primera lengua. It is my conscious resistance en este English-only state.[20] Español es otra conciencia, otro mundo.[21] Spanish is the language of my cognitive self, of my dreams y recuerdos. Aprendí a cantar en español, to play adivinanzas and other games. De chica aprendí a inventar cuentos para que mi hermanita por fin se duermiera. Al terminar el quinto grado, a la edad de once años ya contaba, multiplicaba, dividía, sumaba y resolvía problemas matemáticos en español. ¿Inglés?, eso fue después, when I came to the United States. (20–1)

Sánchez's method claims the *histo* in the word *cartohistografía*. In recuperating her individual history of immigration and language repression, she also reclaims the history of an entire group. For Chicana feminists, the

recuperation of history happens through the recuperation of language—mainly Spanish. They use the Spanish language as a tie to the past, as a link to the memory of colonization as they crossed the border, and as recuperation of a culture and a self that is not defined by oppression alone. Language can transport mestizas to another reality where they can stand outside the existing social arrangements and simultaneously analyze them. Sánchez's shifts from Spanish to English and back again are an example of what Gloria Anzaldúa calls "mestiza consciousness" (1987). The ability to shift between languages is a major mechanism for traveling between different cultural spaces.

A common language assumes a common history. When the history of colonized groups is erased and their language repressed, translation from a suppressed language to a dominant one becomes, at times, impossible. Language requires a shared understanding of reality—when that commonality is not present, translation becomes difficult, if not insurmountable. The experiences Sánchez had of beginning school as a monolingual Spanish speaker, obtaining a master's degree in literature, working as a translator, and becoming a college lecturer and a multilingual creative writer make her deeply aware of the nuances of translation: "My exposure to multilingualismo and my experience as an interpreter and translator have shown me that there are some words that encompass such complex concepts or realities in one language that they cannot be translated into another. Something definitely gets lost in the translation!" (22). She illustrates this point by asserting that "I will not translate poems like 'Tepalcate a tepalcate.' I could not do justice a la realidad de la palabra.[22] At times, translation is frustration; there is no discourse to turn to. Even after breaking the word down, the greatest challenge to the translator or interpreter is to come as close as possible to a dignified expression and meaning of the word. There are times, therefore, when I refuse to translate. This is a deliberate act on my part" (24).

The methods of Chicana feminisms are meant to bridge the multiple realities created by different linguistic systems. The realities do not have to be all Mexican or Chicana or Latina based. The purpose is to bridge differences to create solidarities en el Mundo Zurdo—the world of the queer, the rejected, the marginalized. El Mundo Zurdo is where Gloria Anzaldúa felt radical social arrangements reside and where one is capable of conceiving worlds that are not subject to the existing categories used to oppress. Everyone is welcome to El Mundo Zurdo. All that is necessary is

for the person to join the queer who are bonded by the desire to change the world.

The epistemologies of Chicana feminisms are sensual; they take into account all the senses to avoid denying the wisdom of multiple channels of knowledge that human beings use to guide them through life. Sánchez eloquently demonstrates the problematic of nonsensuality in discussing her poem "Tepalcate a Tepalcate." At the UCSC colloquium, first she read her poem "Tepalcate a Tepalcate" in Spanish without translation, followed by the assertion, "I've never translated it [the poem]. I don't think I will" (1997). Her decision to read the poem in Spanish and never translate it may be taken as exclusionary to non-Spanish speakers. However, instead of translating the poem, she takes the occasion to educate the audience about the complexities of Spanish use and the history of Chicana/o communities. Sánchez (2003) explains that there are many Spanish words that are untranslatable and that

> [o]ne such word is tepalcate. It is impossible to translate the deep stirrings that are elicited inside me by the musical sound of the Nahuatl word tepalcate. It is the feel of the word on my tongue, the history, the senses, the emotions that the word evokes, that give it meaning and definition. The English-Spanish dictionary translates tepalcate as "shard." How can "shard" possibly translate or give meaning to a word that is my umbilical cord, that links me to my mestizo reality? How can the sounds and smells of the water as it fills the jar, the vivid red of the wet clay, that are deeply imprinted in my mind and heart when I hear that living breathing word, become a real experience for someone else in the translation? (22–3)

Sánchez then proposes a less cognitive solution to the lack of Spanish skills. "The untranslatable has to be approached in a different manner. La palabra desconocida necesita [the unknown word needs] a more sensual 'reading,' one that challenges the reading or listening audience to be open and resourceful, to resort to other ways of 'reading' the words or of 'listening' for other meanings" (1997). She then turns the lack of translation into a method to mine a different kind of knowledge. She entices the audience to use the lack of translation as an opportunity rather than a hindrance. She proposes a revelatory, sensual way to overcome linguistic difference and create a bridge of understanding and "hermandad" (a sisterhood) by the use of the senses:

There has to be more than one way to experience a voice and a poem. That is why I sometimes say that you don't have to speak or understand the language in order to feel poetry. Poetry is not just the act of putting the thought on paper or the linear reading and approach to the poem. Poetry is about engaging the senses, the lilt of the words, the rhythm of the verse, the musicality and tone, the energizing and vivid delivery of the poet, his or her body language and movement. It's about the smells in the room as you listen to the poem (or the smells that the poem itself elicits); it's about the live audience's reaction, about "listening" with a different ear, about "feeling" and imagining at another level. (24)

Sánchez explicitly claims multiple linguistic constituencies as part of her feminisms. She asserts the fluidity of her linguistic identities, and her multiple lenguadidades (languaging) gives her the fluidity to speak to multiple language communities. She is explicit about producing work that will not elide the linguistic complexities of Chicana/o communities and is confident that there is indeed an audience for the linguistic hybridity she produces in her writing.

I trust that readers of this work will be linguistically and culturally savvy, polylingüe, comfortable with a certain amount of code switching (in English, Spanish, standard and nonstandard varieties, and others). Despite what many literature profs and editors out there skeptically say, I am confident that there is a significant and, dare I say, large reading audience that is comfortable with an array of lenguas [tongues]. I am talking about an audience that vive una realidad mestiza, en el sentido de mezclada, que se ha expuesto a varias culturas y gentes, one that eats, breathes, dreams, and lives every day en diferentes y múltiples mundos y habla en code-switching, multilingual conciencias.[23] My Chicana voice is singular or unique by its "Chicano" definition, its sociopolitical and historical context. At the same time, even in its Chicananess, my voice may strike a familiar chord with those who have experienced immigration, those who on a daily basis switch and juggle identities and tongues and tangle with cultural conflicts, as they skillfully maneuver making a living, being with family, having a personal life, y todo lo demás (and everything else). (21–22)

Sánchez captures the creativity, linguistic agility, complexity, and beauty of speaking so many varieties of Spanish and English in the United States.

The previous quote also captures the challenge of using language as method to make fully legible the existence of Chicanas and their communities.

Precisely because understanding language through multiple channels can act as a unifier rather than a divider of peoples, the repression of Spanish in the United States has been an effective method to colonize Chicanos/as. Spanish is a mutable characteristic, unlike race,[24] and therefore can be used to oppress while still claiming that the system of oppression is neutral and only helping the non-English speaker assimilate into mainstream U.S. society.

An integral part of Chicana feminisms is the acknowledgment that language repression among Chicana/o communities is common. Spanish repression is multifaceted: because you speak only Spanish, because your Spanish is not good enough, because you speak Spanish with an English accent, because you don't speak Spanish (only English), because you understand Spanish but don't speak it, because you understand English but don't speak it, because you confuse Spanish words with English ones, because you mispronounce English words by using Spanish phonetics (e.g., inserting an *s* in emerald for esmeralda), and so on. Language repression influences writing when different modes of expressions are transferred from spoken Spanish to written English (e.g., "your writing is too flowery"). Linguistic ambivalence is found in speaking, writing, reading, and even listening. Linguistic ambivalence makes many Spanish speakers hypervigilant about performing language in any mode. Chicana feminisms have been at the forefront of tackling these "linguistic issues" as a political failing rather than as a personal one. To avert linguistic ambivalence, Chicana feminists privilege Spanish-English code-switching, word play, Spanglish, and working class Spanish, including dichos y cuentos (sayings and folktales); they take linguistic knowledge produced in working class communities and elevate it as a source of wisdom, a weapon of resistance, and a linguistic shield of pride.

My English, Spanish, Spanglish, and other lengualidades have danced around each other and together en mi boca, casi forever, like seasoned partners on the dance floor, se siguen bien, sus vueltas y pasos bien co-reografiados.[25] Otras veces, chocan y hasta se tropiezan, una lengua con las otras.[26] As a Chicana, mis lengualidades y sus hermanas culturas have been energized and expanded by the urgency, the positive, heart-pulsing beats and spoken word world of hip-hop culture that is a part of my son

and daughter.[27] My life has been enriched by these constant encuentros con otras y otros whose español y cultura are distinctly different from my own.[28] El diálogo que hemos compartido ha expandido no sólo mis horizontes lingüísticos sino mi sentido y entendimiento del mundo, de mi gente y mí misma.[29] (21)

The documentation of language repression makes visible the injuries of linguistic stigma. The initial injury often happens when Spanish monolingual children leave the linguistic safety that for most is their home, family, and community. As Sánchez recalls:

> I remember well my aching jaw, my face muscles hot and tight, tongue feeling twisted, contorting in strange ways, as I learned to mimic with my new English-speaking tongue. Before I learned to speak English, to understand it, the world was a confusing and frustrating blur of face, body, and hand gestures. I felt totally isolated outside of my home. I learned to speak English in six months. This was due in part to my awareness of the urgent need to survive in what I perceived to be, almost immediately, a hostile environment. English became even more critical when I realized how limited my father's own English really was. My mother didn't speak English at all. Within a year, I learned to spell and write English well enough to become the official family translator and secretary. (21)

The acquisition of English early in life as they enter school has placed many Chicano children in positions of authority within families with limited English skills, a phenomenon yet to be explored. The confrontation of a different social, cultural, and economic system as monolingual Spanish-speaking children leads to experiences that have not been documented in developmental psychology. The urgency of linguistic assimilation for family survival is yet another traumatic experience as a result of colonization. And yet, the initial trauma can, and many times does, become an asset of being bilingual, bicultural, and acting as the bridge between multiple worlds. Such is the development of a mestiza linguistic consciousness, with all the magic and gifts that it entails. It is this linguistic tesoro (treasure) that drives Chicana feminists to become scribes, exploring language in all its forms in all that they write. Thus linguistic repression becomes a Chicana feminist method.

Collaboration as Method

I would also encourage you to get together with other Latinas and to share
your work. —Elba Sánchez, "Me Siento Continente"

A commitment to collaboration is a theoretical and empirical standpoint in which self-reflexivity and inclusivity are built into the process of theorizing and knowledge production. The hope is that the inclusion of collaboration in research practices will result in more egalitarian and fair-minded scholarship than what has been conducted in the past. Chicana writers have partnered with non-Chicanas to ensure that in producing Chicana feminist writings, they have done justice to the complexities of Chicana lives and experiences (Arredondo et al. 2003). Chicana feminisms have also been used to address the gender and sexuality issues of non-Mexican descent Latinas, thus expanding their analysis to cover transnational issues across the Americas. For example, Espín (1996) conducted life histories with lesbians who emigrated from Cuba to avoid the stigmatization and political repression in their native country because of their sexuality. Espín was interested in documenting the identity changes undergone by her respondents as a result of the immigration process and coming out as lesbian upon arrival in the United States. Pastor and her colleagues (2007) used participant action research to develop a collaboration between academic researchers and middle and high school students to examine the obstacles and inequalities students face in school. The academic researchers taught the students research methods, and the research team produced art pieces (spoken word and poetry readings) and performed their work. In addition, the students collaborated on the writing of the final product for academic publication.

Collaboration takes place in data gathering disciplines but also in artistic endeavors. During her colloquium lecture, Sánchez (1997) described the process she used when she first began writing poetry. She would meet with a group of "both poets who were published and poets who were just beginning, because in that process of getting together and sharing our work and giving each other critique, you see what works for somebody and then you go, 'I want to try that,' and then you get ideas about other poet's use of words or how they play with words." Sánchez (1997) promoted her philosophy of collaboration in response to a question posed by a young woman in the audience during her lecture: "I would also encourage you to get together

with other Latinas and to share your work. . . . I think that what makes poetry good is being able to get out there and recite your poetry. I really do believe that as you start reading more and, as you start writing more, your writing starts growing and developing, and changing. That's part of the process and it's natural. We all start some place."

Chicana feminists have committed themselves to finding ways to work collectively. They form writing groups, organize workshops, and attend women's conferences where they present works in progress. The purpose is to create a process that makes them accountable to their various communities. Instead of working in isolation, as is the practice of mainstream writers, whether academics, creative writers, or writers outside the academy, Chicana writers seek input *in the process of creation*. The commitment to a collective practice of collaboration helps empower Chicanas who may not have thought of themselves as writers to begin with. As Sánchez indicates above, writing groups often include experienced writers and others who have never formally written before. Elba Sánchez explored poetry through a writing group and by producing her own chapbooks. She also participated in a bilingual writer's workshop in San Francisco with several other key Chicana and Chicano writers. Gloria Anzaldúa participated in a writing group in Santa Cruz, California, where she lived for many years. At the beginning of their writing career, well-established writers like Ana Castillo produced zines to make their writings widely accessible. These are but a few examples of the collaborative writing practices promoted by Chicana feminists.

Chicana feminist writers did not initially have widespread access to mainstream publishing outlets. Chicana feminists' commitment to experimentation by combining different writing genres—autobiography, poetry, social commentary, historical and political sources, essay forms, and so on—made it difficult to publish their work. As a result, several feminist presses emerged that became productive avenues for publishing Chicana feminist writings. One such outlet was the multidisciplinary journal *Revista Mujeres*. Sánchez describes the beginning of this endeavor, which was published at the University of California, Santa Cruz:

> Some of the graduate students started talking about how frustrating it was for them to get their work published. They could not find outlets to get their work published. And what editors were telling them was that they didn't want to deal with bilingual issues, where writers are writing in both

languages. Or that what they were doing was too ethnic and the general audience would not understand or that there wasn't an audience for our writing. It was always, "It's too ethnic. It's too much Spanish, or not enough Spanish. It's too bilingual. It's too this; it's too that." And they were saying, "There's no way for us to get our stuff out and we really need that. It's part of our graduate expectations." (Reti, Sánchez, and Cepeda 2014, 107–8)

The collaborations proposed by Chicana feminisms are meant to create a path for other mujeres to join the ranks as writers, teachers, mentors, and professionals—in essence, collaborations are to foster mujeres helping mujeres. *Revista Mujeres* was the first bilingual Chicana/Latina journal for writers and visual artists produced in California. As Sánchez (Reti, Sánchez, and Cepeda 2014) explained:

There was nothing in the whole state that was like this [*Revista Mujeres*], produced by a collective of women, not just staff or faculty. Because we really, from the beginning, we loved the fact that we had undergraduates, graduates! It was such a wonderful, organic mix of women. And it was wonderful for the undergraduates to be able to establish relationships with graduate students and with faculty outside of the classroom. They weren't used to doing that. It was a whole other culture that we were trying to create and cultivate, where we wanted to make a space to have undergraduate women feel comfortable and have women feel confident and, "Oh, wow. There's my professor. I can go and say hi to her." Or, "That's really interesting that she's talking about her personal life." Maybe they never would have known that if they hadn't come to that working meeting. (113)

The establishment of *Revista Mujeres* is only one of many examples of collaborative projects that resulted in concrete publications (Blackwell 2011). The Chicana/Latina feminist organization Mujeres Activas en Letras y Cambio Social (MALCS) also established their journal in 1997 and underwent different formats and titles. Currently, *Chicana Latina Studies Journal* is an interdisciplinary, peer-reviewed, biannual flagship publication of the MALCS organization. The journal carries out the mission of MALCS as cited in the introduction as a feminist Chicana/Latina and Indigenous academic organization dedicated to building bridges between community and university settings, transforming higher education, and promoting new paradigms and methods.

Regardless of the format, each collaboration is fluid, flexible, and creative in its approaches, but the goal is always to document the subjectivities of Chicanas in their own words. In doing so, the collaboration results in a collective voice that attempts to honor the individual ones. As Sánchez indicates, "In the process of detailing my creative landscape, my voice has renamed and defined my own language and 'individual' experience. Yet this 'individual' voice has reached others along the way and I have been privileged to engage in a meaningful dialogue with people who see themselves reflected in my poems. Through this encuentro I found that my reality is in some significant way a part of theirs too, que compartimos una esencia humana" (24).[30] The purpose of the writing is to assert "la esencia humana" (the human essence) of Chicanas and their communities.

Chicanas' identifications are fluid, and the field's methods have to be flexible enough to capture changes without losing the core of the subjectivities they are supposed to reflect. At the group level, Sánchez (2003) proclaims: "Mi trabajo, 'el nuestro,' me y nos afirma a sí mismas.[31] Our work confirms our constant migrations, transformations, visions, and will. Our Chicana production, both literary and critical, exposes myriad voices and a purposeful dialectic; it is a testament to our resistance as we move and act on our future. Our production delineates our heritage. Es una expresión de quienes somos, de nuestro ollín o movimiento, our sociopolitical, cultural, and human development.[32] This cartohistographical frame fits the expression of my work, theory, and my Chicana feminist framework" (27).

The commitment to collaboration ensures that Chicana feminisms evolve and excogitate—that the continent remains vibrant and sensitive to the rumblings of change. The Chicana body contained in the metaphor of a continent changes; it responds to its surroundings, it evolves with the context—border crossings, multiple social contexts, multiple languages. Collaborative methods document these changes, naming them, because they have not been recorded before. Collaboration then becomes a form of accountability: "As cartohistography, my writings explore the longitudes and latitudes of an ever-shifting map of life, where my conciencia[33] is affected by physical elements and vice versa. My landscape is at times eroding, but rebuilding as well, always renewing, changing once again. Each time I or we write and chronicle our real and imagined spaces, we are consciously naming, putting on the map, so to speak, previously unknown territory. My objective as cartohistographer is to explore, to understand the depth and range of this terrain" (27).

Chicana feminist writers seek collaborative exchanges in a variety of venues and outlets to have their individual voices and continental changes tied to a community of women whose concerns fuel the passion for articulating a variety of subjectivities—no one should be left behind. Transformations start with the self. Like earthquakes, however, they extend to the entire terrain that is the Chicana continent. Dialogue, disruption, collaboration, confrontation, engagement, entanglement, and collectivity are all ways of engaging in a Chicana feminist methodology of change that makes the different layers of a mujerista continent record themselves as they are evolving. As Sánchez (1997) explained:

> Al escribir mi cartohistografía, what I once believed were individual relatos have become encuentros of shared emotion(s), a link that forms and connects my path with the meeting and merging of others.[34] In this encuentro between writer and reader/listener, ser a ser, there occurs the possibility of a powerful process.[35] Como escritora y poeta, es mi lengua, la toda poderosa, la que hace y deshace.[36] My polylingual lengua habla mi realidad, es mi realidad. Cuando digo cilantro, lo pruebo.[37] Mi lengua es como una metáfora, viste colores vibrantes, define mi identidad en español, en English y en espanglish; sprinkled with other stuff, my tongue questions and explains my pocha reality, da voz a mi conciencia, protesta en las marchas.[38] Es mi lengua la que besa apasionadamente en varios idiomas (pa' que se entienda la traducción).[39]

Sánchez's celebration of la mezcla in its many complex forms, as she explains above, is not a path that is appreciated by all. Contact with others does not always result in collaborations or in productive avenues opening up rivers, the blossoming of new species, or the greening of mountainsides en el continente de mujer (in the woman continent). Contact with others can result in an earthquake that can bring damage and even destruction to the self and others. Such is the experience that Sánchez describes when she returns to Mexico to visit family and she is accused of no longer being mexicana. Her continent has been contaminated by her interactions and collaborations with the underbelly of the United States—los Chicanos/as, poor people, Blacks, the Fillmore District; the interactions that have changed her psychic and linguistic landscape make her suspect. Sánchez (2003) is told, "'You're not like us. Eres una pocha [you are a pocha]. ¡Tú ya no eres mexicana! (You are no longer Mexican!)' Those words from my cousin's

mouth shook what I knew until then as my rock-solid Mexican foundation of identity. I was desperately searching for solid ground to stand on. I struggled to respond immediately, to build a sense of myself, to feel a sense of rootedness" (36). Sánchez suffers a choque (a shock of dislocation), to quote Gloria Anzaldúa (2002), from this confrontation—an earthquake of emotions, her roots questioned, her layers of self disaligned from previous stability. Her insides are thrown into disarray with the accusation: "¡Tú ya no eres mexicana!" (You are no longer Mexican!)"; she has become a "pocha"—a hybrid that is no longer "pura mexicana."

"¡Tú ya no eres mexicana!"
I was hurt and angry. I felt rejected. This was my cousin, almost my sister, my own family, rejecting me, pointing out to me how I had changed already, forcing me to reexamine my identity. In my landscape, this was an earthquake, shaking hard the strata of former layers of myself. I began feeling tremors around my roots. I had to closely sift through my home soils, my adopted soils, redefine my borders and reshape my self-definition. I had to come to grips with an evolving identidad [identity]. After those initial moments of shock, I took inventory of what I know to be true, what cannot be taken away from me. (38)

The options to the dislocation either provoked by other mexicanos or by nonmexicanos has few resolutions: to become more mexicana than mexicanos (i.e., to retreat to an extreme position of non-interaction with difference), to become assimilated into U.S. culture and avoid all that is Mexican (when full acceptance by the mainstream is rarely given), or to embrace la mezcla as a source of creativity and potential escape from the narrow boxes that all groups are subject to in a classed, raced, heteronormative society. Many Mexican immigrant parents face a narrow set of options to help their children with these choques (clashes): some never teach their children Spanish, hoping that linguistic assimilation into English will help them thrive and be accepted; some socialize their children as if they were in Mexico, many times with exaggerated Mexican norms that may have already been abandoned in Mexico; and others caution their children against becoming Chicanos/as—hybrids that will no longer be "ni de aqui, ni de alla (not from here or from there)." Yet, some parents have the courage to allow their children to embrace their hybridity as a source of joy and creativity, and hope that their children will thrive as they learn English, maintain Spanish, and

be "the bridge called their backs" (Anzaldúa and Moraga) as they forge new layers of soil into the continent they are building in the United States.

Testimonio as Method

> My writing has been a way to name the landscapes of emotions, to recognize those layers of experiences that have sculpted my ecosystem and have chiseled my herstory.
>
> —Elba Sánchez, "Cartohistografía"

One of Anzaldúa's greatest intellectual interventions was to develop the self theoretically and philosophically as relationally created by the historical, political, emotional, spiritual relationship to others, and even to inanimate objects and nonhuman living species (Amaya Schaeffer 2018). Anzaldúa made explicit the constitution of self and connections that are undeniable although not completely understood. When a writer exposes herself in the act of writing, she is witnessing herself at the same time that she *is* herself. Witnessing can be in the political sense the public acknowledgment of dehumanization and injury to disrupt dominant narratives that ignore injuries to bodies of Color and to women (Hurtado 2018). Testimonio then becomes an act of a single person, like the famous one of Rigoberta Menchú. Testimonio can also be an explicit collaboration as when one person writes the narrative of a collective group of individuals (Hurtado 2015). Yet a third type of testimonio can be a collective accounting of a peoples when the testimonio (or group of testimonios) makes public what many individuals in those communities experience (Latina Feminist Group 2001). Testimonio in its multiple manifestations is now a principle method used by Chicana feminists to estampar las vidas de las mujeres no visibles (to create a portrait of the women not visible) (Delgado Bernal et al. 2018). Testimonio is different than a "case study"—even the name manifests the difference. A case study at some level reifies the subject under study. A testimonio is invested in being as true as possible to the subjectivity of the person testifying. Testimonio centers the untold stories of those who are poor, stigmatized, degraded, objectified, misunderstood, understudied, multiply oppressed—all those in society not worthy of "memoria" (remembrance) or of holding knowledge of value (Pacheco 2018).

Testimonio is generally defined as: "a first-person narration of socially significant experiences in which the narrative voice is that of a typical

or extraordinary witness or protagonist who metonymically represents others who have lived through similar situations and who have rarely given written expression to them" (Lewis et al. 2004, 118). The writer/recorder of the testimonio is generally not the person doing the testifying. However, the commitment that Chicana feminist writers have to articulating their realities, to not separating the personal from the political, and to valuing their experiences as worthy of analysis makes their writing a form of testimonio. Furthermore, Chicana testimoniando (the verb) is also committed to "articulating the connections to the larger social and political structures shaping those lived experiences." The method goes beyond mere description to an "approach that insists on understanding the structures of domination and one's agency in relation to them" (Cuadraz, personal conversation, March 2019).

Chicana feminist writers are equally observers/ethnographers/cartohistographers and witnesses to their own lives. Their personal testimonios break the barrier between subject of study and exposing their own lives to document their subjectivities. As Sánchez (2003) describes her family's migration from Mexico to the Unites States, she gives intimate details of her life through a testimonio, and thus the reader can better understand her literary production:

> When my father brought us from the state of Jalisco, in 1960, to the Black or African American Fillmore District of San Francisco, a small community of five Mexican families came together on Divisadero Street, settling themselves between Bush and California Streets. We lived in a two-bedroom flat directly above the Flying Chicken & Pizza Take-Out Restaurant and a couple of buildings down from the popular ten-cent launderette; nuestros hogares were filled with the sounds of children, español, y música.[40] The smell of frijoles and roasted chiles filled the air. Our families were from small towns outside of Guadalajara, namely, la Experiencia and Atemajac, and were now transported within doors of each other, in San Francisco. I was the oldest of about seven Mexican kids on the block. We played together in each other's houses because our parents rarely let us play outside. (31)

Similarly, Sánchez (48–49) writes the following poem about her son's experience with racism and provides yet another testimonio of what she and her loved ones experience as racialized subjects in the United States.

"For the Middle-Aged Man
Who Sat at a Table in a Regular
Restaurant, in a Regular City, USA"
this is for the middle-aged man
who sat at a regular restaurant
in a regular town (like mine) USA
this is for you mister
because I saw those daggers of disdain
you call your eyes
I saw your hatred your fear
as you sat at the head of that table
you see his brown skin
the glint of his obsidian eyes
the buzzed stubbles of dark hair
there is a gait about him
this budding coffee bean of youth
who looks straight ahead
mister, you see "messican"
maybe you think: "illegal"
you see baggy dark pants
hanging in folds
over hightop sneakers
the grey sweatshirt
splattered with paint
the raggedy sleeves and tattered hood
maybe you think "gang member"
I see your knuckles burst white
as you grip the table
and you don't even know him
my son

The narration recorded by the writer becomes a testimonio of the injuries suffered by various constituencies and family members attached to those doing the testifying. Hence the testifier becomes the scribe/the recorder/the cartohistographer of not only the continent of self but of the multiple layers of human connection that constitute the self.

The narration of self becomes a living testimonio of what it takes for Chicanas to become writers of their own experiences; importantly, their

experiences and writings reflect those similarly positioned. As Sánchez writes:

> I first came to my sociopolitical and activista conciencia during my sophomore year in high school, when my social science teacher, Sister Mary Margaret, assigned an article about the United Farm Workers and César Chávez. I read about the farmworkers and their efforts to organize, about their lived injustices, the conditions they endured and in which they labored for close-to-nothing pay. This had a profound effect on me. I remember both tears and rage welling up inside of me. I had the strongest sense at that moment that I was of these people, that their struggle was also mine. . . . Mi conciencia despertó y abrazó la realidad de su lucha, que también era mía.[41] Esta era mi gente y yo de ellos.[42] I saw myself reflected in the faces of the farmworkers and their families. I saw my father's face in the faces of the men; in their hands, my father's arthritis-gnarled, working hands. These people were my own, and I embraced fully my newly recognized link with the huelguistas [strikers] and with la causa [the cause]. When I embraced this community of Raza fighting for our rights, I began my participation in my future. That year began the exploration of my political map, el despertamiento de mi conciencia [the awakening of my consciousness], on this side of the border. (39)

Chicanas write from the interstices of two nation states, cultures, and languages, and are in a unique position to chronicle journeys that are not easily accessible to the public. Many came to the United States as children and may have started with a Mexican national identity and quickly learned that they were not accepted in Mexico or the United States—this was the beginning of an evolving Chicana identity. As Sánchez eloquently writes:

> I came to this country in August 1960 at the age of 11. Llegué purita Mexicana.[43] There were no questions or confusion about my identity. I knew where I came from, who I was. I was proud to be Mexicana, and my parents reinforced my nationalist loyalties. Almost immediately after arriving in the United States, however, I learned that this new land and climate were not so hospitable. I can still hear mi mamá's constant reminder: "Aquí la gente piensa que los mexicanos somos cochinos, unos flojos. Siempre que salgas a la calle, tienes que salir bien vestida y pórtate bien. ¡No quiero que nadie te diga nada nunca!"[44] (30–31)

Chicanas' testimonios about their own and their families' immigration encounters become a record of a neglected history and serve as building blocks for Chicana feminisms as the experiences of women are centered and exposed.

A common practice among immigrants is to maintain connections with family and communities in their country of origin through letter writing, as Sánchez reports:

> Letters, traditionally written by the women of the house, have been and will continue to be vital to herstoricizing our reality, passing it down to those who come after us. As women, Chicanas, Salvadoreñas, Puertorriqueñas, or however we identify and name ourselves, though our individual story is singular and in that way unique, we share the same pain of uprooting, immigration, cultural conflict, and physical and emotional separation. That is the legacy that links us, links many other women's (and families') stories. (34–35)

Letters are the lifeline to a past where individuals felt at home and shared a language, culture, and national identity. As Sánchez poignantly explains, letters were the only means to keep in touch and informed about birthdays and celebrations—a "vínculo" [linkage] of connection:

> Comencé a escribir cartas a la familia en México poco después de llegar. Eran mi vínculo, mi única conexión a la familia, a las fiestas de cumpleaños, a los ritos y celebraciones que habían sido parte de mi vida diaria.[45] Airmailed letters between my mother and father, who immigrated to Chicago years before, had been the only way to maintain familial ties now stretched by the distance of miles, la separación de meses y años.[46] Letters embraced and delivered the bits of intimate news, the daily challenges, fears, frustrations, y pequeños triunfos de esa nueva vida.[47] Letters were also reminders of the painful physical separation, the empty vastness of distance between us. (33)

Chicana feminisms are transdisciplinary and modify the methods of traditional disciplines, imbuing them with depth and connecting them to a hybrid experience. Letters are traditionally used in historical research by scholars unrelated to the letter writers. Chicana historians modify the method based on their transnational experiences. For example, historian Miroslava Chavez-García (2018) integrates the practice of letter writing in

the methods in her book project. She analyzes the three hundred letters exchanged between her parents as they courted across the U.S.-Mexico border. Chavez-García's analysis of her parent's romantic relationship in the 1940s finds resonance in Sánchez's (2003) description of her family's practice of writing letters, both as a lasting testimony for future generations and as a mechanism for maintaining family ties: "It is not by coincidence, then, that I choose to write stories in the form of letters. In our family, as far back as three generations (that I know of), migration, physical distance, uprooting, and separation have been a constant. Esta experiencia es compartida por muchas otras familias, no es única [This experience is shared by many families and not unique]" (33). Sánchez's poem (33–34) expresses the anguish of separation and the joy and hope found in the missives flying across borders to make a family and love connection:

"Cruzando Fronteras"[48]
A mi mamá, quien esperaba las cartas
de Chicago, donde se encontraba su "viejito"

perseguida por tu ausencia
el pito del cartero me hace correr
mis manos se adelantan
vuelan
extendiéndose como pista
para que sobre ellas
aterrice el sobre esperado
las conocidas letras
quizás haya una mancha
un hilo
un cabello
una foto
algo que me acerque
más a ti
al otro lado
sudas a chorros
te despiertan y acuestan
retorcijones
de entrañas
hambrientas

algunas mañanas
y muchas noches
te sientes morir
tan lejos de tu suelo
de tu gente
yo busco tu aliento
en esas cartas
quizás al desdoblar
las hojas
sentiré el calor
de tus manos
quizás
así llegue a mí
el olor de tu sudor
el sabor de tus palabras
risas besos
vía aérea
vía aérea
vía aérea

Thus testimonio is a method built on la mezcla. Testimonio uses poems, short stories, personal narratives, letters, group narratives, narrative collections on a specific topic, and spoken word—all sources of knowledge and recording devices to make visible the often invisible experiences of Chicanas. Through the analysis of these testimonios, Chicana feminists can make various connections to their many layers of self.

Conclusion

Chicanas who have had the benefits of higher education have been the primary producers of Chicana feminist writings. Even those writers who did not remain in the academy but pursued a career in creative writing (such as Sandra Cisneros, Cherríe Moraga, Ana Castillo, and Gloria Anzaldúa) found that university life provided fertile ground for their early development.

In addition to the four methodologies I outline through Sánchez's writings, Chicana feminists working in a variety of disciplines have developed and depended on several other methods to produce knowledge. These

other forms include oral histories (Cuádraz and Flores 2017; Pesquera 1991; Romero 1992; Ruiz, 1987, 1998; Zavella 1997); the use of different varieties of Spanish; creative artistic production, such as poetry, theatrical performance, painting, dance, music (Baca 1994; Cantú 1995; Cisneros 1994; Mora 1993; Moraga 2019; Pérez 1996; Trujillo 1991, 1998); the documentation of creative production as evidence of feminism (Broyles-Gonzalez 1986, 1994; Yarbo-Bejarano 1986); social science methods (De la Torre and Pesquera 1993; Pesquera and Segura 1993; Segura and Pesquera 1992); and a combination of many of these tools. Examples include the use of creative writing to see Chicanas as "their own ethnographers" (Quintana 1989, 1996) and the use of fables such as those proposed by Derrick Bell and his followers (Hurtado 1996a). Regardless of the method employed, the struggle lies in documenting the complexities of Chicanas' condition, which is highly influenced by gender but not independent of many other historical material conditions.

Chicana/o studies as a discipline and Chicana feminisms as an area of study are possibly the only two major intellectual fields in the academy whose genealogy is firmly rooted in the ethos and practices of racialized, poor subjects—migrants/immigrants, farmworkers, laborers, those not formally educated, culturally different, linguistically diverse, and peoples colonized on their own lands. Chicana feminisms accept this genealogy as foundational to knowledge production in whatever avenues they use inside and outside the academy. Of primary importance is the resignification of working class Chicano/a culture, language, and art production (Díaz-Sánchez and Hernández 2013; González 2014; Ybarra-Frausto 1989) by deconstructing the power relations in the United States that assume that all things Chicano/a are inferior, not worthy of study, and not central to the production of knowledge. Instead of privileging knowledge produced in the academy (and staying within the academy), Chicana feminists examine and resignify their working class foundations, then return these ideas to the community to encourage questioning of their own positionings.

Chicana feminist production is therefore circular; the grounds for excavation are the communities many of the writers, artists, and performers come from—poor, working-class communities in barrios, labor camps, and migrant trails. Chicana feminists carry their unadulterated prior experiences into their education (primarily in English), using them as fodder for their imaginations, theorizing, and intellectual products. They rework

their concepts into accessible forms and return them to their communities, various constituencies, and multiple audiences to enlighten and, hopefully, to affect the psychological, social, political, and economic materialities of Chicana lives (and, more generally, all lives). The circular circuit of knowledge production through various artistic and intellectual forms is the telos of Chicana feminisms.[49] Art, in its many manifestations, has been fertile ground for Chicana feminist interventions from the very beginning of the field in the 1970s to the present. I end with Sánchez's (2003) words as she reasserts that Chicana feminists use writing as the most powerful weapon at their disposal to voice their feminisms, to fight injustice, and to rearrange el continente de mujer.

> My tongue names injustices I witness, a veces en voz de poeta, a veces en mi native lengua pocha, from my pocha perspective.[50] Sometimes I use my university-trained and degreed tongue, when it is necessary. My lengua recuenta en color y olor de carne propia.[51] It is my tongue that boldly translates those injustices in English, para que entiendan los que no las viven y los que por miopes no las ven.[52] Mi lengua es un órgano vital.[53] It is a gift, my power . . . La palabra has been a way to channel my reflections, to question myself, to give shape to the unknown, to honor my roots y mis lengualidades.[54] Con las palabras puedo hacer y deshacer mundos, reclamar y definir mi humanidad, y hablar de mi ser de mujer.[55] (25)

Discussion Exercise

Testimoniando Through Autobioethnography

Professor Norma E. Cantú used the method she calls *autobioethnography* to write her book *Canícula: Snapshots of a Girlhood en la Frontera* (1995, xi). The book is part biography, part ethnography of the border town Laredo, Texas, where Cantú grew up, and part fictionalized relatos (tales) of her girlhood. The method used by Professor Cantú was dependent on photographs from her girlhood. She wrote short entries relating to, sometimes inspired by, and at times not related to the photographs. Others have used autobioenthnography as a class exercise to provide students with "a framework and a strategy for thinking about how their lives intersect with hegemonic narratives of race, place, and gender" and an opportunity to "think critically and collectively about the privileges they enjoy while also

appreciating the networks of family and friends that help them navigate the often treacherous waters of their everyday lives" (Cucher 2018, 94).

Cantú (1995) distinguishes the process of autobioenthnography as different from Anzaldúa's autohistoria, which is a term "use[d] to describe a genre of writing about one's personal and collective history using fictive elements, a sort of fictionalized autobiography or memoir" (Anzaldúa 2002, 578). Cantú adds the ethnographic dimension to her narrative by using photographs. Ethnography is the social science method of describing the customs of individual peoples and cultures. Cantú (1995) used this method for writing her book because "[t]he feminist in me consciously included the strong women—the mothers, grandmothers, aunts, *comadres*. But it was not a difficult task, for they were in my life and in my childhood. I wanted to tell the stories of women who survived, who struggled, who worked as school teachers, who sold Avon and Stanley products door to door, as well as the mothers who went to work in the fields alongside the men" (105).

This exercise in autobioenthnography is not only for women or for Chicanas. As described by Michael Cucher (2018), who uses a modified version of this exercise that he titles "Your Life in Pictures," the autobioenthnographies in his classroom include the following:

[O]ne presentation featured a single photograph of a young Anglo student in a recording studio who used her time to explain how she began her career in music as an homage to the older sibling she had recently lost to an untimely death. A South Asian student challenged the trajectories many students think as typical to Texas immigration narratives when she brought a photograph of the store her family owned and ran in the Republic of Zimbabwe for three generations before moving to Dallas. Yet another student shared a photograph of her extended family gathered for a birthday party in Baghdad before telling her classmates that many of those pictured in the photo had been killed in the aftermath of the U.S. invasion of Iraq in 2003. (107)

Cantú's autobioenthnography is a true Chicana feminist method that is based on the experiences of Chicanas at the U.S.-Mexico border. Her story is universal in its usefulness as a means to open up avenues for all students to grow by telling their stories.

To conduct your testimonio through autobioenthnography, follow these steps:

1. Find a photo that has significance to you and bring it to class.
2. Break into groups of four or five students and take turns discussing each student's photograph.
3. Once everyone has taken their turn, discuss what you have learned about the students and their communities, their intersectional identities, and anything else of interest to the group.
4. Choose one person (or more) to summarize and present the group's discussion to the class.

Further Reading

Cantú, Norma E. *Canícula*: *Snapshots of a Girlhood en la Frontera*. Albuquerque: University of New Mexico Press, 1995.

Cervantes, Lorna Dee. *Emplumada*. Pittsburgh: University of Pittsburgh Press, 1981. http://www.jstor.org/stable/j.ctt5vkfn5.

The Latina Feminist Group. *Telling to Live: Latina Feminist Testimonios*. Durham, N.C.: Duke University Press, 2001.

Chapter 3

"Mi Lucha Es Mi Arte" /
My Struggle Is My Art

Chicana Feminisms and Art

I got into art I think because it was a way for me to feel present in a time where I felt invisible, and people that looked like me were largely invisible. It is my way to have a voice, and to give visibility to the things that we experience.

—Faviana Rodríguez, "Art Is Resistance"

Chicana feminisms did not develop as a body of work solely to increase the representation of Chicanas in various social spaces. The study of gender and its workings provided an aperture into the power arrangements existing in all societies. Ultimately the objective of the Chicana feminist project is to dismantle power and its oppressive effects on all involved through the process of analysis, dialogue, community organizing, political mobilization, art production, performance, and writing. Chicana feminists aimed to create a theory of liberation that would benefit both women and men of all races, ethnicities, and sexualities in the United States and globally. That is quite a tall order—one that has spurred an impressive body of intellectual, cultural, and artistic production in a still-developing area of study.

In this chapter I illustrate how Chicana feminisms are deployed in Chicana art and performance to highlight injustices, raise consciousness, and ultimately contribute to alleviating social inequality (Davalos 2008; González 2014; Pérez 2007). Early Chicana feminist organizers used art as un sitio (a space) to articulate an incisive critique of gender relations in Chicano/a communities, with a specific focus on the sexism present in the Chicano movement (Broyles-Gonzalez 1994). Following this early tradition, there are now a group of artists who identify themselves as *artivistas*, a term that combines the words art and activism to signify the act of creating art

as part of an activist *movida* (move) to create social change (Sandoval and Latorre 2008). As elaborated by M. K. Asante (2009), "The *artivista* (artist + activist) uses her artistic talents to fight and struggle against injustice and oppression—by any medium necessary. The artivist merges commitment to freedom and justice with the pen, the lens, the brush, the voice, the body, and the imagination. The *artivista* knows that to make an observation is to have an obligation" (203). *Artivistas* consider art production and performance an integral part in furthering the social justice agenda in Chicana feminisms (González 2014).

The practice of art in its various forms is advocated to foster the acquisition of both knowledge and wisdom and the use of diverse forms of contemplative practices to elicit deep awareness, social consciousness, and transformation in self and others (Rendón 2009). Chicana feminisms advocate the restitution of self through the use of art forms such as dance (Roberts 2005), visual art (Hurtado and Gurin 2004), and spiritual practices based on wholeness and rooted in the epistemology and ontology of Chicana, Mexican, and Indigenous cultures (Facio and Lara 2014). Chicana feminisms do not advocate the uncritical practice of cultures but rather conceptualize them as changing, fluid, and applicable to different individuals according to their social identities examined through an intersectional lens (Hurtado and Cervantez 2009, 178).

This chapter covers four case studies that exemplify the use of Chicana feminisms in visual arts, music, writing, and dance. The case studies are examples of each artistic modality that create Chicana feminisms. Each case study has three principles in common:

1. The art production is intimately tied to Chicana/mexicana culture.
2. The art production is aimed at creating new modes of expressions that incorporate history, folklore, and academic production.
3. The artistic production is designed to raise consciousness around issues of sexuality, gender, class, ethnicity, and race. Ultimately, the core of the art production is to achieve social justice for all.

Of course, there are many other principles involved in the complexity of Chicana/o art production. However, for the purposes of addressing the intersection of Chicana feminisms and art production, I will only address these three principles here.

Case Study I: Visual Arts

> We still have our community. We still have song and dance—that's something that can't be captured.
>
> —Ester Hernández

In 1848 Mexicana/o and Chicana/o communities were devastated by the colonization of the Mexican territory known now as the U.S. Southwest. Many of the research and written efforts of the Chicano movement and Chicana feminisms uncovered the elided history of Mexican descendants (and other people of Color) in this country (Castañeda 1993). Memorialization included revisioning official history and reconstructing everyday Chicana/o and mexicana/o cultural practices. Chicana feminist writers and artists have been at the forefront of reconstituting (or resignifying) (Sandoval 2000) religious and cultural rituals for the restitution of self, which has led to political mobilization and community empowerment (González 2014).

Chicana feminists refuted the predictions of assimilation theory (also present in white feminist theorizing) claiming that as Chicanas became more liberated, they were more likely to resemble white middle class feminists and leave their culture, languages, and communities behind. Instead, Chicana liberation was constructed in the context of mexicana/o, Chicana/o, and Indigenous cultures—modified, reconstructed, analyzed, criticized, and ultimately recycled through a feminist lens (Nájera-Ramírez et al. 2009). Chicana feminists brought into the archive a "history of their own," to paraphrase Virginia Woolf, through music, paintings, performances, and writings, thus providing social-political frameworks for memory (Pérez 2007; Serna 2011).

La Virgen as Symbol for Political and Social Change

> I related to her in those ways, that she is my image, that I'm growing up with . . . but also . . . this is a revolutionary image.
>
> —Alma López, on La Virgen de Guadalupe

A powerful and persistent example of Chicana feminist visual artistic intervention is the resignification of La Virgen de Guadalupe (Dávalos 2008; Gaspar de Alba and López 2011; Pérez 2007). La Virgen, as she is commonly referred to, is an iconic figure of "Mexicaness" and the patron saint of Mexico—a predominantly Catholic country, if not in practice, in cultural rituals associated with Catholicism. Such Catholic practices as baptisms;

Mass to celebrate weddings, quinceañeras, and funerals; blessings by priests of homes, cars, and rosaries; and the presence of religious objects in homes and gardens such as crosses, small statues of saints, depictions of Jesus Christ all indicate the influence of Catholicism in Mexican/Chicano/a communities. These religious displays do not necessarily correlate with actual church attendance or adherence to the dictums of the religion. These rituals are more in line with a cultural Catholicism that is practiced and lived regardless of adherence to the Catholic religion.

Within this context, La Virgen de Guadalupe is revered by most mexicanos as representing the nation. In addition to being the patron saint of Mexico, La Virgen is for many the Catholic version of the Aztec goddess Tonanztin. La Virgen also has special significance for Chicana feminists because she is Indian and therefore symbolizes the redemption of female mestizaje (the mixture of European, Indian, and African "races"). There are extensive Chicana feminist analyses of La Virgen de Guadalupe that deconstruct traditional views of mexicana/Chicana womanhoods (Blackwell 2018; Hurtado 2003c).

During the height of the Chicano movement, when a strong impetus for mobilization was masculinist in nature, the artist Ester Hernández (box 6) was first to liberate La Virgen in 1975 by rendering her as a karate fighter (Blackwell 2018). The work is acclaimed as a "groundbreaking piece" that "established the beginning of a Chicana/o artistic tradition of recuperating the Virgen de Guadalupe in a humorous" fashion and as a "symbol of defiance" (Mesa Bains, quoted in López 2011, 276; figure 6). Hernández followed this work with *La Ofrenda* (figure 7), an art piece that caused further controversy by portraying what many critics saw as a lesbian with a tattoo of La Virgen on her back. Adding to the polemic, *La Ofrenda* was the cover image used in the first edition of Carla Trujillo's (1991) edited book *Chicana Lesbians: The Girls Our Mothers Warned Us About* (López 2011). According to Laura Pérez (2007, 264), Hernández received a death threat because of the portrayal of La Virgen in her silk screen *La Ofrenda*. Following suit in 1978, the artist Yolanda M. López (box 7) painted a triptych of La Virgen. Her series depicts the different facets of Chicana working-class subject positions—from quintessential abuelita (grandmother) to oppressed factory worker to liberated athlete with skirt billowing around her (Dávalos 2008; figures 8, 9, and 10).

In 1997 Ana Castillo edited *Goddess of the Americas: Writings on the Virgin of Guadalupe*, a volume of essays by Chicana feminist writers highlighting

Box 6. Biography of Ester Hernández

Ester Hernández is a Chicana visual artist based in San Francisco. She was born in 1944 to parents of Yaqui and Mexican heritage in the central San Joaquin Valley, California. Her grandparents had immigrated from Mexico to the United States during the Great Depression to work on commercial grape farms. Her parents settled in Dinuba, California, where they worked on farms and were involved in the farmworkers' movement.

Ester comes from an artistic family. Her mother kept the family tradition of embroidery in the style of Central Mexico, and her father was an amateur photographer and visual artist. Her grandfather was a master carpenter and made religious sculptures in his free time.

To help support their families, Ester's parents cut their own educational journeys short. They were determined to get Ester through school. After graduating from high school, she moved to the San Francisco Bay Area. Soon after, she began studying anthropology at the University of California, Berkeley (UCB), but she shifted her focus to the visual arts. She obtained her bachelor of arts in practice of art in 1976 and began working as an art instructor in schools and universities in California's Bay Area.

During her time at UC Berkeley, she came into her political consciousness. She became involved with the United Farm Workers of America and joined Las Mujeres Muralistas, an influential group of female mural artists in the San Francisco's Mission District. Their large-scale murals were created in conversation with the Chicana/o movement and depicted the social concerns and everyday lives of the Mexican American community in the Mission District. By 1977, she had completed eleven murals with Las Mujeres Muralistas.

Ester's best-known work, *Sun Mad* (1982), was created out of her deep concern for the Dinuba community. Many Dinuba residents were exposed to the leaching of pesticides from the grape farms into the town's water supplies. Ester used subvertising, an art practice in which corporate logos and slogans are altered to undermine their message. In this instance, the Sun-Maid Raisins snack box logo was replaced with the "maiden" grape-harvesting skeletal face of Death. The art piece contained the warning that the raisins had been "unnaturally grown with insecticides, pesticides, herbicides, fungicides." *Sun Mad* did not draw much attention when it was first created in 1982. Ester, however, has been credited with creating the first image linking the plight of farmworkers to the effects on consumers and the environment. The Sun Maid Company has never publicly commented on the work.[1]

Ester's other works focus on farmworkers, laborers, women's issues, civil rights, and social justice. She is best known for her depiction of Latina/Native women in

pastels, prints, and installations. Her work has been included in the permanent collections of the Smithsonian American Art Museum, Library of Congress, Legion of Honor (San Francisco), National Museum of Mexican Art (Chicago), Museo Casa Estudio Diego Rivera y Frida Kahlo (Mexico City), Museum of Contemporary Native Art (Santa Fe, New Mexico), Victoria and Albert Museum (London), and other national and international institutions.

In 2008, as an artist in residence for The Serie Project workshop, Ester reworked her *Sun Mad* screenprint. The result was *Sun Raid* (2008)—the skeletal maiden wears a security-monitoring bracelet labeled "ICE" (Immigration and Customs Enforcement) and the copy names several Mexican Indigenous groups from the Oaxaca area (a large number of farmworkers in the United States immigrated from this region). This work was designed to begin a dialogue about issues affecting marginalized populations.

After more than thirty years of teaching, Ester retired from her post at Creativity Explored, an art center for adults with developmental disabilities. She is focusing full time on creating more works of art.

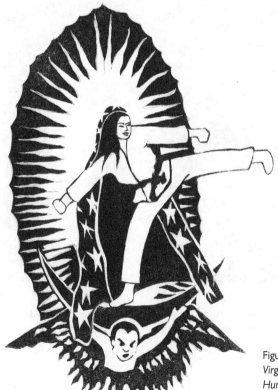

Figure 6. Ester Hernández, *Virgen Defendiendo los Derechos Humanos* (Virgen Defending Human Rights).

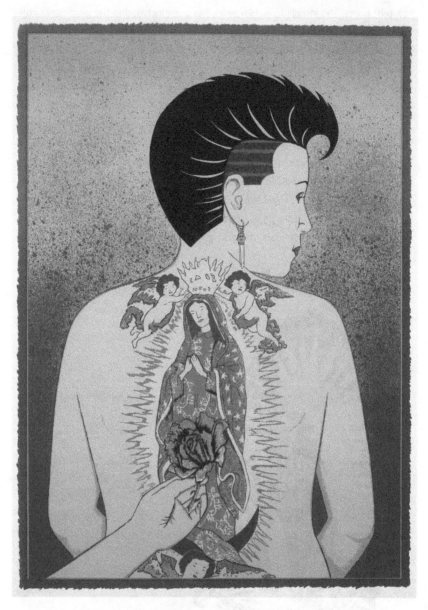

Figure 7. Ester Hernández, *La Ofrenda*, from the National Chicano Screenprint Taller, 1988–1989, 1988. Printer: Self-Help Graphics Smithsonian American Art Museum.

Box 7. Biography of Yolanda M. López

Yolanda M. López is a Chicana conceptual artist located in San Francisco, California. She was born in 1942 as a third-generation Chicana and raised in San Diego's Logan Heights neighborhood by her mother and maternal grandparents. From an early age, her family supported her interest in art and encouraged her to develop her creativity.

After graduating from high school, Yolanda moved to San Francisco and attended San Francisco State University (SFSU). She became active in the arts and gained an awareness of her social position as part of a larger legacy of oppressed peoples. She was involved in the Third World Liberation Front student movement. This group became known for the 1968 "Third World Strike" by faculty and students who demanded an Ethnic Studies department, more faculty of Color, and more students of Color at SFSU. As an undergraduate, she worked as a community artist in the Mission District with Los Siete de la Raza, a group of seven young Latino men accused of killing a police officer.

In the 1970s, Yolanda returned to San Diego and enrolled in San Diego State University. She earned her bachelor of arts in painting and drawing in 1975. At the University of California, San Diego, she obtained her master of fine arts in visual arts in 1979. Her MFA professors Allan Sekula and Martha Rosler encouraged her to consider the political function of art as opposed to the notion of "art for art's sake."

Yolanda is known for her Virgen de Guadalupe series portraying "ordinary" Mexican women (including herself, her mother, and her grandmother) performing everyday tasks while enrobed in the star-studded blue mantle that is worn by the Virgen. By incorporating the iconography of the Virgen into images of working-class Chicanas, the series deconstructs the image of the Virgen and rebuilds the self-imagery of Chicanas.

Yolanda's works also include art installations, videos, and slide-show presentations. Her project *Women's Work Is Never Done* is a series of prints and an installation titled *The Nanny* that emphasizes the invisibility of immigrant domestic workers. The work was displayed in the San Jose Institute of Contemporary Art's exhibition "Mirror, Mirror . . . Gender Roles and the Historical Significance of Beauty."

Her traveling exhibition "La Frontera/The Border: Art About the Mexico/United States Border Experience" included the *Cactus Hearts / Barbed Wire Dreams: Media-Myths and Mexicans* series. This exhibition explored stereotypes of Mexicans in the media, in advertising, and in common everyday objects. The series also included the installation *Things I Never Told My Son About Being a Mexican*, an exploration of identity, assimilation, and cultural change.

(*continued*)

Box 7. (continued)

Yolanda has produced two films, *Images of Mexicans in the Media* and *When You Think of Mexico*. The films challenged the stereotypical ways in which Mexicans and other Latin Americans are depicted in the media. Yolanda's work advocates "visual literacy" to understand and critique culture in the United States.

In 2014, after forty years of renting the same home in San Francisco, California, Yolanda was faced with eviction through the Ellis Act. The law permits landlords to evict tenants when the landlord no longer will be in the rental business. Yolanda responded as an artist and hosted "eviction garage sales," inspired by her mentor Rosler's 1973 "Monumental Garage Sale." The first sale was held at the Mission District's Galería de la Raza as a conceptual performance commenting on the city of San Francisco's rampant evictions and lack of concern for longtime residents. Soon after, she held another garage sale event, "Accessories to an Eviction," the title of which implicated both customers and passersby in the crisis.

Yolanda's career accomplishments include having served as director of education at the Mission Cultural Center for Latino Arts in San Francisco. She taught studio classes and lectured at UC Berkeley, Mills College, Stanford University, and in other reknown venues.

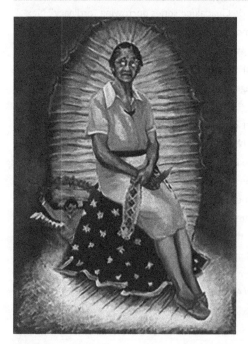

Figure 8. Yolanda M. López, *Guadalupe: Victoria F. Franco*, from the Guadalupe series, 1978. Oil pastel on rag paper, 22 × 30 inches.

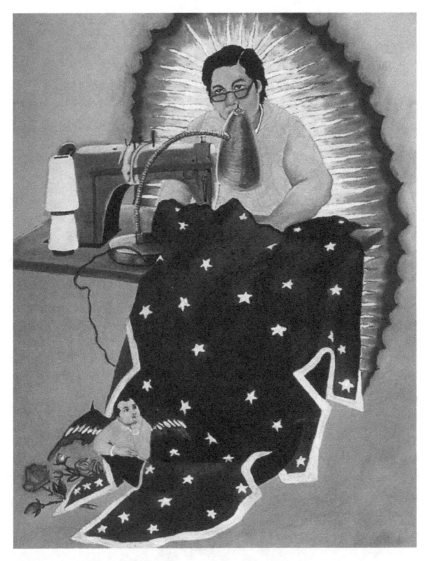

Figure 9. Yolanda M. López, *Margaret F. Stewart: Our Lady of Guadalupe*, from the Guadalupe series, 1978. Oil pastel on paper, 22 × 30 inches.

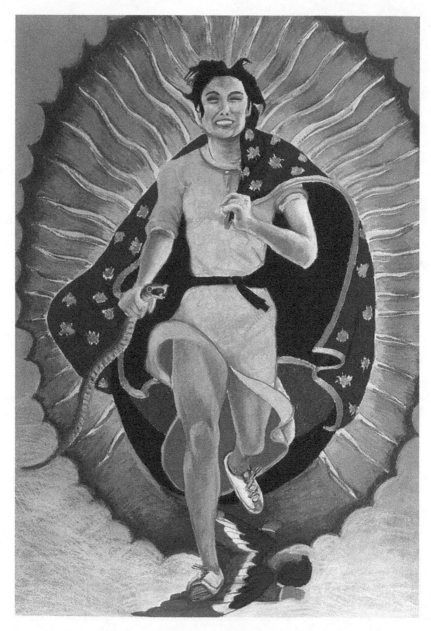

Figure 10. Yolanda M. López, *Portrait of the Artist as the Virgin of Guadalupe*, from the Guadalupe series, 1978. Oil pastel on rag paper, 22 × 30 inches.

the importance of La Virgen to Chicana womanist/feminist views of self, including sexuality. This book contains the essay "La Virgen de Guadalupe and Her Reconstruction in Chicana Lesbian Desire," in which Carla Trujillo makes La Virgen her lover. Also in the book is an essay by Sandra Cisneros (1997), in which she appropriates La Virgen to refute the image of la madre sufrida (the suffering mother), replacing it with La Virgen as "sex goddess":

> When I look at *la Virgen de Guadalupe* now, she is not the Lupe of my child-hood, no longer the one in my grandparents' house in Tepeyac, nor is she the one of the Roman Catholic Church, the one I bolted the door against in my teens and twenties. Like every woman who matters to me, I have to search for her in the rubble of history. And I have found her. She is Guadalupe the sex goddess, a goddess who makes me feel good about my sexual power, my sexual energy, who reminds me I must, as Clarissa Pinkola Estés so aptly put it, "[speak] from the vulva ... speak the most basic truth," and write from my *panocha* [cunt]. (49)

The resignifications of La Virgen have not received universal approval; it has, however, invited different constituencies to reexamine mexicano/Chicana culture and to widen their lens from the binary of acceptance or rejection to critically reassess this body of artwork through the prism provided by Chicana feminist production.

The most famous/infamous controversy surrounding the resignification of La Virgen was actually inspired by the words of liberation as quoted above by Sandra Cisneros. A national controversy erupted when a digital portrayal of La Virgen (figure 11), produced by Chicana artist Alma López (box 8), was exhibited at the Museum of International Folk Art in Santa Fe. Numerous newspaper articles described López's representation of La Virgen as "bare-midriff Mary" (Benke 2001b), "bikini Virgin" (Benke 2001a), and less inflammatory, "a computerized photo collage of Our Lady of Guadalupe wearing a two-piece swimsuit of bright roses" that also featured "a barebreasted angel holding the virgin aloft" (Janofsky 2001, 27A).[2] To non-believers, the image "seems rather innocuous," but for many devout observers, especially in the predominantly Catholic state of New Mexico where it was exhibited, the art piece "caused such an uproar that museum officials say they have been threatened with physical harm and state law makers have suggested that the museum should lose some of its funding" (27A).

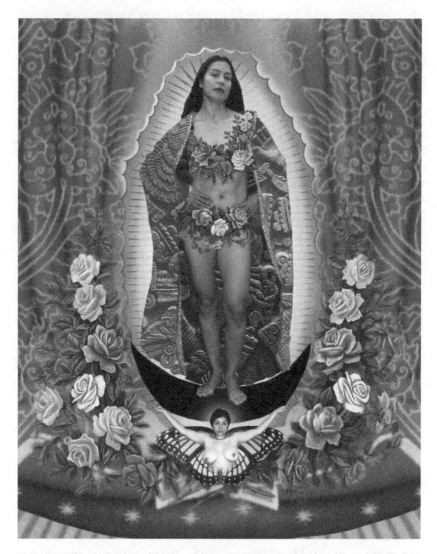

Figure 11. Alma López, *Our Lady*. Copyright © 1999 Alma López. (Special thanks to Raquel Salinas and Raquel Gutierrez.) See more at http://www.sfreporter.com/santafe/article -7526-shame-as-it-ever-was.html#sthash.z35zim2M.dpuf.

Box 8. Biography of Alma López

Alma López is a Chicana visual artist who was born in Los Mochis, Sinaloa, in 1966. She and her family moved to Los Angeles during her childhood but returned to Mexico for frequent visits. The border culture and the Chicana/o art renaissance in the sixties and seventies influenced the development of Alma's artwork. The core of Alma's work is characterized by the reimagination of important Chicana/o cultural icons through a queer Chicana feminist lens.

Alma earned her bachelor of arts with distinction in studio art from the University of California, Santa Barbara, and her master of fine arts in studio art from the University of California, Irvine. While working as a research assistant for professor and artist Judy Baca at UCLA, she was introduced to digital media as an art medium.

One of her first digital series, *Lupe and Sirena*, included a work titled *Lupe and Sirena in Love*. In this piece La Sirena from the lotería cards is superimposed over La Virgen, appearing to be in an intimate embrace. Reviewers dubbed Alma the "Digital Diva" for this series. One of her most notable works, *Our Lady*, was also included in this series. *Our Lady* features a young Latina gazing confidently at the viewer while wearing a bikini of roses. She is supported beneath by a bare-breasted woman with her arms raised.

In 2001 *Our Lady* was exhibited as part of the *Cyber Arte: Tradition Meets Technology* exhibit at the Museum of International Folk Art in Santa Fe, New Mexico. Soon after, Alma and the museum curators were inundated with criticisms and threats. One main objection was that the imagery of *Our Lady* was oversexualized and blasphemous. Alma argued that the work was about strong women and the lives of Chicanas. The model depicted in *Our Lady* explained her choice as part of her healing after being raped. With her spouse, poet and professor Alicia Gaspar de Alba, Alma co-edited a book about the controversy, titled *Our Lady of Controversy: Irreverent Apparition* (2011). Alma posted several hundred messages she received about the work on her website (http://www.almalopez.com) to engage in public discussion.

Alma was an artist in residence for The Serie Project and produced the serigraph *La Briosa y La Medusa*. She was inspired by *Lucha Libre* and the female luchadoras participating in traditionally masculine activities and flourishing in their pursuit. The serigraph depicts two female luchadoras in their masks, backless and high-cut wrestling outfits, and combat boots planted firmly on the mat, staring each other down before the fight. In the background, she included a selfie of her niece, indicating that watching others succeed is an avenue for youth to learn what is possible.

(continued)

Box 8. (*continued*)

Alma's work has been exhibited in more than a hundred solo and group exhibitions across the globe, including the UCLA Fowler Museum of Cultural History, Sheldon Museum of Art (Lincoln, Nebraska), Richman Gallery (Baltimore, Maryland), Mexi-Arte Museum (Austin, Texas), International Print Center (New York), and other institutions in Mexico City, Italy, and Ireland. She has permanent collections at the Museum of International Folk Art (Santa Fe, New Mexico), Oakland Museum of California (Oakland, California), and McNay Art Museum (San Antonio, Texas).

Alma is currently a lecturer in the César E. Chávez Department of Chicana/o Studies and the LGBTQ Program at UCLA. She facilitates several teaching projects that engage her students in community art.

Where many saw offense and blasphemy, artist López stated that as a Catholic, she was showing La Virgen "as a strong woman 'and not as the young, passive' more traditional image with head bowed and hands clasped" (Janofsky 2001, 27A). López explained that the angel's bare breasts represented "beauty and nurturing" (27A) and that the art piece, as mentioned previously, was inspired by another Chicana feminist Sandra Cisneros, who "in one of her stories wonders what Our Lady of Guadalupe wears underneath the mantle" (Gonzales and Rodríguez 2001). López, with the model for the image, concluded it must be "roses" (27A).

At the time of the controversy, Alma López was a member of an artist group called Cyber Arte,[3] which, instead of rejecting their culture or damning it as reactionary and sexist, engaged head-on (as many Chicana feminists do) the controversies generated by their resignification, even when the consequences are as serious as receiving "death threats," as López (2011) did. She felt that

> when I look at the image of the La Virgen de Guadalupe, I see a complex activist revolutionary cultural icon. To me, she is the poster image for the first successful act of mass nonviolent civil resistance/disobedience on this continent. Like the Aztec moon goddess Coyolxauhqui, La Virgen de Guadalupe needs to be deciphered and *re-membered*. Hundreds of years of conquest and Catholic misinformation shifted her meaning. She documents the spirit of indigenous resistance. We witness this spirit of resistance

resurface throughout our Mexican, Mexican American, and Chicana/o history. (247)

Alma López is not unique in risking her well-being for the sake of a Chicana feminist agenda. The same risks have always existed for Chicanas who rebel and do not accept the restricted social-cultural spaces assigned to them by society in general and by enforcers in their own communities. Such backlash is documented by Maylei Blackwell in her book ¡Chicana Power!: Contested Histories of Feminism in the Chicano Movement (2011) on feminist organizing in the 1970s and earlier in Cotera's book The Chicana Feminist (1977), in which she reports on both the men who supported feminist organizing and those who vehemently labeled Chicana feminists "lesbians" or Chicanas with "white woman's" disease (Del Castillo 1974). A central question then is, Why do Chicana feminists pursue such dangerous dynamics? Why not instead create art that is outside the confines of their culture and communities— a move that could lead to greater acceptance and success in the mainstream art world? Part of the answer lies in Chicana feminists' commitment to the generation of knowledge as a site (or sitio) for social, cultural, and economic transformation; ultimately, the Chicana feminisms agenda for social change relies heavily on knowledge production and dispersion as a primary source for liberation (Blackwell 2018).

Case Study II: Music

Artivistas: Making Music in the Kitchen

Connection is so crucial for the writer because it gives them the sense and the knowledge that their experience is not solitary.

—Elba Sánchez

Chicana feminisms is a "living theory" (Trujillo 1998), with young scholars, performers, and artists evolving the tenets of the theory and applying it to new artistic and political expressions. An example is Martha González (2014; figure 12), who describes herself on her website as follows: "I am a Chican@ Artivista, PhD, feminist music theorist and an Assistant Professor in the Intercollegiate Chican@ Latin@ Studies Department at SCRIPPS/ Claremont Colleges. This website is designed to feature the different facets of my artistic, community, and academic work. Please look around and leave some feedback. Thank you for visiting!" (87).

Figure 12. Photo of Martha González. Photo courtesy of Pablo Aguilar.

González is a songwriter, performer, and member of the Grammy award-winning group Quetzal; she is also an academic. Most recently, González has participated in and further developed a method of collective song writing with a group of U.S. and Mexican women, who, with one exception, had never written original compositions. González's yearlong project called "Entre Mujeres" (Among Women) was a transnational effort to create a space, a kitchen space more specifically, for women to gather, depending on their availability given their childcare and home commitments, to create music. González theorizes that hegemonic structures of music production often exclude women because they fail to recognize women's restrictions due to familial arrangements and obligations. By purchasing affordable and mobile recording equipment through a grant, which also provided funds for her and her family to relocate to Xalapa, Veracruz, Mexico, for a year, González was able to have women from the United States and Mexico come together in her kitchen to create music. The results are recorded on a CD titled *Entre Mujeres: Women Making Music Across Borders*, which is based on original music composed by the women in the project and incorporates their observations on pregnancy, childrearing, and life in general.

González (2014) proposes that songs are sung theories that can further our understanding of women, as well as the creative process: "A song as a sonic and literary manifestations is life's sound-scape, a unique cathartic memento, and a powerful political tool. Without question, a song is also an important historical text. A person's *testimonio* ('testimony'), life views, triumphs, aphorisms, and struggles can be expressed in song lyrics. In this way, song lyrics can be viewed as knowledge and theory. Multiplied by community, they can be a powerful exercise in consensus and collective knowledge production" (78).

González has held similar workshops with male and female youth in juvenile detention centers. She includes boys because, as Anzaldúa admonishes, "que no se nos olviden los hombres" (let us not forget the men) when creating social change. González, together with a group of artists, produced a video in which she states:

Last spring, six teaching artists from Seattle & LA had the privilege of spending a week at the King County Juvenile Detention Center in Seattle with an amazing group of youth. Together they wrote three songs utilizing a collective songwriting process developed by Mayan indigenous

communities in Chiapas, Mexico and Chican@ artivistas in East LA. The project, called "Sounds Beyond Barriers," included youth & staff at KCJD, Martha González, Ph.D., Quetzal Flores, Stephany Hazelrigg, Teresa Bazan, Alex Chadsey and Scott Macklin. It was made possible with support from the Jubilation Foundation and the City of Seattle Office of Arts & Culture. (González 2015)

The Sounds Beyond Barriers project provides an avenue for examining music creation as a process, not a product. The process of creating music lends itself to personal reflections and transformation because, when writing a song collaboratively, youths tend to be more open and engaged with one another than when they are simply talking. A critical consciousness often develops in the youths, who then examine the behaviors, values, feelings, and circumstances that led to their detention in a juvenile hall. This is the beginning of changing their circumstances.

For González, there is no separation between her community of origin (Los Angeles), the musical knowledge she obtained in her family's native country (Mexico), the education she has achieved (a doctorate), and her artistic and academic production. Every aspect of her life is fully integrated.

Case Study III: Spoken Word

We have always been writing as resistance . . . even when we are writing about our existence, it is an act of resistance.

—Emmy Pérez

Creative Writing as a Gate to Liberation

An innovative art form embraced by Chicana feminists is spoken word. Spoken word is poetry usually written for performance, although some is also published. The roots of spoken word come from oral traditions, and for mexicanas/os the performance is called "declamación," usually performed at parties and special occasions like weddings and New Year's celebrations. Among people of Color in the United States, spoken word may include rap, hip-hop, storytelling, theater, and jazz, rock, blues, and folk music. The content of spoken word often refers to social justice issues, politics, race, community, and gender issues.

In an explicitly Chicana political and creative product, the poet Lady Mariposa uses spoken word to express her feelings about gender oppression

and resistance to patriarchy (figure 13). The first poem, titled "My Reality Is My Poetry," in Lady Mariposa's self-produced CD *Lady Mariposa Spoken Word and Borderland Beats* begins with a mini-bioethnography.

"My Reality Is My Poetry"
My reality is my poetry. . . .
I weave loomlessly beyond the expectations of my family.
I weave poemas that sound like barbacoa on Sunday after martinis on Saturday.
I weave loomlessly, a story of a life not hindered by my parents' desire to become abuelos.
Loomlessly, stories of a life beyond the real estate secretaria de la gringa que hacía y hacía y no pensaba, no pensaba.
Beyond an ex husband that used to call me puta.
Beyond an ex suegra I never punched in the face.
All of this is my story.
My landscape is that landscape of many girls like me that married and never escaped, and when they did they brought along babies.
Girls that never imagined life belonged to them.
Girls that never imagined that life without that chokehold that is co-dependency and that pinche gusano that "marry me and marry me, and love me and marry me and marry me."
And this is how I weave my landscape.
This is how I adorn my temple with American possibilities and Mexican memories.
With Mexican love songs and American jazz.
With education that showed me the world.
With education that gave me the words.
To weave my mother's lessons into a reality that is me—una lady.
Lady Mariposa (echoes out).

Lady Mariposa, like the poet Elba Sánchez discussed in chapter 2, uses the geographical metaphor of landscape to describe herself: "And this is how I weave my landscape. / This is how I adorn my temple with American possibilities and Mexican memories." The term *landscape* implies that others can influence its design, future use, and unclear boundaries. A landscape is also open to the influences in her environment—cultural, historical, political, patriarchal, among others—which Lady Mariposa clearly delineates:

"My landscape is that landscape of many girls like me that married and never escaped . . . / Girls that never imagined life belonged to them. / Girls that never imagined that life without that chokehold that is co-dependency and that pinche gusano that 'marry me and marry me, and love me and marry me and marry me.'" Lady Mariposa's landscape is not only marked by the restrictions of her gender imposed by society, her family, and her community; she also recognizes her own internalization of the gender restrictions imposed on her rather than following her inner voice.

Figure 13. Photo of Lady Mariposa. Photo courtesy of Veronica Sandoval.

Lady Mariposa grew up in South Texas in the small town of Sullivan City, only fifty-one miles west of Gloria Anzaldúa's homeland but forty-some years later (Smith 2010). Despite this significant distance in time, her experience of gender restrictions was very similar to Anzaldúa's experiences in her family and community. Eventually, through the acquisition of higher education, Anzaldúa and Lady Mariposa were catapulted out of their cultural "captivity" into self-awareness as writers. Lady Mariposa was born Veronica Sandoval to Mexican parents with limited education who worked hard in a town of four thousand only twenty-three miles from the U.S.-Mexico border. Sandoval was married at nineteen and soon became aware that she preferred to be a writer rather than a wife and mother. She invented the writer's persona of Lady Mariposa because she wanted to be "a butterfly emerging from the cocoon of captivity" (Smith 2010, 1). Lady Mariposa attributes the acquisition of her wings to escape from her surroundings to encountering Gloria Anzaldúa's essay "How to Tame a Wild Tongue" in her book *Borderlands* (1987). Anzaldúa's writing validated Lady Mariposa's borderland experience and steered her away from cultural and linguistic assimilation into the U.S. mainstream: "[I learned] there's no such thing as correct Spanish or incorrect Spanish because it's constantly changing. . . . My Mexico is right here, this borderland, this region that's a mix of languages and a mix of hip hop, cumbias, and Tejano and norteno" (Smith 2010, 3).

Before Sandoval became Lady Mariposa, became a poet, and became a doctoral student at Washington State University, she followed the "girl culture" of the Rio Grande Valley. Her landscape was dictated by her "co-dependency" on a husband who did not understand her and her writerly ambitions, her compliance with her parents' wishes to see her married and raising a family, and her secretarial work that required conformity and lacked intellectual challenge. She lays out her circumstances fully for the listener to understand where she is "coming from" and the genealogy of her writings. In doing so, she claims un sitio y una lengua (a space and a language) as a feminist writer who will not be made to feel shame for a patriarchy she did not create and from which she eventually escapes. Lady Mariposa, as an independent artist who leaves the cocoon created by patriarchy, flies away and is transformed from gusana (larva) to full-fledged mariposa. She becomes an example for other young women living in rural Texas (or any other geographical space of restriction). As predicted by Chicana feminisms, education *and* art become Lady Butterfly's ticket to liberation.[4]

Case Study IV: Dance

> The cry of La Llorona is every woman's lament.
>
> —Cherríe Moraga

Ballet Nepantla: Resignifying the Legend of the La Llorona

The Mexican nation was built on a program of culling its regional cultures into a coherent whole designed to represent "lo mexicano"—that which is Mexican to its citizens and to the world. This program began after the 1910 Mexican Revolution and continued through most of the twentieth century, when government agencies were specifically created to collect and organize regional folk expressions to begin to constitute a Mexico that was independent from previous colonization by Europeans, including the Spanish (1519–1821) and the French (1861–67). The desirable "high" culture in Mexico was represented by European customs, aesthetics, and tastes (Nájera-Ramírez 2012). Out of this movement to reclaim la madre patria—the homeland—was the recuperation and eventual institutionalization of Mexican folkloric dancing. The National Ballet de México under the direction of Amalia Hernández, who founded the dance troupe in 1952, was at the forefront of presenting folkloric dance to the world in

the form of spectacle unprecedented on the world stage (Nájera-Ramírez 2012). Hernández modified and glamorized the folkloric dances to impress a world audience and to become iconic of "lo mexicano."

Many of the efforts of the Chicano movement were to undo the assimilation imposed on Chicanas and Chicanos prior to their mobilization efforts. The recuperation of lo mexicano became the rallying cry of the 1960s—"La Cultura Cura" (culture is healing). Denial of lo mexicano resulted in identity confusion and self-loathing. Speaking Spanish and wearing huipiles, rebozos, and huaraches reclaimed lo indígena as well. These efforts were not part of the same program as that of the Mexican government, which simultaneously exalted indiginismo while oppressing indígenas. Rather, for Chicanas/os, exalting lo indígena was the recuperation of their working class, immigrant, farm working, Indigenous roots (as exhibited by phenotype, if not by culture). Reclaiming the "india within" was a political act of resistance to U.S. assimilationist policies. The reclamation was also a rejection of the Mexican government's homogenization of folkloric practices into spectacles such as the Ballet Nacional de México. For many Chicanas/os in higher education during the Chicano movement, joining folklórico dance troupes on U.S. university campuses became both an act of reclamation of Chicano/a culture and a political statement to predominantly white institutions. The practice persists to the present, where many universities have student Mexican folklórico groups, with Chicanos/as and non-Chicanos/as members (Nájera-Ramírez et al. 2009). Many of these groups have developed into semiprofessional performing groups, with a strong academic component that provides a training ground for its members who join professional dance groups after graduation or who become academics writing about folkloric dance practices (Nájera-Ramírez 2012).

Ballet Nepantla represents this next stage of development in the process of folklórico; its existence is a cultural affirmation within the framework of Chicana feminisms. Ballet Nepantla was founded by Andrea Guajardo, with her co-director Martín Rodríguez. Guajardo was born in Edinburg, Texas, also in the Rio Grande Valley, only thirty-four miles west from Lady Mariposa's and twenty miles north from Anzaldua's hometowns. The "magic valley," as it is advertised in much of the tourism and investment literature for the region, has indeed produced magical artists and writers whose deep connections to the U.S.-Mexico border is reflected in their consciousness and in their art. Unlike Martha González and Lady Mariposa, who explicitly claim a Chicana feminist genealogy, Andrea Guajardo, also

the principal dancer and co-director of Ballet Nepantla, uses her artistic sensibilities to claim a womanist orientation that is inadvertently influenced by Chicana feminisms. Guajardo was aware of Gloria Anzaldúa's use of the concept of Nepantla when she chose the name for the dance troupe. As stated on the Ballet Nepantla website: "Drawing inspiration from Gloria Anzaldúa's borderlands theory . . . they could create performances that spoke to the "in-between" qualities of being from both sides of the borderland. They found the idea of Nepantla, a Nahuatl term of the indigenous people of Mexico. Nepantla provides a historical, intellectual, and artistic framework through which to explore the 'in-between' spaces of history and culture by exploring new artistic expression that fuses different traditions on stage. Thus, Ballet Nepantla was born in January 2017" (Ballet Nepantla n.d.).

The mission of the dance troupe captures the essence of Chicana feminisms by applying Anzaldúa's concept of Nepantla to dance to create a new mixture que no es ni de aqui ni de alla (not from here or from there). At the same time, neither side is diluted nor subsumed, or as Anzaldúa (1987) so aptly put it: "To survive the Borderlands/you must live *sin fronteras*/be a crossroads" (401–2).

In the case of Ballet Nepantla, Guajardo enlisted the artistic expertise and creativity of Martín Rodríguez who came del otro lado, as Chicanos refer to mexicanos. Rodríguez's traditional training in folklórico complements Guajardo's expertise in ballet and contemporary dance. As a teenager, Rodríguez immigrated from Guadalajara, where he was already a professional folklórico dancer, having studied and performed with Indigenous communities in his native country. He came to Los Angeles and joined the well-reputed Grandeza Mexicana Folk Ballet Company as dancer and choreographer.

Guajardo's training is equally impressive, though situated largely in a different genre of dance. As the daughter of dance teacher Yvonne Guajardo and Professor Francisco Guajardo at the University of Texas, Rio Grande Valley (where Anzaldúa obtained her college degree), Guajardo's early training was primarily in ballet; she learned folklórico as part of a regional/cultural education that many aspiring dancers are taught in the valley. Guajardo decided early on that she wanted to be a professional dancer and both of her parents helped make the dream come true. Guajardo left her home and family in the valley to train in New York City under the auspices of the prestigious African American dance school founded

by Alvin Ailey. Upon graduation, Guajardo joined the famous MOMIX contemporary dance company and toured the world. She came upon the idea of Nepantla Ballet after a side booking with a New York–based folklórico group. Guajardo "didn't consider her border upbringing relevant to her career until a stopgap freelance gig with an NYC folklórico company. 'It made me realize that something was missing,' Guajardo says. 'I wanted to be representing who I am—my culture, my heritage—through dance'" (Tyx 2017, 4).

Ballet Nepantla combines the European-based art form of ballet, the U.S.-based art form of contemporary dance, and the Mexican-based art form of foklórico, and gives them equal billing to produce a fusion art performance not seen before. The commitment of Ballet Nepantla to consider all avenues of creativity is also exhibited in Guajardo's decision to work with Rodríguez, a mexicano dancer who is an equal partner in producing a third space. The philosophy of inclusiveness in Ballet Nepantla carries over to the musical director Felipe Fournier, who is from Costa Rica and appreciates the fusion: "Musically speaking, we are exploring the spaces in between traditional folkloric and classical music—along with jazz, Caribbean and everything else" (Tyx 2017, 7). Fournier has produced music in a variety of genres and was nominated in 2017 for Latin Grammys in Mariachi, Ranchero, and Latin Jazz categories, winning as producer with the mariachi musicians Flor de Toloache, an all-women's group. Ballet Nepantla's dance ensemble also reflects this diversity: dancers are from Mexico City, Queens, New York, South Texas, Long Island, and New York, and they are of various ethnicities and races with a variety of training backgrounds—ballet, contemporary, foklorico, and African dance training. An apt metaphor for Ballet Nepantla's version of diversity is a capirotada—a dessert made in Mexican households of any available ingredients found in the home (day-old bread, brown sugar, vanilla, nuts, dried fruit, fresh fruit). The ingredients are mixed and baked into a type of bread pudding that is best when left to stand overnight.

The dance capirotada that is produced is based on everyone contributing their own ingredient of diversity into the final product, which in the ballet program consisted of the appropriately titled *Sin Fronteras* (Without Borders). The ballet had its debut on September 16, 2017, Mexican Independence Day, in Queens, New York, and has since toured to various sites in the United States and dance festivals in New York City (figure 14).

TICKETS $20

Ballet
NEPANTLA

PRESENTS:

"SIN FRONTERAS"

San Antonio: Nov 25 @ 8 pm, Guadalupe Theatre
Austin: Nov 26 @ 3 pm, Scottish Rite Theatre
Edinburg: Nov 29 @ 7:30 pm, Edinburg North HS

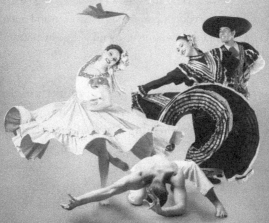

BALLET NEPANTLA: exploring cultural, historical, and artistic in-between-ness

Artistic Directors: Andrea Guajardo
Martín Rodríguez
Musical Director: Felipe Fournier

Tickets: go to eventbrite.com
SEARCH city of choice:
Sin Fronteras San Antonio
Sin Fronteras Austin
Sin Fronteras Edinburg
or call 956-330-9439

Figure 14. Ballet Nepantla, poster from inaugural performance, designed by Martín Rodrí-
guez. Courtesy of Martín Rodríguez.

The original full-length program consists of sixteen dance pieces, fifteen dancers, and five musicians. Two pieces best exemplify Ballet Nepantla's Anzaldúan intervention of working in the interstices of various social, artistic, historical, and cultural systems. The first is titled "La Bruja" (the witch). "La Bruja" is a traditional folklórico dance with its origins in the region of Veracruz. Daniel Tyx (2017) from the *Texas Observer* describes the performance of this dance piece:

> In the opening moments of "La Bruja," a traditional folk dance from Veracruz newly reinterpreted by the New York City-based Ballet Nepantla, a spotlight trains on a barefoot dancer in a red dress—the witch—pirouetting at center stage. She is soon joined by a shirtless male "victim" who executes a series of acrobatic lifts as they take turns pursuing one another across the stage. It's a prototypical contemporary ballet duet, until something surprising happens: Six dancers in flowing white dresses and high-heeled shoes emerge from the wings and place flickering candles atop their heads. Their feet strike an intricate pattern as the candles remain stationary, as though levitating. Meanwhile, the contemporary pair weaves in and out of the folk dancers in an ethereal braid entwining new and old, seduction and pursuit, and life and death.

As Anzaldúa points out, the border is where antithetical elements meet not to obliterate each other nor to generate tensions out of their contradictory stances, but to create something new and unprecedented. The reinterpretation of "La Bruja" is one of the best examples of an Anzaldúan vision of harmony found within difference and of consciousness expanded by blurring boundaries and creating spaces sin fronteras.

Anzaldúa envisions yet another outcome of border crossing. Instead of elements respecting each other's essence and creating within each other's composition, the different elements can be combined in unique ways to create a third space, something that is neither solely ballet nor solely folklórico, solely Mexican nor solely from the United States—but truly Chicana/o. The creation of the dance piece "La Llorona" is a prime example of this third space. "La Llorona" was choreographed by Guajardo and is based on the Mexican leyenda (legend) of the title (figure 15). "La Llorona" is one of many Mexican legends taught to young children as a cautionary tale against bad behavior. As is common with folktales, there are many regional and historical variations that are modified according to the needs

of the performer, the circumstances under which the tale is told, and the gender of the narrator, among other variables. One of the most common and oldest versions of "La Llorona" that is commonly repeated among Chicana/o communities across the Southwest relates the tale of María, the most beautiful girl in the world, who lived in a small rural village in Mexico. Her beauty led her to believe that no man in her village was a good match for her. One day a man who was extraordinarily handsome and the son of a wealthy rancher from a nearby village rode into town. María chose him and used the right tricks to win his attention. By small acts of rejection, the handsome stranger became infatuated with María and swore to make her his wife. They marry, have two children, and after a few years, he leaves and only comes back sporadically to visit his children, ignoring María. He talks of abandoning her and marrying a woman of his own class. María's anger toward her husband turns to plans of revenge: if he loves the children so much, she will hurt him by killing them. María takes her children and throws them into the river with the intent of drowning them. As the children disappear downstream, she immediately regrets her actions and runs along the riverbank, trying to rescue them, but they are gone. In her desperation to reach them, María slips on the riverbank and drowns. Her body is recovered and she is buried. The first night after her funeral, the villagers hear someone wailing by the river: "Where are my children?" The villagers report a woman walking up and down the riverbank, dressed in a long white robe, the way María was dressed for her burial. Thus, the leyenda of La Llorona—the weeping woman—is born. The folktale is told to children as a ghost story to warn them not to go out at night because La Llorona might snatch them and they will never return.

There are many gendered and sexist elements evident in this story. Obviously a mother drowning her children out of spite is the most egregious one. María is not only a murderer but a narcissist who is blinded by her beauty and her husband's attractiveness. She is also punitive and vengeful, and not worthy of compassion nor even her husband's love—that is, mala mujer (an evil woman). When I asked Guajardo about her choreographed version of the legend, she gave a very different interpretation of "La Llorona." In Guajardo's rendering of the tale, the mother lives in South Texas, close to the Rio Grande River, which marks the U.S.-Mexico border and is one of the poorest areas of the United States. La Llorona is a single mother, with no money, and is near starvation. When she realizes that her children will die of hunger, she throws them into the river to alleviate their suffering. As

Figure 15. Photo of Ballet Nepantla's "La Llorona" choreographed by Andrea Guajardo and danced by Hannah Zinn and Krystina Wendelken. Performed at Queens Theatre on September 16, 2017. Photo courtesy of Luis Guajardo.

soon as she commits the horrendous act, she regrets her actions and enters the river to save her children. She fails, and in the course of the rescue, she drowns. The ghost of La Llorona is haunted by her actions and travels along the Rio Grande wailing for her children.

The differences in these two versions of "La Llorona" are striking. Guajardo's narrative is a more modern interpretation, focusing on the burden

women must bear when abandoned by their husbands and are unable to care for their children. The dance piece "La Llorona" enacts this pathos of the struggle women face as mothers who parent without support. The resulting piece is a haunting combination of ballet and contemporary dance with only two dancers—La Llorona and her daughter. The two dance in duet and solo, representing the struggle of a grieving mother holding on to the daughter whose life she has sacrificed out of love; the daughter's spirit cannot rest until the mother releases her. In Guajardo's brilliant casting of the dancers, the mother is a tall, powerful dancer, the daughter small and fragile, dancing mostly en pointe. Unexpectedly, the dance begins with the mother carrying the daughter after her death, and at the end of the dance, the daughter is finally set free and melts to the floor as the mother drapes herself over her, protecting her daughter even in death. The original music is a haunting score, with adapted elements from the folk song "La Llorona" and violin strings and atonic sounds that remind the audience of the hereafter.

Guajardo's "La Llorona" is not one thing. It is not Mexican, although it is based on a Mexican folk leyenda, nor is the choreography beholden to one dance style but rather to a combination of several. The music is grounded in elements from the original Mexican folk song but is converted into an emotionally responsive soundtrack reframing the conflict between the mother and daughter as they struggle with their mutual grief. Finally, the choreography itself destroys the gendered boundaries of dance movement. As described by Tyx (2017):

> The fusion of both musical and dance styles is on full display in "La Llorona," the eerie story of a woman who haunts the forest at night after the loss of her children and her subsequent suicide. In Ballet Nepantla's version, the Oaxacan melody is played starkly by a jazz-influenced bass and violin duet. Meanwhile, the grieving mother upends gender roles associated with both ballet and *folklórico* as she performs the kinds of athletic lifts more typically delegated to male dancers—as if she were trying to pull her ghost daughter back to the earth through the sheer force of maternal will.

Gloria Anzaldúa would no doubt applaud this creation of a third space by Andrea Guajardo, one of her intellectual/artist daughters who was born and raised in the valley that Gloria loved and whose source of inspiration for dance derives from Anzaldúa's life's work.

Principles of Chicana Feminist Art Production

> The door opens to us, just by spending time looking at the images, the symbols. And we begin to understand. These paintings and installations are a conceptual language, a suggestion of how to find our way back to home.
>
> —Celia Herrera Rodríguez

At the beginning of this chapter, I articulated three principles of Chicana feminist art production: (1) art production is intimately tied to Chicana/mexicana culture; (2) art production is aimed at creating new modes of expressions that incorporate history, folklore, and academic production; and (3) the objective in artistic production is to raise consciousness around issues of sexuality, gender, class, ethnicity, and race. Ultimately, art production has at its core the achievement of social justice for all.

The first principle of Chicana feminist art production is its connection to Chicana/mexicana culture. Indeed, all four case studies presented in this chapter adhere to this principle. However, the engagement with Mexican/Chicana culture is not without critique and reevaluation. Art production becomes an effective intervention to disrupt old ideas and regressive elements within Chicano/a and mexicano/a culture, and to provide new visions that do not succumb to mainstream white assimilation as the only means to address gender and sexuality issues in Chicana/mexicano communities.

Chicana feminisms make conscious that which is taken for granted because it has become naturalized through cultural practice. The "taken for granted" silences of Chicanas as well as other women are essential to maintaining invisibility. By making dialogue and disruption components of intervention, Chicana feminists invite others to further deconstruct their situations (Arredondo et al. 2003). The resignification of the venerated Virgen de Guadalupe is but one example of Chicana feminist disruption. It is noteworthy that this disruption took place early in the Chicano movement, almost forty-five years ago, before there was a well-articulated discourse to protect artists Ester Hernández and Yolanda López from the inevitable attacks by Chicanos and Chicanas in their own communities. These are fierce artists who continue to hold radical views of gender and sexuality within the framework of Chicana/o culture.

The second principle of Chicana feminist art production is to create new modes of expressions that incorporate history, folklore, and academic

production. Chicana feminisms are deeply committed to la mezcla (the mixture) of genres. Academics are also performers, artists are also academics, and performers use folklore and feminist writings to produce art (as in the case of songwriter Martha González). The confluence of different genres and methods is strategic and deliberate to fully capture the experiences of Chicana feminists, as well as the experiences of those of their constituencies. As proposed by Anzaldúa, the third space created between social systems is the experimental ground on which to rehearse a new version of freedom; it is a space where individuals can give up fears, give up shame, give up policing of societal boundaries, give up sanctions, and give up being repressed.

A third space gives individuals the freedom to create something that no one, not even the creators, knew existed. For example, Ballet Nepantla's goal is to create dance that fuses Mexican folkloric dancing and contemporary forms of dance, including ballet, modern, West African, tap, among others. The third space is created not only by the fusion of these different dance traditions but also by the personal and professional backgrounds of the dancers, by the variety of musicians, and by the very process of creation where members' subjectivities and input are allowed in the creation of new dance pieces. Anthony Bocconi is one of the members of Nepantla Ballet. He is trained as a modern dancer at Alvin Ailey, grew up in Brooklyn, and had never danced folklorico before joining Ballet Nepantla. Now he is one of the principle dancers in the company. During a class presentation of Ballet Nepantla in my Chicana/o Studies introductory course, Bocconi articulated an aspect of art creation in a third space:

> We're still historians in the sense that we're trying to preserve some sort of storyline in history, but at the same time . . . we all have this calling in life to be an artist. An artist isn't in the present day, sitting in the past. We still have to create and create new ideas and evolve things to connect with other people around the world . . . So, we're still finding those new ways of creating things that are tangible to each other in order to get it out to the bigger public. At the same time, I'm preserving stuff, we're still artists trying to create something new at the same time. [For example] I'll take an idea of something I was trained in, hearing a story that Andrea [Guajardo] proposes, "Oh, I want to use this folktale story" ["La Llorona"]. Well, I'm like, "I have an idea." I'll talk to Martín [Rodríguez] as well and we'll add a hard shoe—hard shoe movement with contemporary ballet. If this was an

average folklórico company, you're not going to have these layers of ideas bouncing off each other; cultivating a new genre underneath it all. At the same time as preserving the history, more so, if not, we are still artists trying to create a voice for ourselves in things that we believe are necessary for you to hear and understand. So that's pretty much why I wake up and do this every day.

Anthony Bocconi articulates this third space of creation where ideas emerge, others react to them from their own training and life experience, the ideas get recombined, tried out, refined, and reconsidered. The outcome is the magic of art.

New modes of art production also involve new modes of relating to each other—honoring everyone's subjectivities and avoiding the creation of hierarchies, whether they are based on knowledge, skill, experience, age, sexualities, ethnicities, class backgrounds, or other axes of difference. Yet there is recognition of difference, because to homogenize individuals is to deny their humanity and self-valuation when the "difference" matters to them. It is in honoring the differences that hierarchies are avoided. The creative process within Ballet Nepantla implements the Anzaldúan ideal of recognition/valuation/equality.

In addition to raising consciousness around issues of sexuality, gender, class, ethnicity, and race, Chicana feminist art production ultimately has at its core the achievement of social justice for all. This is the third principle guiding Chicana artists, and that principle is certainly present in all four of the case studies covered in this chapter. The artistic products created by the artists highlighted are meant to reconstruct commonly held oppressive notions about Chicanas/os, and the artists themselves are in solidarity with others of all backgrounds in fighting oppressions based on a multiplicity of vectors. In addition to the creation of art being "their lucha" (struggle), the artists in all four case studies use their art to help others: donating artwork to raise scholarship funds for Latinas, as Ester Hernández and Yolanda López do; going to juvenile detention centers to engage youth in song-writing to reconfigure themselves, as Martha González and Quetzal do; performing in community centers like Lady Mariposa does; and teaching folklorico dancing to elementary school children, as the Ballet Nepantla troupe members do. There is a circular method at work as they use the community for inspiration, transform that inspiration through the alchemy of

their training and talent into art, and return to their communities to invite others to join them in their journeys as artists.

The Circle of Knowledge Production: Multiple Sitios to Communicate in Multiple Lenguas

I want to know that there's generations coming after and I want them to know that there's a history. It's important for them to make community, to dialogue, to challenge each other intellectually and as a community.

—Elba Sanchez

The trajectory of Chicana feminist production is circular. Many of the writers, artists, and performers began their lives in poor, working class communities situated in barrios, labor camps, and migrant trails. The end product of their work does not stop with artistic and intellectual production. Instead they seek to have the fruits of their labor fed back to their communities so that their communities can also benefit from their successes. When such interventions take hold, their communities can continue to thrive and create fertile ground, from which Chicana feminisms derive their rootedness and continue to flourish. For Chicana feminisms, this circular relationship is activated through community organizing, knowledge dispersal, consciousness raising, and political mobilization. Indeed, as discussed in chapter 2, this process is inherent in the Chicana feminist method.

Consider the controversy surrounding López's resignification of the La Virgen, which caused an uproar in various communities. The controversy could have remained restricted to certain privileged quarters; for example, only people who had access to print and internet media. Given the "silo" aspect of art and academic production, López and her group could have dismissed the controversy and moved on. Instead, the controversy circled back to the Chicana community at large and Chicana feminists took up the cause and defended López's work. In response to the attacks on López, Chicana feminist Patrisia Gonzales wrote a syndicated column in which she interviews Raquel Salinas, the model who posed for the image. Raquel's participation was also a feminist intervention, intended to help her heal from a rape attack at the age of eighteen, after which many close to her "made her feel shame and told her it was God's punishment. Guilt-ridden, she was made to believe it was she who precipitated her own rape." The lack of support from family and friends was one of the factors that led

Salinas to alcohol abuse and "caused her to cover herself up—to hide her body, her curves... her femininity." According to Gonzales and Rodríguez, Raquel Salinas "led a double life. Fiercely proud of her heritage, she became politically active at a young age. She witnessed the raw brutality of police officers against protestors at the East L.A. Chicano Moratorium in 1970. 'When I saw that brutality, I committed my life toward fighting injustice.' Yet, through all the political movements she participated in, she was always silent about her rape" (quoted in Hurtado 2003, 290).

Salinas began her healing process when a woman friend told her: "It wasn't your fault. You didn't ask to be raped." Salinas took up modeling for art classes at the University of California, Los Angeles, to discard her "guilt around her body." The image created by López was a culmination of sorts for Salinas who after the turmoil caused by the controversy came to adhere to an "indigenous spirituality that views Our Lady of Guadalupe as Tonantzin—her common name in Náhuatl—meaning 'Our Most Venerable Mother'" (quoted in Hurtado 2003, 290).

There was yet another layer of feminist intervention to Patrisia Gonzales's column. Only a month before she covered the López and Salinas controversy, Gonzales had written a moving account about her own traumatic rape at the age of twenty-five. Roberto Rodríguez, her then husband and co-author, wrote a reaction to Patrisia's account, explaining his feelings about the violation of his wife and witnessing her continuing pain. He connected Patrisia's pain to his own experience of being brutally beaten by the Los Angeles police, over which he sued and won a substantial economic settlement. Rodríguez readily admitted that the violation Patrisia suffered was greater than his trauma; still, he periodically experienced post-traumatic syndrome as a result of the police beating.

Artist Alma López, writer Patrisia Gonzales, and model Raquel Salinas (with sympathetic partners) critically embraced Chicana/mexicano culture, engaging different constituencies to recognize regressive elements in Chicana/o communities and, through mutual struggle, created a circle of dialogue. Visual art, creative writing, personal and critical essays, and interviews are all geared toward the goal of raising the level of understanding among Chicana/o communities. Patrisia Gonzales noted with pride that she wrote about the "'Our Lady' controversy and the tale of Salinas, who posed for the image to heal herself as a rape survivor. One reader responded that her 83-year-old grandmother, given the context, found a new meaning in the art: 'Now I understand. The artwork should stay in the museum'"

(quoted in Hurtado 2003b, 291). In the case of the López controversy, Roberto Rodríguez's engagement with Patrisia Gonzales' commentary created ever-widening ripples of analysis that culminated in the concientización of a devout Catholic, eighty-three-year old abuelita who eventually understood why López's representation of La Virgen is not blasphemous. The ongoing process of deconstruction of hierarchies is propelled by the ultimate goals of developing awareness and creating a just society.

Thus the circular nature of knowledge and art production—using the Chicana/o community for inspiration and motivation, the products of which fertilize the vitality of the community, which in turn enriches the artists and writers—is normative in this field of study. The circular generation of knowledge is also an integral part of the three principles of Chicana feminist art production, as discussed earlier in this chapter. Community involvement is not only paradigmatic of the four case studies presented here, but normative in the creation process of most Chicana feminist artists. For example, Professor Judith Baca, a successful painter, muralist, and Professor of Chicana and Chicano Studies at UCLA, recruits young people (some of whom were former gang members) from East Los Angeles to help paint her murals, thereby building linkages between the themes of her creative production and the participation of the subjects of those themes (Neumaier 1990, 261). Similarly, creative writers like Sandra Cisneros, Elba Sánchez, and Gloria Anzaldúa (before her passing) have worked with high school students in predominantly Chicano communities and shared the creative production among the communities they write about. Regardless of the class origins of Chicana feminists and their current class attainment, there is a strong loyalty to working class issues and to Chicana/o communities.

Notably, knowledge and art production are circular within the Chicana feminisms paradigm and academic community as well. For example, the portrayal of La Virgen by Alma López was based on Sandra Cisneros's short story in which she wonders what La Virgen wears under her robes. Cisneros concludes that it must be a bikini made of roses. Cisneros's essay appeared in *Goddess of the Americas/La Diosa de las Américas: Writings on the Virgin of Guadalupe*, edited by Ana Castillo (1997), who in turn was influenced by the community practices around La Lupita, as La Virgen is lovingly referred to by community members. The controversy provoked by Alma López's digital art inspired Patrisia Gonzales and her partner to write syndicated columns that I then read as I was writing my book *Voicing Chicana Feminisms*. This in turn inspired me to propose this circular model

of community enlightenment, which thousands of undergraduates have read since its publication in 2003. The controversy over La Virgen, with all its antecedents, has helped educate the community. And most recently, Alma López de Alba and her spouse, Alicia Gaspar de Alba (Professor of Chicana and Chicano Studies at the University of California, Los Angeles) edited a book of essays analyzing the controversy over López de Alba's portrayal of La Virgen. This circle of knowledge production is now complete, but there are many others in the making.

Discussion Exercise

Resignifying Lotería

As illustrated in "Case Study I: Visual Arts, La Virgen as Symbol for Political and Social Change," resignifying cultural and religious symbols that are part of mexicano/Chicana communities is one of the methods used by Chicana feminist artists to create consciousness and help community members rethink cultural values. Professor Dolores Inés Casillas in the Department of Chicana and Chicano Studies at the University of California, Santa Barbara, uses this method in her introductory Chicana Studies class, which focuses on popular culture. In one class assignment, Professor Casillas uses the Mexican game of lotería, which is also played in the United States and often referred to as "Mexican bingo." Instead of numbers, as in bingo, lotería uses a deck of cards with fifty-four labeled images (figure 16). Each player has at least one tabla (board), with a four-by-four grid containing sixteen of the fifty-four images. Each tabla presents a different selection of images. The

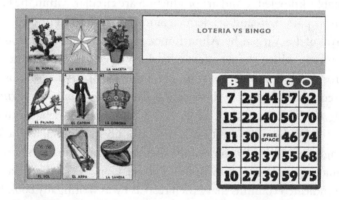

Figure 16. Lotería and bingo cards. Courtesy of Aída Hurtado.

caller shuffles the cards and calls out each image by name, and the players mark off the called image (if they have it on their board) with a chip (many Mexicans traditionally use small rocks or pinto beans as markers). The first player with four chips in a row (horizontal, vertical, diagonal, or square pattern) shouts "¡Lotería!" (Lottery!) or "¡Buenas!" (Good!), indicating they have won.[5]

For the class assignment, Professor Casillas asks her students to pick a lotería card and modify it to express some aspect of their social identities. Professor Casillas asked me to give a guest lecture in her class on social identity theory to prepare the students for the lotería exercise. As part of my lecture, I included Professor Casillas's class assignment to illustrate the main concepts of social identity theory integrated with the principles of Chicana feminisms art production. Here are the results.

Social Identity Theory and Chicana Feminist Art Production

The social identities that are of psychological significance and have political and economic consequences in most societies are race, class, gender, ethnicity, and physical ableness. These social identities are considered master statuses by sociologists, because power, wealth, privilege, and subordination are all allocated according to these social identities. Figure 17 illustrates these master statuses through the images found in lotería. Each of these social identities carry certain expectations of how individuals should behave and are often used to assign individuals to the social categories based on the master statuses.

Social identities are not biologically determined but rather socially constructed and are used to stigmatize and limit individual expression according to sexuality, race, class, ethnicity, gender, and physical ableness. Take la lotería card La Dama: the image on the card portrays the social expectations that "a lady" is supposed to exhibit, wearing a conservative blue suit and heels and appearing proper, demure, obedient, docile, heterosexual, and light skinned; she is a potential mother or sister (figure 18). Social identities also limit the amount of mobility between social categories. Once an individual is categorized as La Dama, there are certain social expectations that individuals find difficult to violate, and if they do, there are real consequences to the violation. For example, if El Catrin (Dandy) wants to be La Dama, it is highly unlikely that society is going to allow that social identity migration or that El Catrin will not suffer social psychological anguish over the transition. Similarly, if El Negrito (The Black Man) wants to be

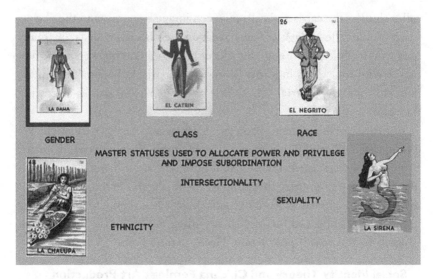

Figure 17. Lotería cards and master statuses. Courtesy of Aída Hurtado.

La Sirena (The Mermaid), sanctions will also be applied to that individual. Social identities as determined by master statuses are very restricted and bounded. Chicana feminist artists have used la lotería to open up possibilities for these restricted identity spaces.

Because social identities are *socially constructed* and used to limit and stigmatize individuals, social identities can be *socially deconstructed* and used to empower, inspire, and provide alternatives to stigma. Professor Casillas invites students to participate in the deconstruction and resignification of their social identities using la lotería. Her assignment directs students to do one of two things: (1) *resignify an existing lotería card* to sabotage, change, broaden, or question the existing lotería card; or (2) *make a new lotería card* that reflects the students' views of their social identities. In effect, Professor Casillas is inviting students to engage in the technique used by Chicana artists to resignify lotería cards—from making the lotería cards into characters from films like *Star Wars* to queering the lotería cards to express different sexualities. Artist Alma López Gaspar de Alba produced an art series called *Lupe and Sirena*, and one of the iconic images in this series is titled *Lupe and Sirena in Love*, which queers both La Virgen de Guadalupe and La Sirena as a lesbian couple (figure 19).

A goal of Chicana feminisms is for everyone to have the freedom to be who they are as individuals, independent of their social identities. To that

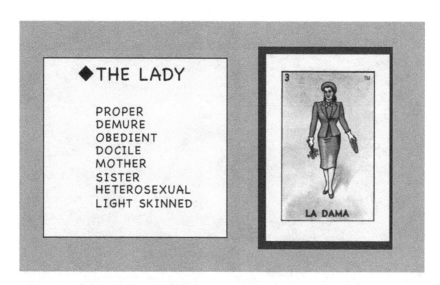

◆THE LADY

PROPER
DEMURE
OBEDIENT
DOCILE
MOTHER
SISTER
HETEROSEXUAL
LIGHT SKINNED

LA DAMA

Figure 18. La Dama: Gender social identity. Courtesy of Aída Hurtado.

end, artists have used la lotería as a technology of deconstruction by using visual and conceptual techniques. One visual technique is to expand the image from a stereotypical, restricted representation to one that is more inclusive of other categories of individuals that can be assigned a particular social identity. As demonstrated in figure 20, the hegemonically constructed La Sirena, with westernized facial features, light skin, a slim waist, a flat stomach, and perky breasts, is resignified as La Sirena, a large female with brown skin, a wide waist, overflowing breasts, and Indigenous facial features.

Another resignification technique is to take the actions or behaviors associated with one social identity and assign them to the opposite gender, race, ethnicity, or sexuality. Because the resignified behavior violates a social identity expectation, the same act becomes a radical gender statement. Take La Dama, with its gendered and conservative views of "a lady"; the image can be modified to represent a more radical and broader view of women. Figure 21 is two resignifications of La Dama. One depicts La Dama as Princess Leia from the film series *Star Wars*, a superhero who demonstrates strength and agency (and notably does not expose her body). She stands on both feet, does not wear high heels, and has her hair pulled back ready for battle. The second resignification uses the lotería card El Borracho (The Drunkard, a stereotypical depiction of Mexican masculinity), and turns it

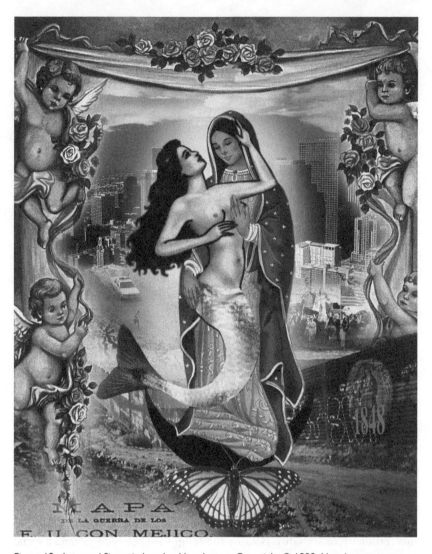

Figure 19. *Lupe and Sirena in Love* by Alma Lopez. Copyright © 1999 Alma Lopez.

on its head—La Dama becomes La Borracha, a transgressive image (created by artist Linda Minivas). Here is the beauty and power of art: the flipped visuals flip the meaning because of social expectations. La Dama can be reconceived as a superhero in *Star Wars* or as La Borracha, neither figure bowing to social pressures. These personas are considered transgressive because La Dama is expected to be a "proper" woman, and the reconstruction of her image and behavior becomes a means by which to rethink gender.

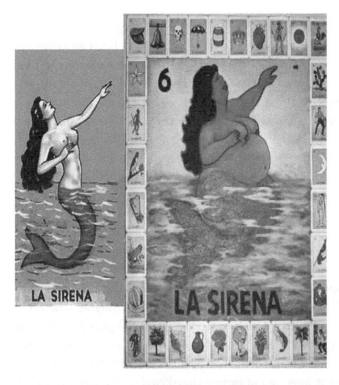

Figure 20. Resignifi-
cation of the lotería
card La Sirena.

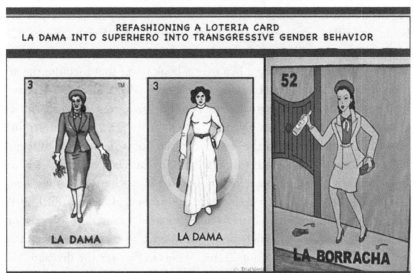

Figure 21. Resignification of the lotería card La Dama—Princess Leia and La Borracha.
Courtesy of Linda Minivas.

Constructing la Escritora Lotería Card

For my guest lecture, I created a lotería card that exhibited an important identity for me, being a woman who writes. I attempted to subvert the usual understanding of gender—for a woman to become a writer is a transgressive act. The lotería card can be made by using a variety of art techniques—drawing, cutting and pasting from various sources, composing an image in Photoshop or another art program. The purpose is to construct an art project. Once finished, students write a two-page paper to explain and analyze the artistic and conceptual choices made in resignifying the lotería card.

My transgressive lotería card focused on a hand engaged in the act of writing. I began by searching the internet for "hand writing." The most famous and artistic rendition found from this search was the 1948 lithograph of hands rendered by the renowned artist M. C. Escher; the hands are actually drawing rather than writing (Escher 2018). My initial idea was to take the image and place my book covers in the background and state, "I am a writer." Upon closer inspection of the Escher lithograph, however, I said to myself, "Those are male hands!" I searched again for a "female writing hand" and found none. I decided to make my internet search part of my lotería card. I discarded the lithograph of drawing hands, which are not only masculine looking but form a closed circle—the artist only feeding his own art. I photographed my hand holding a pen over one of my books and titled my lotería card "La Escritora—The Writer" (figure 22). My lotería card highlights a female brown hand (the nail polish is a strong signifier of gender) holding a pen over a book cover that includes the art piece titled *La Linea* (The Line) by Alma López (1998). *La Linea* depicts a map of the U.S.-Mexico border with a red line dividing the two countries and a little girl precariously balancing on one foot over the red line, trying not to fall on either side of the border. My pen hovering over the little girl indicates that I write not only for myself but for the next generation. I write in an accessible manner because I'm invested in teachers, social workers, and other people working with youth to use my work. I want the little girl's teachers to have as many materials to educate her so she does not exist on "a thin line" without the safety net of knowledge to save her from a fall. I want the little girl to grow intellectual wings to fly over the divisions she gingerly tries to balance growing up mestiza, living between two countries, two social and economic systems, two languages, two cultures. My writing is a contribution to her intellectual freedom.

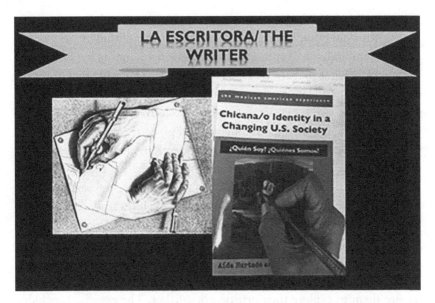

Figure 22. La Escritora / The Writer: Lotería card designed by Aída Hurtado, 2016.

In my lotería card I left my name visible, which felt like an arrogant decision. But as Elba Sánchez (2003) has said (as quoted in chapter 2), we are taught as women to hide what we do—to not have a voice because "asi eres mas linda" (you are prettier [i.e., more acceptable] that way). I was surprised at how difficult it was *not* to hide my name when constructing my lotería card—to display my name was to display myself and claim an intellectual space that is still not readily available to women. Through the process of serendipity and with no planning on my part, I had placed the book I photographed over my desk calendar, which showed every minute of the day scheduled for months on end. Women live by schedules, especially mothers, grandmothers, and aunts, as children in the family (and oftentimes beyond) are the responsibility of the womenfolk. A biological connection to children is not necessary for women to take responsibility for them. Above the book in the photo are the calendar's days of the week: Thursday, Friday, Saturday, and so on. Contrary to many women's schedules, I am writing most of these days—the fact that my calendar is in an office and that I wrote a book, as exhibited by the cover, implies this. I'm not cooking, I'm not washing dishes, I'm not doing laundry. I am writing. My calendar and its penciled-in appointments are about writing, not about meeting the needs of others or serving patriarchy—a very radical statement

for a woman who is also a Chicana. The hand captured in the act of writing also indicates an internally initiated process of accomplishment, individual achievement, individual authorship, an individual claiming her purpose in the world—claims that are very different from La Dama but that nonetheless circle around to serving the community by producing knowledge *for the community*. An individual act converted to collective success.

Artists have modified lotería images and given them to their communities to encourage them to rethink social identities and to create a critical consciousness of whether their communities are falling prey to the very narrow definitions implied in these social identities—the same mission as Chicano/a studies in general. This exercise explores students' different abilities—drawing, spatial arrangement, color choices, artistic orientations, views of self, and views of others. Many students have never attempted an art project, and this exercise introduces them to new skills and potentially to the discovery of previously unacknowledged creative abilities, which may inspire them to explore their artistic side further. The exercise concludes with the students writing a two-page paper analyzing their art project, similar to the analysis I have given above.

The process of creating the art project in itself heightens awareness of the impact of social identities—it did so for me, as I became aware of my discomfort at claiming my own work. By writing the analysis of your lotería card, the exercise further cements the identity layers of "our woman continent" and how the plates of meaning can be reassembled through the process of creation and analysis.

Further Reading

Gaspar de Alba, Alicia, and Alma López, eds. *Our Lady of Controversy: Alma López's Irreverent Apparition*. Austin: University of Texas Press, 2011.

González, Jennifer. *Subject to Display: Reframing Race in Contemporary Installation Art*. Cambridge: MIT Press, 2011.

Nájera-Ramírez, Olga, Norma E. Cantú, and Brenda M. Romero, eds. *Dancing Across Borders: Danzas y Bailes Mexicanos*. Champaign: University of Illinois Press, 2009.

"Por La Raza Habla Mi Espíritu" / Through My People Speaks My Spirit

Intersectional Chicana Feminisms and the Women's March on Washington

Introduction

In early January 2017, I received an email invitation from my former undergraduate student Carmen Pérez to participate in the Women's March to be held on January 21, 2017, in Washington, D.C. (box 9, figure 23). At the time I received this invitation to speak, nobody knew the gathering would turn out to be of historic proportions. Close to a million gathered in Washington, D.C., not far from the site where the forty-fifth president of the United States had been inaugurated the day before. In fact, the presidential inauguration stage and some of the seating were still in place as thousands of women and others marched past the inauguration grounds, attempting to reach the Women's March main stage. Nationally, the Women's March on Washington was likely the largest single-day demonstration in recorded U.S. history, with an estimated 4,157,894 in attendance (Chenoweth and Pressman 2017). To put this number into perspective, there are only 2,000,000 people serving in the combined armed forces of the U.S. military, including the air force, army, navy, marine corps, reserves, national guard, and coast guard (Chenoweth and Pressman 2017, 1). There were 653 reported women marches in the United States that day, with gatherings of well over 100,000 marchers in Los Angeles, Oakland, San Francisco, New York, Chicago, Denver, Seattle, and Boston. Women worldwide also marched in solidarity with the Women's March on Washington, making it a transnational movement. All told, it is estimated that there were at least 261 marches abroad, with attendance totaling between 266,532 and 357,071 people (the best guess is 307,275 people) in such "international locales ranging from Antarctica to Zimbabwe" (Chenoweth and Pressman 2017, 1). In this massive, unprecedented mobilization, there was not one single arrest.

Box 9. Biography of Carmen Pérez

Carmen Pérez is a recognized expert in juvenile and criminal justice reform and an activist for women's rights, violence prevention, mass incarceration reform, racial healing, and community policing. She was born in 1977 in Oxnard, California, the youngest of five siblings. She started her college studies at Oxnard College and transferred to the University of California, Santa Cruz (UCSC), where she obtained her bachelor's in psychology. As an undergraduate, Carmen studied Chicana feminisms and learned the importance of intersectionality under the mentorship of psychology professor and Chicana feminist Dr. Aída Hurtado.

Carmen's dedication to restorative justice, especially for youth, began with the untimely death of her older sister Patricia in 1994, just before Carmen's seventeenth birthday. She also had a brother who was in and out of the criminal justice system. In 2002 she started working for Barrios Unidos in Santa Cruz, an organization providing nonviolence training and reentry services for the formerly incarcerated. During this time, Carmen also co-founded the Girls Task Force group to provide gender-responsive programming for women in Santa Cruz County. In 2005 she was invited to serve as a youth representative for the Gathering for Justice, an organization working to end child incarceration and eliminate racial inequities in the criminal justice system. Carmen moved to New York City in 2008 to work as the national organizer for the Gathering for Justice. In 2013 Carmen co-founded the Justice League NYC, which is the criminal justice reform taskforce for the Gathering for Justice organization.

Carmen served as the national co-chair for the 2017 Women's March on Washington. As one of the main organizers, she facilitated the creation of the unity principles of the movement. The principles guide the multipronged and intersectional fight for women's rights. She organized the artists' table and the honorary co-chair selection, and recruited more than five hundred partners for the Women's March. In 2017 Carmen was honored for her activism by being named one of *Fortune*'s "Top 50 World Leaders" and *Time* magazine's "Most Influential People."

Carmen serves as the executive director for the Gathering for Justice and most recently has founded the California-based taskforce Justice League California. She coorganized the "Growing Up Locked Up" conferences on juvenile justice and led the 250-mile March2Justice protest against police brutality and racial profiling. Under former president Barack Obama, Carmen was invited to testify before the President's Task Force on 21st Century Policing and to speak at the Justice or Else! rally to celebrate the twentieth anniversary of the Million Man March. Carmen continues to advocate for criminal justice reform and system accountability.

Figure 23. Photo of Carmen Pérez, Women's March on Washington, January 21, 2017. Photo courtesy of Aída Hurtado.

To say this was a historic event for women in the United States and in the world is an understatement.

When Carmen Pérez, my former student, invited me to speak at the gathering in Washington, I was at first incredulous, given the importance of the march and the number of distinguished speakers, including many celebrities, on the program. However, upon further inquiry, Carmen insisted that I should speak because my class on Chicana feminisms, which she had taken as an undergraduate in 2001, was one of the major influences in adding an intersectional perspective in every aspect of the march, from speakers selected and organizers included, to allies identified and brought onboard. I humbly accepted the invitation and flew from L.A. to D.C. on January 20, 2017.

In this concluding chapter, I illustrate the claim that Chicana feminisms is a "living theory" (Trujillo 1998). Unlike much of hegemonic feminist

theory, where the purpose is to increase dialogue among those residing in the academy, Chicana feminisms derive its value and purpose by affecting social justice issues directly. One of the concepts and evolving theories that has had a tremendous impact on social mobilizations is intersectionality. There are many versions of intersectionality, with different intellectual, historical, and disciplinary genealogies (Collins and Bilge 2016; Crenshaw 1989; Hurtado 2019; Romero 2017). In this chapter I discuss the version of intersectionality that I have developed by combining theories in social psychology, social identity, and Chicana feminisms, with an emphasis on the writings of Gloria Anzaldúa (Hurtado 2018; 2019). It is in this capirotada (or mixture, literally a dessert with multiple ingredients) of influences that we can further understand the importance of the women's marches that took place in Washington in 2017 and in Las Vegas one year later.

I begin by outlining the components of intersectionality, including a brief history. This summary is followed by an extensive analysis of how intersectionality was manifested in both of the women's marches, which I support by providing transcripts of select speakers. The marches were extremely successful because of the mindful inclusiveness practiced by the organizers and everyone associated with the marches. Their emphasis on inclusiveness affected the political discourses manifested in the speeches and subsequent political mobilizations. As Chicana feminisms advocate, a "living theory" means that the theory is never fully settled—that, like the border, there are elements that are always changing, remixing, and developing. In this nonlinear, somewhat chaotic movement of peoples, beliefs, cultures, and languages, Chicana feminisms finds its inspiration to always fight for what is right and just.

What Is Intersectionality?

In the 1960s there was recognition that gender had multiple axes of difference, with significant consequences for social justice issues. In the 1980s, law professor and African American scholar Kimberlé Crenshaw named the process *intersectionality*. Intersectionality is a term used to describe intersections between the social identities of an individual based on master statuses and the modes of their oppressions (Hurtado 2019). However, the same intersections that are used to oppress—say, being a woman, poor, black, lesbian—may also result in an individual's awareness of the socially constructed nature of master statuses. Gloria Anzaldúa's borderlands theory proposes that a mestiza consciousness facilitates an individual's recognition of stigma as

socially constructed and therefore arbitrary. *Intersectional identities* produced by different potential combinations of master statuses are helpful in multiple arenas—legal, economic, artistic, and political (Hurtado 2018).

Since the 1980s, the concept of intersectionality has been invoked in many areas of public life. The theory originated in the legal arena and has had widespread implementation in other sectors, including public art and political mobilization. Intersectionality has been popularized and used by many different constituencies in the United States and has had particular resonance with young people who are politically engaged. For example, in 2017, a local newspaper in the small college town of Santa Cruz, California, reported on the painting of a set of murals at a local community center. The murals were designed with the help of local youth, one of who (Andrea Flores-Morgado) presented the ideas for the mural to the Santa Cruz Arts Commission. The central concept of the murals was intersectionality, and the work was titled *Unify, Decolonize, Thrive* (York 2017). The newspaper article stated, "the murals will delve heavily into a term known as 'intersectionality,' coined by law professor Kimberlé Crenshaw, as a way to reveal limitations of single-issue anti-discrimination laws" (York 2017, 2). Jamie Joy, youth program coordinator for the county's Diversity Center, elaborated on the project's implementation of the concept of intersectionality:

> The kids that I work with, they hold multiple identities; they're not just thinking about the fact that they're gay or trans or gender non-conforming. They're thinking about their families' citizenship status and they're also thinking about their class status and their mental health and they're thinking about other issues that affect them also. . . . The way that I understand intersectionality is just being aware of multiple identities and how they impact someone's privilege or lack of privilege in the world. I think the kids that we work with understand that on a deeper level than I did when I was 14 or 15 years old. (York 2017, 4)

In this chapter, I address the contributions Chicana feminisms have made to the theory of intersectionality and its popular use and effectiveness in political organizing.

Brief Historical Overview of Intersectionality

Since the 1960s, many activists and legal scholars have grappled with the complexities of gender and other axes of difference, but could not fully

articulate from a legal standpoint why women's experiences in the workplace or in the home did not fit within existing legal doctrine. There were no legal frameworks in place that accommodated the contingent categorizations of disadvantage based on race and gender that operated simultaneously in structural systems of oppression. Forty-two years later, the Diversity Center coordinator Jamie Joy and student collaborators like Andrea Flores-Morgado could refer to the legal doctrine of intersectionality, which was published by Crenshaw (1989) in the article "Demarginalizing the Intersection of Race and Sex: A Black Feminist Critique of Antidiscrimination Doctrine, Feminist Theory and Antiracist Politics." As Crenshaw's writings elucidate, the consideration of gender and race, and how these categories intersect, is critical in understanding how women in the United States and around the world are subjected to multiple sources of oppression. Crenshaw's intervention was part of the growing chorus in feminist scholarship and feminist organizing asserting that the feminisms developed by such influential figures as Betty Friedan and Gloria Steinem could not be applied without modification to all groups of women. For example, women in Africa suffer from starvation as well as rape and other gender-specific horrors and oppressions resulting from political upheavals, historical circumstances, and economic and cultural oppression (White 2008).

Crenshaw's pioneering work on intersectionality exposed the inadequacies of the legal system in handling multiple sources of discrimination experienced by African American women. Crenshaw (1989) demonstrated that in the case of employment discrimination, African American women were forced to bring legal suits either as women or as Blacks, but not as Black women. The courts would not accommodate Black women's claims, fearing that the expansion of another protected category would open the possibility of endless discriminatory subgroups: "The legislative history surrounding Title VII does not indicate that the goal of the statute was to create a new classification of "black women" who would have greater standing than, for example, a black male. The prospect of the creation of new classes of protected minorities, governed only by the mathematical principles of permutation and combination, clearly raises the prospect of opening the hackneyed Pandora's box" (142).

In addition to employment discrimination, Crenshaw applied intersectionality to the legal analysis of rape. The law's archaic assumptions of white women's chastity[1] led to more punitive punishment for interracial rape when committed by Black men. In addition, the rape of Black women

was less often prosecuted than that of white women when it was committed by men of any race. Similarly, in domestic violence cases, excessive punishment was handed down by the criminal justice system to Black men. The system's treatment of Black men led to the perhaps not-so-unintended consequence of Black women underreporting physical abuse by the men in their lives. Crenshaw (1995) also outlined the consequences of intersectionality for political behavior. Black women were pressed to join political movements aimed at ending racism or to join feminist movements aimed at ending sexism—they did not feel free to join both. Crenshaw did not explicitly examine other social categories that oppress women, such as class and sexuality, but the application of intersectionality to race and gender became central to examining multiple sources of oppression within feminist analysis.

While Crenshaw focused on the previously unexplored legal injuries of intersectional subordination, sociologist Patricia Hill Collins focused on the nonlegal, societal structures that produce similar outcomes. According to Collins (2000), "intersectionality is an analysis claiming that systems of race, social class, gender, sexuality, ethnicity, nation, and age form mutually constructing features of social organization, which shape Black women's experiences and, in turn, are shaped by Black women" (299). Collins posits that societal structures are formed and sustained to exert power over people of Color in general and African Americans in particular. From Collins' perspective, intersectionality "emerged from the recognition . . . that inequality could not be explained, let alone challenged, via a race-only, or gender-only framework" (82). Furthermore, macro-level systems of oppression are interlocking and affect individuals at different class and race intersections (82).

Cultural critic and Chicana feminist writer Rosa-Linda Fregoso (2003b) applied intersectionality to the categorical differences between women in different nation-states. In particular, Fregoso scrutinizes the tendency of "First World feminists" to apply the human rights paradigm to women globally. Fregoso calls attention to the error of "claiming a singular transnational identity for women" (23), noting the differences among women even within one nation-state. Her call is for "framing women's international human rights within very complex and specific cultural contexts" (23). As her key example, she uses intersectionality as a lens in understanding why young, working-class, dark-skinned Mexican women rather than wealthy, light-skinned Mexican women were the victims of "feminicide" in the border city of Ciudad Juarez (across from El Paso, Texas). Fregoso identifies variations among the Mexican victims based on class and race, which can

give rise to a more penetrating analysis of the murders than one provided by human rights discourse alone.

The writings of African American scholars like Crenshaw and Collins, among others, were foundational in developing the concept of intersectionality. Contemporaneously, Gloria Anzaldúa was developing borderlands theory while other Chicana feminists were developing their own versions of intersectionality as part of their political mobilization in Chicana/o communities and with other communities of Color. These versions of intersectionality were more relevant to Chicanas, integrating such concepts as mestiza consciousness, an intersectional identity that privileges the positive aspects of multiple identities, which ultimately leads to a deeper understanding of oppression and the constructed nature of social reality.

Borderlands Theory

Chicana feminist scholars since the 1980s and 1990s have been at the forefront of the work on intersectionality (Alarcón 1990a, 1990b; Castillo 1995; Hurtado 1996a; Moraga and Anzaldúa 1981). Their work on intersectionality aims to build multiple feminisms that center on culture, class, sexuality, race, ethnicity, and, most recently, racialized masculinities (Hurtado and Sinha 2016). An important theoretical addition to intersectional theory is the work of Gloria Anzaldúa (Anzaldúa 1987; Moraga and Anzaldúa 1981). As embodied in borderlands theory, Anzaldúa theorizes the consequences for individuals who are exposed to contradictory social systems and who develop la facultad (the gift)—that is, the ability to perceive and challenge linear conceptions of social reality. Other writers have called this ability "differential consciousness" (Sandoval 2000), perception of "multiple realities" (Alarcón 1990), "multiple subjectivities" (Hurtado 2005), and a state of "conscientización"[2] (Castillo 1995). This theoretical approach has produced rich and unique analyses in various academic fields, including the social sciences (Hurtado 2003c; Hurtado and Sinha 2016), literature (Saldívar-Hull 2000), history (Pérez 1999), education (Delgado Bernal 1998; Delgado Bernal et al. 2018), and political theory (Barvosa 2008; 2011).

Borderlands theory expanded intersectionality by incorporating social identity theory as embodied in the master statuses of gender, class, sexuality, ethnicity, race, and physical ableness. The fluidity and context-dependent nature of social identities result in "social travel" between structural systems, cultural symbols, and cognitive understandings, ultimately creating a non-normative consciousness of the arbitrary nature of social reality. Following

the logic inherent in borderlands theory, stigmatized social identities based on master statuses are not additive; they do not result in increased oppression with an increased number of stigmatized group memberships. Instead, individuals' group memberships are conceptualized as intersecting in a variety of ways, depending on the social context (Hurtado and Gurin 2004), many of which have the potential for liberation.

Borderlands theory provides the experiential documentation for Tajfel's (1981) social identity theory. Tajfel does not address extensively what it means for individuals, let alone women, to carry the burden of stigma when they have no control over how others categorize them into social groups. Furthermore, he does not explore how individuals cope with the incongruence between their private self-perceptions (say, as competent, intelligent, logical) and others' negative perceptions shaped by stigmatized social identities. Anzaldúa's theory proposes that one possibility among many is to use the contradictions to one's advantage, rising above the negative assignation to develop a complex view of the social self, or what Gurin and colleagues (1980) call a consciousness about one's *intersectional identities* (Hurtado 2018). One potential type of consciousness, according to borderlands theory, is a mestiza consciousness. In many ways, Anzaldúa's work exemplifies the poetics of political resistance and rescues Chicanas (and other Latinas) from potential stigma derived from their derogated social identities.

Borderlands theory is particularly important for social action and coalition building. There are no absolute "sides" in conflict; instead, there are contingent adversaries whose perceptions can be understood by examining (and empathizing with) their subjectivities. Furthermore, no one is exempt from contributing to oppression in limited contexts (Pérez 1999). Self-reflexivity and seeing through the "eyes of others" become more important in gaining a deeper consciousness than staying within one's social milieu. As explained by Anzaldúa (1987):

It is not enough to stand on the opposite riverbank, shouting questions, challenging patriarchal, white conventions. A counterstance locks one into a duel of oppressor and oppressed; locked in mortal combat, like the cop and the criminal, both are reduced to a common denominator of violence. The counterstance refutes the dominant culture's views and beliefs, and, for this, it is proudly defiant . . . but it is not a way of life. At some point, on our way to a new consciousness, we will have to leave the opposite bank, the split between the two mortal combatants somehow healed so that we are

on both shores at once and, at once, see through serpent and eagle eyes. . . .
The possibilities are numerous once we decide to act and not react. (78–79)

Like many feminist theoretical contributions, intersectionality was birthed from the necessity to address inequality based on sex, gender, sexuality, race, class, and ethnicity. Most recently, physical ableness has been added as another possible axis of inequality. Chicana feminisms, like other feminisms, are committed to fighting for equality for all, not eliding difficult issues of representation. The commitment to social justice has pushed all feminist writers and activists to extend the boundaries of the conceptualization of the intersections that contribute to inequality. In 1975 Ruth Bader Ginsburg litigated to persuade the Supreme Court that sex discrimination was not confined to women—that all individuals who did not fit the roles assigned by the gender binary of male/female were affected. She and her colleagues saw the wisdom of defending Stephen Wiesenfeld against his oppression based on his gender nonconforming behavior. The principle applied by Bader Ginsburg in *Weinberger v. Wiesenfeld* was derived from an African American feminist activist from a prior generation, Pauli Murray, who also argued that the gender binary applied when the law denied justice, in this instance to Black women fighting for equality in the workplace.

The labor of these early feminists and many others has come to fruition, as has the concept of intersectionality, as one of many feminist contributions that has entered the everyday experiences of people. Developing from its earliest theoretical formulation, intersectionality can now be applied to political organizing, whether it be on a local scale, as in the community mural mentioned earlier in this chapter, or on an unprecedented global scale, as in the historic Women's March that took place in Washington and worldwide in January 2017.

The Women's March in Washington

Telling our stories, first to ourselves and then to one another and the world, is a revolutionary act. —Janet Mock

I come in peace, but mean business. —Janelle Monáe

A powerful and very visible example of the implementation of the concept of intersectionality occurred during the Women's March in Washington

on January 21, 2017. Carmen Pérez, one of the main organizers for the march, together with the organizing committee and the many individuals involved in planning this historic event, agreed to use intersectionality as a guiding principle for the march's political and social agenda, as well as for selecting the roster of speakers. In an interview (Hurtado 2017), Pérez explains how intersectionality became such a useful concept in structuring the Women's March.

> My expertise has been in criminal justice for the past twenty years. But as women or just as human beings, we are not one-dimensional. We are intersectional human beings. We live in poverty; if we get deported we don't have access to reproductive justice rights; if we are incarcerated we don't have access to quality education. We have to be intentional about being intersectional; about stepping outside our "issue expertise" and finding our liberation bound [up] with others—whether it is climate change, reproductive justice, immigration reform, criminal justice reform, Indigenous rights, these things impact us all. Instead of working in silos we have to coordinate our efforts a little bit better and be more intentional about intersections.

Intersectionality was applied at all levels in the Women's March, including the leadership, issues addressed in the platform, list of speakers, and process followed to organize the march.

The team of organizers of the Women's March embodied the intersectionality they used to frame the event. The entire protest rally was organized in two months and followed a "horizontal approach to leadership" that was committed to a nonhierarchical organizational structure characterized by fluidity and inclusivity (Felsenthal 2017, 2). All told, there were between fourteen and twenty main organizers representing different ethnicities, races, social backgrounds, and expertise in political and social organizing: Ting Cheng,[3] Tabitha St. Bernard,[4] Janaye Ingram,[5] Paola Mendoza,[6] Cassady Fendlay,[7] Linda Sarsour,[8] Bob Bland,[9] Nantasha Williams,[10] Breanne Butler,[11] Ginny Suss,[12] Sarah Sophie Flicker,[13] Tamika Mallory,[14] Carmen Pérez,[15] and Vanessa Wruble[16] (Felsenthal 2017, 2; figure 24). Of this fluctuating group, there were four co-chairs: Bob Bland (box 10), Tamika Mallory (box 11), Linda Sarsour (box 12), and my former undergraduate student Carmen Pérez (figure 23). Each of the organizers brought different expertise and experiences to the vision and organization of the march. However, they all agreed to take an intersectional approach to fully

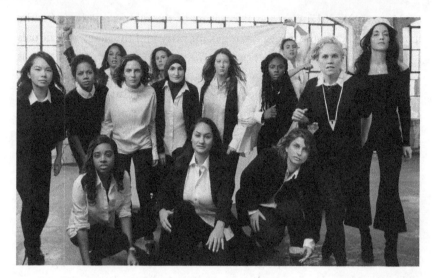

Figure 24. The organizers of the Women's March on Washington, January 21, 2017. Photo courtesy of Cass Bird.

address the multiplicity of political issues affecting the different constituencies and not to define the event by a commitment to women's issues alone. The organizers were committed to unpacking the social signifier "woman" that in past feminist mobilizations had meant "white (mostly middle-class) women" (Harris-Perry 2017).

The idea for the Women's March also emerged in an organic manner as a reaction to the election of "a man who ran the most brazenly misogynistic presidential campaign in recent history, and whose victory has emboldened a Republican-led Congress to wage an epic war on women's rights" (Felsenthal 2017, 2). Rather than conceived from the top down, say from a group of elite leaders or a large organization, the idea for the march was generated from two almost simultaneous posts on Facebook. The first post came from Teresa Shook, a retired lawyer from the state of Hawai'i, on the evening of the presidential election, November 8, 2016. As the election results came in announcing the loss of Hillary Clinton, who was poised to be the first woman president, Shook created a Facebook page proposing that women gather in Washington, D.C., on inauguration weekend to protest the outcome. The following morning, ten thousand people had approved of the plan. At the same time, Bob Bland, a woman and entrepreneur based in New York City, had a similar idea and posted it on Facebook, where she had a considerable number of followers

Box 10. Biography of Bob Bland

Bob Bland is a fashion designer and activist. Born in 1982 to two public school teachers in northern Virginia, her interest in fashion began early. She was able to sew at eight years old and held her first fashion show in her high school cafeteria. After graduating from Thomas Jefferson High School for Science and Technology, she attended the Savannah College of Art and Design and obtained her bachelor of fine arts in fashion/apparel design.

In 2012 Bland founded Manufacture New York (MNY), a social enterprise that seeks to build a new model of design, development, and distribution in the fashion industry. She advocates for onshoring apparel manufacturing and ethical and sustainable supply chains. MNY also provides work space for independent designers and seeks to help grow their brand by offering production resources typically unavailable to all but the largest brands. She has spoken internationally and domestically about MNY as a case study in sustainable fashion, and she has been featured in books and TV interviews.

After the 2016 presidential election, Bland and other women, like Teresa Shook, Evvie Harmon, and Fontaine Pearson, posted on Facebook and called for a march on Washington to protest the election of Donald Trump. Eventually, these post threads were consolidated and resulted in a single event for the Women's March on Washington, set for January 21, 2017—immediately following Trump's inauguration. Bland served as national co-chair for the Women's March on Washington. The Women's March would become the largest single day protest in modern U.S. history, with an estimated 500,000 to 1 million protesters in Washington, D.C., 3.3 to 5.6 million in the United States, and 5 million globally.

Bland currently serves as co-president and board member of the Women's March on Washington. She has continued to speak out against social injustices, most notably about the complicity of white women in upholding white supremacy by ignoring their white privilege. She has emphasized the importance of listening to people of Color and letting them lead.

from fundraising by selling "Nasty Woman" and "Bad Hombre" T-shirts (Felsenthal 2017, 5). Bland's vision was to create a resistance movement that would highlight the positive, "something that will help empower us to wake up in the morning and feel that women still matter" (5–6). Several others made contact and the organizing began. Vanessa Wruble joined Shook and Bland, and was the organizer who articulated early

Box 11. Biography of Tamika Mallory

Tamika Mallory is a social justice leader, activist, and advocate. She was born in 1980 to activists Stanley and Voncile Mallory in the Bronx, New York. Her parents were founding members of the National Action Network (NAN), a civil rights organization. She became a member of NAN at age eleven, and at fifteen she was working for NAN as a staff member. She became the youngest executive director at NAN and stepped down after fourteen years to pursue her own activism goals.

Mallory was selected to serve on the transition committee of New York City Mayor Bill de Blasio in 2014. During this time, she played an instrumental role in creating the NYC Crisis Management System, an official gun violence prevention program that awards almost $27 million annually to violence prevention organizations. During the Obama administration, she was a member of Joe Biden's gun-control task force. She has served as national organizer for the Fiftieth Anniversary of the March on Washington and Justice or Else!, a rally to commemorate the twentieth anniversary of the Million Man March.

In 2017 Mallory brought her activism and organizing expertise to serve as one of the national co-chairs of the Women's March on Washington. While the march was created in response to the election of Donald Trump, she and the organizers worked to focus the march on intersectional issues and to provide space for the concerns of women, people of Color, LGBTQIA people, and other marginalized people. She explained that inclusivity was central to promoting the greatest change. For her role in the Women's March on Washington, she was included in *Time* magazine's 2017 list of "100 Pioneers" and *Fortune*'s 2017 list of "World's Greatest Leaders."

Currently, Mallory is the president of her firm, Mallory Consulting, a strategic planning and event management firm. She has worked with Fortune 500 companies and other organizations on projects related to mass incarceration, gun violence, and police brutality. Her position as board member of the Gathering for Justice and constituent of the Justice League NYC has enabled her to continue her life's work of advocacy and activism.

on that because Shook and Bland were white and she had worked as a white person in Black spaces, they could not be the only ones organizing the protest. Wruble wrote to her coorganizers: "You need to make sure this is led or centered around women of color, or it will be a bunch of white women marching on Washington. . . . That's not okay right now,

Box 12. Biography of Linda Sarsour

Linda Sarsour is a Palestinian-American-Muslim racial justice and civil rights activist and community organizer. She was born in Brooklyn to Palestinian immigrant parents in 1980 and raised in Sunset Park. After graduating from John Jay High School in Park Slope, she took courses at Kingsborough Community College and Brooklyn College with the intent of becoming an English teacher.

Sarsour began her activism work defending the civil rights of Muslim Americans after the September 11 attacks in 2001. She was mentored by her relative and founder of the Arab American Association of New York, Basemah Atweh. After Atweh's death in 2005, Sarsour was named to succeed her as executive director of the association. As executive director, she advocated for the Community Safety Act in New York to counter the biased policing of Muslim Americans she and the organization had witnessed in local neighborhoods. She was instrumental in the Coalition for Muslim School Holidays and helped secure the New York public school system's observance of two Muslim holy days, Eid al-Fitr and Eid al-Adha. She also co-chaired the March2Justice protest against police brutality and racial profiling. She was named one of *Time* magazine's "100 Most Influential People" in 2017 and was invited to speak at the Justice or Else! rally to celebrate the twentieth anniversary of the Million Man March. Her activism has extended to the Black Lives Matter movement, immigration policy, mass incarceration, and other social justice issues.

Sarsour was recruited by the Women's March organizers to serve as a co-chair of the 2017 event. In keeping with the intersectional goals of the march, she worked to link the different agendas of many civil rights groups into a pan-progressive movement of social justice for all. In the year following the Women's March on Washington, Sarsour became a favorite target of media attacks on social media and conservative news outlets, causing concern for her safety.

In spite of this, Sarsour has continued to advocate and agitate for the civil rights of all. She helped organize the A Day Without a Woman strike soon after the Women's March and has been active in opposing the Trump administration's "travel ban" on several Muslim-majority countries. She is a member of the Justice League NYC, an organization dedicated to reforming the New York Police Department and the criminal justice system. She is also the co-founder of MPOWER Change, a Muslim online organizing platform.

especially after 53 percent of white women who voted, voted for Donald Trump" (6). Shortly after, Tamika Mallory and Carmen Pérez came on board, followed by Linda Sarsour.

A Day of Reckoning: They Came by the Thousands

On January 21, 2017, WUSA-9, a local Washington, D.C., news station, reported on the Women's March on Washington. The segment began with aerial shots of the National Mall and on-the-ground clips of protestors exiting public transportation and being shepherded block after block toward the main stage. Clips of impassioned speeches given by celebrities like Ashley Judd, Alicia Keys, and Scarlett Johannson illustrated both the political and cultural importance of the historic march. A variety of women—college students, mothers and daughters, women of Color, white women, women in alien costumes—with a multitude of reasons for marching demonstrated the scope of the impact Trump's inauguration had on different groups of women in the United States. Below is a kaleidoscopic vignette of scenes from the march.

Video Scenes from the Streets: "D.C. Women's March Fills Streets Despite Report of No March"

Adam Longo (reporter): All right. Still plenty of people out there tonight after organizers estimate half a million people participated in today's Women's March on Washington. Check out this picture from on top of the Washington Monument. The main stage is at Third Street, thirteen blocks away from where this shot was taken.

Lesli Foster (reporter): The group was so big they couldn't march along the planned route, but they still made their way to the Ellipse. They came to be part of history.

Ashley Judd (from clip): So we are not here to be debunked. We are here to be respected.

Alicia Keys (from clip): We will not allow our bodies to be owned and controlled by men in government or men anywhere, for that matter.

Scarlett Johannson (from clip): We must stand up for what are our basic human rights and always move forward, never backwards.

Reporter: Debra Alfarone is live at Seventeenth and Constitution by the Washington Monument and, Deb, tell us more about the message of today's march.

Debra Alfarone (reporter): Hey there, Lesli. Yeah, people came with lots of signs. In fact, there are people right here, right now, still. . . .

"'Love thy neighbor' has no exceptions." . . . We're here, right under the Washington Monument and you can see right here, lots of signs that have been left behind. People came out, they had so much to say: "If you are neutral in situations of injustice and continue on there, you have chosen the side of the oppressor."

Vassar student (from clip): Love trumps hate! Love trumps hate!

Lesli Foster (reporter): They came from all over and for many reasons.

Yellow bow (from clip): What makes America great is people believing in one another and getting along and being able to grow and mature.

Pink hat 1 (from clip): I want to make a better world for her (indicates child). She's a mini-feminist, so . . . (laughs).

Purple hat (from clip): I want to be here to do the Women's March because Donald Trump is doing really bad things to women and I don't support that, and I believe that we have to stand up and he has to hear our voices.

Lesli Foster: So many marchers.

Bullhorn: Twenty-third and Constitution, guys. Six more blocks—you have to keep going 'cause there are so many people here!

Crowd: Yeah!

Lesli Foster: Mostly, there was a feeling of solidarity and love. This woman came from Seattle.

Seattle woman (from clip): Right now, there's tons of emotion. Everyone's kind of really upset about what's going on, and we wanna make sure that we spread as much love and positivity throughout it, and I decided to make ten thousand [love] stickers and bring [them] with me to pass out.

Lesli Foster: There was also some sadness.

Obama fan: [Barack Obama] was the best president ever and it's so shocking to go from him to [beep] Donald Trump.

Lesli Foster: Some confusion.

Alien woman 1 (in costume, speaking in an alien voice): What happened to this country? We don't understand.

Alien woman 2 (also in costume and speaking in an alien voice): We are here to save the Americans.

Lesli Foster: And some disagreement. This guy is pro-life surrounded by people who are pro-choice.

Pro-life guy: Abortion, right, I wanna abolish it—

Pro-choice woman: More babies are gonna die if you do that.

Pro-choice bullhorn: Free abortions!

Guy in orange vest: We need you to continue down to Twenty-third!

Pink hat 2: I think that there's so much strength in standing together, show-
ing a strong but peaceful front and I'm—just honored to be a part of it.

Debra Alfarone (reporter): I'm back live here, I just want to show you
Constitution Avenue. They just opened it a little while ago. Seven lanes
of traffic, this was closed, yeah, and it was absolutely filled with people
from as far as the eye can see on one side to the other. We're live here on
the National Mall tonight, Debra Alfarone, WUSA-9.

No one expected the huge number of women who pilgrimaged to Washing-
ton on the morning of January 21, 2017. The day was cloudy and blistering
cold but manageable with coats, gloves, and the hand-knitted, pink pussy
hats that many women wore. Women brought their daughters, nieces, moth-
ers, grandmothers, neighbors, and women friends. Many used vacation time;
others borrowed money to make the trip. The two white women sitting on
either side of me on the flight from Los Angeles to Washington had used
their air mileage—perks they could have otherwise saved for leisure travel.
Instead, these two women, like many others, traded in their miles to hop on
a plane and join what exactly? That was not yet clear to any of us. The plane
I was on was full of exuberance. There was a sense of mission—we would
not be ruled by this man who flaunted his patriarchal power by asserting his
right to grab a woman's "pussy."

Behind the main stage on Independence Avenue was a large white tent
with seating areas for the scheduled speakers as they waited their turn at
the podium. Mingling with the speakers were guests, media personnel, and
equipment. The program began at 10:00 a.m. and ended around 5:00 p.m.
(EST). Originally the rally was supposed to stop at 1:15 p.m., followed by
the march. There were so many people in attendance, however, that there
was no room to march. In addition, the program did not end until 5:00 p.m.
because speakers did not stay within their allotted time slots, and new
speakers were added throughout the day. All told, there were forty-four
speakers who were officially announced before the march. The range of
constituencies represented by the speakers and performers was impressive.
In the following section, I review the transcripts of five of the speakers.
These individuals embody intersectionality and represent the spirit the or-
ganizers hoped to capture. The march turned out to be the largest protest
ever organized in the history of this country. Notably, one of the organizers,
Carmen Pérez, a young Chicana, born and raised in Oxnard, California,

happened to take the first undergraduate course in Chicana feminisms taught by me—one of the few Chicana social psychology professors in the University of California system, who hails from the valley of South Texas, only twenty-nine miles south of Gloria Anzaldúa's homeland. The Chicana feminisms circle of knowledge takes from lived experience and turns it into activism.

Janelle Monáe: "I March Against the Abuse of Power"

Janelle Monáe was one of many artists who spoke and/or performed at the Women's March. Monáe is primarily known for her music and has played significant roles in films such as *Hidden Figures* (2016) and *Moonlight* (2016). Monáe began her performance by outlining her constellation of intersectional identities and how the experiences provided by these intersections influence her politics.

> **Janelle Monáe (JM):** Hello, future! I'm so proud to stand here as a woman, an African American woman. My grandmother was a sharecropper; she picked cotton in Aberdeen, Mississippi. My mother was a janitor and I am a descendent of them, and I'm here in their honor to help us move forward and Fem the Future. I just wanna say, I wanna remind you, that it was woman that gave you Dr. Martin Luther King Jr. It was woman that gave you Malcolm X. And, according to the Bible, it was woman that gave you Jesus. Don't you ever forget it, and we must remind them—those who are abusing their power. That is what I am here today to march against: the abuse of power. I want to say to the LGBTQ community, my fellow brothers and sisters; to immigrants, my fellow brothers and sisters; to women, continue to embrace the things that make you unique, even if it makes others uncomfortable. You are enough, and whenever you feel in doubt, whenever you want to give up, you must always remember to choose freedom over fear.

In her address, Monáe focuses on women while simultaneously committing to other oppressed social formations in a move of inclusivity and shared humanhood. She nonetheless places hope for the future on "FEMS," as she declares in her introduction and as inscribed on her shirt.

> (JM unbuttons her coat to reveal a black sweater emblazoned with the phrase "FEM THE FUTURE" in white. She steps away from the podium to

stand next to two other Black women with the same sweaters. She returns to the podium.)

Monáe then deconstructs her privilege as a successful and economically powerful artist and expresses solidarity with the concerns and oppression of those who do not hold as much privilege. She claims women's visibility and asserts, "We will not remain hidden figures." This is a sly reference to the 2016 award-winning film of the same title, based on the book of the same title, which recounts the true story of three brilliant African American women scientists at NASA—Katherine Johnson, Dorothy Vaughan, and Mary Jackson (the latter played by Monáe in the film). These women were central but forgotten figures in the success of the space mission that launched astronaut John Glenn into orbit on February 22, 1962.

Monáe also claims the sexual body as la cuna (the cradle) of liberation—"Get off our vaginas!" At the same time, she claims her solidarity with men, even those who serve the state to implement laws—"We have amazing cops!" Her intersectional lens avoids making any one group the enemy; instead she focuses on structures of oppression, to paraphrase sociologist Patricia Hill Collins (2000).

In the next segment of her performance, Monáe brings the "Mothers of the Movement," those who have lost children to police violence, onto the stage.

JM: I come here again as an American and as a woman, not as an artist. When I go home, I have the same concerns. When I see bullies trying to bully you, just know that I am upset about it, and it does not go unnoticed. The things that are happening from Washington to even other Americans abusing their power and abusing others will be hidden no more. Women will be hidden no more. We will not remain hidden figures. We have names, we're complete human beings, and they cannot police us, so get off our areolas. Get off our vaginas! Again, we birthed this nation and we can unbirth a nation, if we choose. We can stop completely, if we choose. This is about unity, and I wanna bring onstage some more American women and men, Jedenna and the Mothers of the Movement, as I talk about the abuse of power. It's not just happening here in Washington. It has also happened on the ground in the police force. We have amazing cops, we have amazing Americans, but again, we are here to fight against the abuse of power and to unite and to remind us all that

at the end of the day, we all pee the same color and we must protect each other. We must protect one another. So, this is a song—this is a song, music that we wrote, not for ourselves but for you. Make some noise if you're gonna continue to be out there on the front lines.

Crowd: (Cheers)

Monáe states there are different ways of expressing protest: "Some of us protest in silence and some of us believe that silence is not an option and music, our sound, is a weapon." As an artist, her weapon of protest is her music, and she introduces the song she wrote for the occasion, "Hell You Talmbout" (Hell You Talking About)—the title in Black English.

JM: This is a song that is a vessel, and this is a tool for you to take out as you march. This song is called "Hell You Talmbout," and we're talking about this right now, 'cause we must continue to exercise our voices. Some of us protest in silence, and some of us believe that silence is not an option and music, our sound, is a weapon. No wrong way to do it. But this song is gonna honor those who are victims, victims due to the abuse of power. This is a chant, and for us to be one living, breathing organism, I need your help. Can I get you to sing with us?

Crowd: (Cheers)

JM: So, it goes like this: It's a call and response. I'm gonna use Sandra Bland, Sandra Bland, our sister Sandra Bland. So, when I say, "Sandra Bland!" (points to crowd) "Say her name!" I'ma say, "Sandra Bland," you say, "Say her name!" So one more time. Sandra Bland!

JM: Hell you talmbout? Hell you talmbout? Hell you talmbout? Hell you talmbout? Hell you talmbout? Hell you talmbout?

JM: Sandra Bland!

Crowd: Say her name!

JM: All right, that was a test. Band, drop it in!

(The band starts playing, everyone on stage dances and sings along until the end of the performance. JM moves from the podium to the standing mic next to the singers.)

JM: Everybody! Put those hands in the air and sing with us!

JM and band: Hell you talmbout? Hell you talmbout? Hell you talmbout?

Monáe continues with the call response of a series of individuals who have been the victims of police violence: Janisha Fonville! Natasha McKenna!

Tanisha Anderson! These are the little-known names of African American women, as opposed to African American men, who were victims of police violence. In her TED Talk on intersectionality, Kimberlé Crenshaw (2016) uses this example, asking the audience if they know these women's names after the audience has recognized the names of the African American men who were killed by police. Monáe's intervention is different from Crenshaw's, however, because she does not emphasize the contrast between African American women and men but unites the two groups into a larger, single group of those lost to the "abuse of power." Notably, she does not group all police into unlawful perpetuators of violence; instead she praises the police officers present and admits that there are some "amazing police."

In the next segment of her performance, Monáe addresses the Mothers of the Movement, bringing each mother up to the microphone while the band plays a rhythmic, pounding beat that pulsates through the crowd of hundreds of thousands. She calls out the names of the deceased. There is an electricity in the performance as each mother calls out the name of their son in a cry of ferocious loss—a wailing cry of hurt, despondency, anguish, despair; an open wound of the child lost forever, the cry of La Llorona as depicted by Ballet Nepantla in chapter 3. Instead of a lone wail, however, it is a *collective wailing* of loss as the crowd witnesses the mother's pain. Most of us are in tears as we respond to the chant with the child's name. Monáe repeats the name to the beat of the music with periodic interludes of "Say his name! Say his name! . . . Won't you say his name? Hell!" And so the collective mourning for the young men lost begins:

> (JM takes the mic and moves down stage next to the Mothers of the Movement. She addresses Lucy McBath, mother of Jordan Davis, first.)
>
> **JM:** All right, so we gonna improv this! So what we gon' do right now is we're gonna jump back in. All right, we got the mothers right here! Say your baby's name.
>
> **Lucy McBath (LM):** Jordan Davis!
>
> **JM:** Here we go! We're gonna say, "Jordan Davis" so he can feel us, and we're doing this for his mother who gave birth to him. We are proud of you for standing up here with us today. I'm giving you the mic 'cause this is not about me. So, you go, say, "Jordan"—
>
> **LM:** Jordan Davis!
>
> **JM:** No, no, no. Nope.

LM: (Laughs)

JM: We're gonna do it right 'cause this is a moment, for history. We're gonna have a moment together where we listen in and we are in tune. We are in tune, all right? One, two, three, Jordan Davis!

Band: Say his name!

JM and LM: Jordan Davis!

Band: Say his name!

JM and LM: Jordan Davis!

JM and band: Say his name! Say his name! . . . Won't you say his name? Hell!

JM: We got another mother.

(LM steps back and Gwen Carr, the mother of Eric Garner, moves up to JM.)

Gwen Carr (GC): Eric Garner.

JM: Eric Garner's mother. And we're gonna give you the mic; this is not about me. This is about you, and this is about your son, and this is about all of us fighting back against the abuse of power. So when this comes in, we wanna be in tune with you. On the one, two, say his name, one, two, three!

GC: Eric Garner!

Band: Say his name!

GC: Eric Garner!

Band: Say his name!

(JM moves down the stage to reach Hawa Bah, mother of Mohamed Bah.)

JM: This is the mother of . . .

Hawa Bah (HB): Mohamed Bah. Mohamed Bah was my son. In 2012 NYPD came and executed him. It was an execution and cover-up. We need justice for all! Mohamed Bah. Mohamed Bah.

JM: Okay, here we go. One, two, one!

HB and JM: Mohamed Bah!

Band: Say his name!

HB: Mohamed Bah!

Band: Say his name!

(JM moves down the stage to Sybrina Fulton, mother of Trayvon Martin.)

JM: The mother of Trayvon Martin. Thank you for your words and thank you for your . . . thank you for everything. This is about you. One, two, three!

Sybrina Fulton (SF): Trayvon Martin!

Band: Say his name!

(SF): Trayvon Martin!

Band: Say his name!

(SF): Trayvon Martin!

Band: Say his name!

(JM and SF hug. JM hugs Maria Hamilton and brings her to center stage.)

JM: Dontre Hamilton's mother. Here we go. One, two, one, two, three!

JM and Maria Hamilton (MH): Dontre Hamilton!

Band: Say his name!

MH: Dontre Hamilton!

Band: Say his name!

Monáe then turns to Cherno Biko, who is co-founder of the Black Trans Lives Matter—Black Trans being another invisible group of African American folks who have been killed by police but have not garnered as much attention as the deaths of young African American men. Monáe does not interrupt the flow of the music, the ritual, or the emotion. These losses are all of our losses, and there is no marker of distinction.

JM: We got one more. This is for my trans brothers and sisters. You are not forgotten. We will continue to fight with you. An injustice done to you, an injustice done to anybody, any of you, is one done to me and should be one done to all of us. Here we go!

Cherno Biko (CB): Maya Hall!

Band: Say her name!

JM and CB: Maya Hall!

Band: Say her name!

CB: Deonna Mason!

Band: Say her name!

CB: Deonna Mason!

Band: Say her name!

JM and band: Hell you talmbout? Hell you talmbout? Hell you talmbout?

JM: That's what we talking about! Remember! We must protect each other, and we must continue to choose freedom over fear! We can't give up, we can't be scared, and we gotta keep talking about this. We are watching, as Alicia Keys said. We are here, we are watching! God bless you, God bless you.

Monáe has taken all of us to the feminist church of collective mourning, forgiveness, and healing. We do not feel alone in our losses nor in the infinite possibility of hope.

Sophie Cruz: "Making a Chain of Love to Protect Our Families"

There were many extraordinary moments at the Women's March. One uniquely moving moment was when the massive crowd was touched by a child of only six years old. Sophie Cruz stood on stage with her undocumented Mexican immigrant mother and father and her baby sister. Sophie first gained national attention in 2015, when she handed a crayon-scrawled letter about her parents' legal status to Pope Francis. Sophie wrote: "Pope Francis, I want to tell you that my heart is sad. And I would like to ask you to speak with the president and the Congress in legalizing my parents because every day I am scared they will take them away from me." Her eloquent hand-written note was surpassed by her speech, in English and Spanish, at the march.

Sophie Cruz (SC): Hi, everybody!

Crowd: Hi!

SC: My name is Sophie Cruz. We are here together making a chain of love to protect our families.

Crowd: (Cheers)

SC: Let us fight with love, faith, and courage, so that our families will not be destroyed.

Crowd: (Cheers)

SC: I also want to tell the children not to be afraid because we are not alone. There are still many people that have their hearts filled with love and tenderness to snuggle in this path of life. Let's keep together and fight for the rights. God is with us!

Crowd: (Cheers)

Sophie then repeated her message in equally articulate Spanish. Sophie is already a recognized activist, fighting for immigration reform. Her awakening happened when her undocumented parents and she could not enter Mexico to visit her grandfather. She audaciously told her parents, "I'll fix this!" She has visited the White House, at President Obama's invitation, for a Cinco de Mayo celebration. Sadly, her parents had to wait outside for Sophie because of their lack of papers. Nonetheless, Sophie claims love

as the source of political resistance. Even at such a young age, she claims her voice as a girl and "inspires other young girls to also make their voices heard" (Battersby 2017, 1).

Angela Davis: "We Who Believe in Freedom Cannot Rest Until It Comes"

Angela Davis, legendary Black activist and professor emeriti from the History of Consciousness Department at the University of California, Santa Cruz, focused her remarks on the importance of the history of colonization suffered by the peoples of Color in the United States and the Americas. She also explicitly named the many oppressed groups the Women's March was centering in their policy agenda and in their selection of speakers.

> **Angela Davis (AD):** At this very challenging moment in our history, let us remind ourselves that we the hundreds of thousands, the millions of women, trans people, men, and youth who are here at the Women's March, we represent the powerful forces of change that are determined to prevent the dying cultures of racism, heteropatriarchy from rising again.
>
> **Crowd:** (Cheers)
>
> **AD:** We recognize that we are collective agents of history and that history cannot be deleted like web pages. We know that we gather this afternoon on Indigenous land, and we follow the lead of the First Peoples who, despite massive genocidal violence, have never relinquished the struggle for land, water, culture, their people. We especially salute today the Standing Rock Sioux.
>
> **Crowd:** (Cheers)
>
> **AD:** The freedom struggles of Black people that have shaped the very nature of this country's history cannot be deleted with the sweep of a hand. We cannot be made to forget that Black lives do matter.
>
> **Crowd:** (Cheers)
>
> **AD:** This is a country anchored in slavery and settler colonialism, which means, for better or for worse, the very history of the United States is a history of immigration and enslavement. Spreading xenophobia, hurling accusations of murder and rape, and building walls will not erase history. No human being is illegal.
>
> **Crowd:** (Cheers)

Professor Davis made an explicit connection to climate change and the environmental causes that progressives are committed to: opposing the installation of an oil pipeline on their lands of the Standing Rock Sioux and resolving the continued contamination of the water supply in Flint, Michigan. Professor Davis connects these national issues to the struggles across the globe, such as the Palestinian and Israeli conflict on the West Bank and Gaza.

> **AD**: The struggle to save the planet, to stop climate change, to guarantee the accessibility of water from the lands of the Standing Rock Sioux, to Flint, Michigan, to the West Bank and Gaza. The struggle to save our flora and fauna, to save the air—this is ground zero of the struggle for social justice.
>
> **Crowd**: (Cheers)

Professor Davis emphasizes "an inclusive and intersectional feminism" that addresses a multiplicity of political issues and calls for resistance "to racism, to Islamophobia, to anti-Semitism, to misogyny, to capitalist exploitation."

> **AD**: This is a women's march, and this Women's March represents the promise of feminism as against the pernicious powers of state violence; an inclusive and intersectional feminism that calls upon all of us to join the resistance to racism, to Islamophobia, to anti-Semitism, to misogyny, to capitalist exploitation. Yes, we salute the Fight for 15. We dedicate ourselves to collective resistance. Resistance to the billionaire mortgage profiteers and gentrifiers. Resistance to the health care privateers. Resistance to the attacks on Muslims, on immigrants. Resistance to attacks on disabled people. Resistance to state violence perpetrated by the police and through the prison industrial complex. Resistance to institutional and intimate gender violence, especially against trans women of color. Women's rights are human rights all over the planet and that is why we say "Freedom and Justice for Palestine."
>
> **Crowd**: (Cheers)

Professor Davis also names the political prisoners who represent different constituencies and social issues—for example, Leonard Peltier representing

native peoples and Chelsea Manning representing trans people. She explicitly refuses to apply feminism only to women or only to African American people and African American causes; instead, she makes a commitment to all "vulnerable populations." Her solidarity extends across differences, as mandated by intersectionality.

> **AD**: We celebrate the impending release of Chelsea Manning. And Oscar López Rivera. But we also say free Leonard Peltier. Free Mumia Abu-Jamal. Free Assata Shakur.
>
> **Crowd**: (Cheers)
>
> **AD**: Over the next months and years, we will be called upon to intensify our demands for social justice to become more militant in our defense of vulnerable populations. Those who still defend the supremacy of white male heteropatriarchy had better watch out.
>
> **Crowd**: (Cheers)

Professor Davis also names the multiple spheres and forms in which resistance to oppression will take place: in classrooms, on the job, in art and music. As advocated by Chicana feminisms, awareness and resistance to gender oppression can take place in a multiplicity of sites and genres, not just through academic production or on university campuses, but in every sector of society.

> **AD**: The next 1,459 days of the Trump administration will be 1,459 days of resistance. Resistance on the ground, resistance in the classrooms, resistance on the job, resistance in our art and in our music. This is just the beginning and in the words of the inimitable Ella Baker, "We who believe in freedom cannot rest until it comes." Thank you.
>
> **Crowd**: (Cheers)

Professor Davis reinscribes the initial commitments of the political mobilizations of the 1960s for solidarity between Third World Peoples. The struggles of the era were Marxist inspired, with a strong commitment to socialist values that were expanded by the Black civil rights movement, the Chicano movement, the women's movement, the gay liberation front, and Chicana and African American women's feminisms—all of these social mobilizations expanded the base on which social justice is conceived.

Carmen Pérez: "I Stand Here as a Chicana, Mexican-American Woman"

Later in the afternoon, Carmen Pérez spoke and gave an overview of her work in the New York–based organization she leads, the Gathering for Justice, and her work with her co-chairs of the Women's March. She also spoke about the hardships she grew up with, including the incarceration of family members and surviving domestic abuse. In true feminist fashion, she related her own bioethnography as part of the undying motivation for her activism and dedication to women's issues within the intersections of other oppressions.

Carmen Pérez (CP): Good afternoon, family. My name is Carmen Pérez, and I am the executive director of the Gathering for Justice.

Crowd: (Cheers)

CP: I am truly humbled to join and serve you as one of the national co-chairs of the Women's March alongside my sisters Tamika Mallory, Linda Sarsour, and Bob Bland, as well as the many, many people who have worked so hard to make today happen. Thank you! I stand here as a Chicana Mexican-American woman.

Crowd: (Cheers)

CP: As the daughter and granddaughter of farmworkers. As a family member of incarcerated and undocumented people. As a survivor of domestic violence. As a woman who knows pain and who has transformed her pain into gifts, gifts that have allowed me to see light in the darkest places. For twenty years, I have worked in America's prisons. I have seen families being torn apart, locked up in cages. Many stripped of their rights, their freedoms, and ultimately, their lives. And the majority are black and brown—including women, women who I call sisters. This has to end. This will end because of you, because of us. Today, I join you all and raise my voice loud and clear to say we have had enough. We know what the problems are. We know who our enemy is. We know what the injustices have done to us and those we love. But to overcome them, we have to stand in solidarity. We have to listen to each other and know that we always have more to learn. To protect each other, we don't always have to agree but we have to organize and stand together. We must remember that unity of action does not mean that we have to be unanimous in thought, but that injury to one is injury to all.

As one of the main organizers, Pérez had been deeply involved not only in the magical collaborations that resulted in fourteen to twenty nearly complete strangers successfully organizing the biggest protest in U.S. history, but also holding what the *New York Times* identified as "contentious dialogues about race" (Stockman 2017, 1). The tensions among the organizers grew with the success of their efforts and ranged from disagreements over the roster of speakers to the sequencing of the program. Pérez had to develop a language to explain the goal to querulous parties: "We must remember that unity of action does not mean that we have to be unanimous in thought" but that ultimately "injury to one is injury to all." In other words, Pérez relied on her mestiza consciousness, as Anzaldúa (1987) advocates: "At some point, on our way to a new consciousness, we will have to leave the opposite bank, the split between the two mortal combatants somehow healed so that we are on both shores at once and, at once, see through serpent and eagle eyes. . . . The possibilities are numerous once we decide to act and not react" (78–79).

Pérez also relied on the wisdom of her elders, who were not necessarily women or Chicanas; one of her main mentors has been Harry Belafonte, the actor, singer, and activist, who founded the Gathering for Justice, now led by Pérez. Adhering to Chicana feminist principles allows Pérez to work across differences and to honor the maxim that "those closest to the problem are also closest to the solution." Pulling from her training in feminist theory, lived experience, and dedication to political organizing, Pérez was instrumental in implementing the agreed-upon unity principles.

Crowd: (Cheers)

CP: I am often reminded of the words of my mentor and boss Harry Belafonte, "Those who are working towards the liberation of our people are only subject to friendship and support. Those who are being divisive are playing the enemy's game." And so, our responsibility is to find our way. There is an entry point for all of us to be involved in this movement. So get involved, stay involved, and keep your eyes on the prize. Know that those closest to the problem are also closest to the solution. Trust them, stand with them in your actions, because I believe what Fannie Lou Hamer said: "When I liberate myself, I liberate others. And if you don't speak, ain't nobody gonna speak on behalf of you."

Crowd: (Cheers)

Like many of the speakers at the march, Pérez claimed active resistance to multiple oppressions: "We will resist Islamophobia, xenophobia, white supremacy, sexism, racism, misogyny, and ableism." Also, like Professor Davis, Pérez explicitly claims an intersectional feminism: "We will be brave, intentional, and unapologetic in addressing the intersections of our identities and collectively we will stand up for the most marginalized among us— because they are us." She also asserts women's agency and rejects a position of victimhood because "[w]e are not helpless" and "[w]e are the ones we've been waiting for" to take the reins for social change.

CP: And to those threatening us and our livelihood, I say, si no nos dejan soñar, no los vamos a dejar dormir. If they don't let us dream, we will not let you sleep.

Crowd: (Cheers)

CP: We stand here on day one of the new administration, refusing to let them sleep, not for one second. We will hold all our officials, whether elected or appointed, accountable. There are some in this country who say we should adjust to—work with and adjust to hatred—but Dr. Martin Luther King spoke of the power of being maladjusted to an unjust society. We will not adjust to hatred and bigotry. We will resist Islamophobia, xenophobia, white supremacy, sexism, racism, misogyny, and ableism. We will be brave, intentional, and unapologetic in addressing the intersections of our identities and collectively we will stand up for the most marginalized among us—because they are us. We will not wait for some magical being to rise up and save us. We are not helpless. We are the ones we've been waiting for. We are who we need. When I see my liberation bound in your liberation, and you in mine, together we will get free! So remember, when you go back home, think about why you marched and organize! Organize! Organize! Si se puede! Thank you!

Carmen Pérez in this speech becomes the embodiment of Chicana feminisms. She learns from all sources and integrates the acquired wisdom into her own standpoint. She does not see a division between her well-being, the well-being of her community, and that of society at large. Carmen is not threatened by coalitions; instead, she welcomes everyone that has the same agenda for social justice. Carmen claims her feminisms at the same time

that she engages with the criminal justice system; although it hurts women, its effects are disproportionately meted out to men of Color. Carmen's vision is one of inclusion and united struggle.

Aída Hurtado: "Believe in Education, Believe in the Vision That Education Gives You"

Once the march began, the roster of speakers grew and grew. Many speakers were scheduled, and others were inspired by the day and appeared on their own accord. Such was the case with the pop star Madonna. She descended unannounced on the main stage with her band and her daughter, among others, to perform and speak. I was slated to speak next and got caught in the mélange. Because of Madonna's celebrity and the bluntness of her message, her speech was one of the most repeated in the media and blasted worldwide. There I was, standing behind Madonna, my five minutes of notoriety!

The Madonna interlude allowed me to reflect on what had transpired earlier in the day as each speaker took the podium. I had prepared a short speech; however, I had heard most of the speakers since the beginning of the event, and my planned remarks seemed to repeat the same messages from previous presenters. To avoid eliminating speakers, our instructions explicitly admonished us to keep our remarks to three to five minutes. On the spot, I decided to ditch my written remarks and embrace the moment. Upon reflection, I thought it was important to highlight my connection to Carmen Pérez as her former professor. Carmen represents the best of public education. When public universities open their doors to students like Carmen, their educational trajectories change from what is expected in working-class families. Carmen did not follow her family's history of working the agricultural fields; instead she became a brilliant political organizer. California's public education system had given Carmen opportunities, as she stated in her speech, which had "transformed her pain into gifts, gifts that have allowed me to see light in the darkest places." We were protesting a newly minted administration that had promised to abolish the federal education department, cut funding of special programing for poor students and students of Color, and abolish Affirmative Action—the program responsible for my hiring as an assistant professor at the University of California, Santa Cruz. The day of the march also happened to be Carmen's birthday (figure 25). I decided on the spot, in front of millions of viewers, to go with my sudden inspiration and gave the following speech.

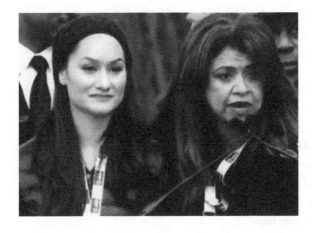

Figure 25. Photo of Carmen Pérez and Aída Hurtado at the Women's March on Washington, January 21, 2017. Courtesy of Aída Hurtado's personal archive.

Aída Hurtado (AH): Yes! Soy Aída Hurtado. I am professor of Chicana and Chicano studies at UC Santa Barbara. I want to dedicate my couple minutes to honoring one of my former students, Carmen Pérez!

Crowd: (Cheers)

AH: It is rare that a professor, a teacher gets to stand next to a student and say, "You've done better than I have."

Crowd: (Cheers)

AH: And I want to say that one of the saddest things that happened during this incredible period is one of our leaders saying that he does not read, that he does not believe in books. And so I am here to say, as professors, as teachers, this is the product of that knowledge (holding on to Carmen), this is the product of what we produce in the universities. This is what we cannot envision when we are doing the day-to-day teaching. This is what the future—where the future lies (holding on to Carmen). So I'm here to represent the academy, the best of what we have in writing. And so I want to say, believe in education, believe in the vision that education gives you!

Crowd: (Cheers)

AH: Carmen! And today is her birthday! (laughs)

Crowd: (Cheers)

AH: She [Carmen] is the best of our public education, she is the best of what your tax dollars pay for, so support your professors, support your university, and most of all, support education in K through 12. God bless!

Crowd: (Sings "Happy Birthday" to Carmen)

Below I include the text of the prepared speech I was scheduled to give. These remarks follow the themes that Chicana feminisms assert as central to political mobilization.

Building a Wall of Resistance Through Love and Political Action

We are here to build a wall,
not a wall of hatred and exclusion
but a wall of fierce defiance,
of persistent resistance.
We are here to build a wall to defend what we fought for.
We will not build a wall through violence and destruction.
We will do it by rejecting hate.
We will do it by insisting that our hard-won victories, as women, will not
 be taken away.
We fought hard to get the vote.
It will not be taken away.
We fought hard to control our bodies,
to insist on laws that protect us from rape, from not being touched in ways
 we do not want to be touched.
No, we will not surrender our sexual harassment laws even when labeled
 by some as nothing more than "political correctness."
We fought hard to own our bodies, to have contraception so only we, and
 no one else, can decide when to procreate.
We fought hard to have a right to safe abortion so we can choose when
 and *if* to have children.
We fought hard to elect a woman president and we voted in such num-
 bers that she won by three million votes—mostly by women, and
 mostly by women of Color.
We invite you to join our movement; to build the wall of resistance, of
 defiance, of fierceness.
Join all the "nasty women"—Asian American, Black, Chicanas, Mexican,
 undocumented, immigrant, white, privileged, poor, Indigenous, home-
 less, trans, and all those that identify as our allies.
Everyone is welcome as long as you are committed to the notion that
 women's rights are human rights.
That to fight for us is to fight for yourselves, your communities, your
 children, to fight for social justice.

Como dice nuestra admirada, la venerable Dolores Huerta, we are here
to say "que si se puede," because we have done it in the past, when we
won the vote, when we won the right to protect our bodies, when we
won the popular vote.
We will not fall back.
Help us build the wall of creativity, of ingenuity, of defiance, to fend off
the destructiveness of hate, of exclusion, of patriarchy.
Si, se puede! Yes, we can!

During the Republican presidential campaign, a primary rallying call was
to build a wall to stop the "illegal" immigration between the United States
and Mexico (and the rest of the Americas). I use the metaphor of a wall here,
but not to exclude and manifest hatred; it is a wall "of fierce defiance," ded-
icated to preserving the hard-won feminist victories of the past fifty years:
voting rights, control over our bodies, protection against rape, laws against
sexual harassment, availability of contraception, access to safe abortions, and
the right to choose *when* and *if* to have children. These rights were fought for
by women who placed their bodies on the line, risking being labeled crazy
and even institutionalized and lobotomized, either biologically or socially.
These rights were not handed over to women but wrested from patriarchy.

Being called a "nasty woman" is a minor insult compared with the vio-
lence that women have endured on a daily basis—violence that is invisible
and rarely articulated in public spaces. Ironically, while I was writing this
chapter the media was focused on Brett Kavanaugh's confirmation hearing
for the Supreme Court. In between writing spurts, I checked social media
to read about the retraumatizing effects experienced by women from all
walks of life as they witnessed Professor Christine Blasey Ford's testimony
on her sexual assault by Kavanaugh (Reilly 2018). Professor Ford's testi-
mony before the Congressional Committee provided explicit details of the
violence she charged took place when she was only fifteen years old visiting
a friend, where a then teenaged Kavanaugh was also a guest: "Ford's voice
sometimes trembled as she recalled how Kavanaugh and his friend, Mark
Judge, shoved her into a bedroom at a high school party when she was 15,
and Kavanaugh held her down on the bed as he attempted to remove her
clothing. She described her terror when Kavanaugh clapped his hand over
her mouth as she tried to scream—a moment where she said it was so hard
to breathe that she thought he might accidentally kill her" (Reston 2018, 1).

Kavanaugh's male friend watched the episode without taking any action to help her (Hayes 2018b). When asked by a senator what she remembered the most about the assault, Professor Ford stated, as she fought back emotion: "'Indelible . . . is the laughter, the uproarious laughter between the two and having fun at my expense,' Ford replied, her voice breaking. . . . 'I was underneath one of them, while the two laughed,' she said, in the most chilling moment of the hearing. 'Two friends having a really good time with one another'" (Reston 2018, 1). The boys' laughter indicated that as a young girl of fifteen, Professor Ford was a plaything that could be violated with impunity.

The day after Kavanaugh's testimony denying the assault, Jessica Valenti, a prominent feminist writer being interviewed in a news show, stated with a trembling voice, "I feel so upset that women have to continue to lay bare their pain again and again and it—it just makes me sort of furious. How much trauma do you want from us? How much do we have to bleed until you recognize that this is really bad, that this is really happening and that we're human!" (Hayes 2018a).

At the Ohio Women's Rights Convention in 1851, Sojourner Truth, a former slave, abolitionist, and women's rights activist, asked a roomful of white women and men, "Ain't I a woman?," because she was not given the same rights that white women had. Here we are today, after the abolishment of slavery, after the feminist movements, after the civil rights movements, after the Anita Hill testimony, and women—even white, educated, elite women like Professor Ford—have to pose the question: Ain't I human? September 27, 2018, will be a day of remembrance, when women, including privileged, educated, white women, got their answer: no, women are still not human. Chicana feminisms, as well as other feminisms of Color, have long alerted us to this fact—women are not in the same category of humanity as men. As Gloria Anzaldúa (1987, 186) reminds us in her poem "Letting Go," no one is going to endow you with your humanity; you must claim it for yourself because no one is going to "save you":

Nobody's going to save you.
No one's going to cut you down,
cut the thorns thick around you.
No one's going to storm
the castle walls nor
kiss awake your birth,

climb down your hair,
nor mount you
on the white steed.

There is no one who will feed the yearning.
Face it. You will have
to do, do it yourself.
And all around you a vast terrain.
Alone. With night.
Darkness you must befriend if
you want to sleep nights.

Yet in spite of their dehumanization, "women persist," to paraphrase the feminist slogan "Nevertheless She Persisted," which was developed after the U.S. Senate vote in 2017 to silence Senator Elizabeth Warren's objections to the nomination of Senator Jeff Sessions for U.S. Attorney General. Women persist, not with violence, nor with explosive demonstrations of anger (as displayed by Supreme Court Justice Kavanaugh during his congressional testimony). Women persist with fierce, loving defiance in peaceful demonstrations, even when they involve millions of participants, as they did in the Women's March, where there was not a single arrest. That is the power and dignity of a Chicana feminist consciousness.

The Women's March in Las Vegas

It's gonna take all of us to build a beloved community that Dr. King dreamt of. It's going to take us all. So let's get to work.

—Carmen Pérez

A year after the first Women's March, a second was organized and held in Las Vegas, Nevada, on January 21, 2018. This time, the march was away from the city center, held in the large Sam Boyd Stadium. There were fewer speakers and participants than in the 2017 march, but it was still considered successful, with as many as 2.5 million in attendance nationwide. The theme of the march was "The Power of the Polls," and it was held in the state of Nevada, hoping to flip the state from red to blue during the November 2018 midterm elections. The fervor was as intense as the previous year. Once again, I was asked to speak by Carmen Pérez, and I had the honor of being introduced by her:

Carmen Pérez (CP): Are we fired up?

Crowd: (Cheers)

CP: I can't hear you! Are we fired up?

Crowd: (Cheers louder)

CP: It is truly an honor and pleasure to bring up the next speaker. You see, about twenty years ago I was at—on this campus called UC Santa Cruz.

Crowd: (Cheers)

CP: And I was studying psychology and I was in a class called "Chicana Feminisms."

Crowd: (Cheers)

CP: And this professor by the name of Dr. Aída Hurtado—

Crowd: (Cheers)

CP:—introduced to me the word "intersectionality."

Crowd: (Cheers)

CP: She talked about making sure that there was representation from different racial and ethnic groups at the table. And at the time, when I was a little nineteen-, twenty-year-old, I never knew I was gonna actually organize and mobilize with that spirit. And so when we see the Women's March intentionally be intersectional, know it was this professor that allowed me to learn the true meaning of this. And so I wanna bring up Dr. Aída Hurtado, who is a professor of Chicana studies at UC Santa Barbara.

Crowd: (Cheers)

CP: She is a fementor, she is an educator, and she is the true definition of a Chicana feminist.

Crowd: (Cheers)

(Dr. Aída Hurtado comes to the podium. She and Pérez hug, and Pérez leaves the podium.)

I include Carmen's introduction not to focus on myself but as a reminder that feminisms are an investment in the future. We are sometimes ridiculed for teaching a course on Chicana feminisms in a mainstream psychology department, and the immediate questions and comments from colleagues and students alike are, "How is this psychology?"; "Of what importance is this topic?"; or, most hurtful, "This is not an academic topic." We are trivialized and delegitimized, and we ourselves do not know what impact (if any) our ideas will have on the future or on those whom we teach—a difficult lesson to acknowledge and impart, but one that Chicana feminisms adhere to by stressing that knowledge is not linear. Knowledge is obtained

through all our senses, including our feelings and emotional commitments. Culture and language are important legacies to preserve, share, and respect, and we are not the only ones with valuable knowledge but we remain open to all the lessons that made the Women's March successful.

At this March, I did not improvise; I delivered my prepared remarks. Again, the central theme of my remarks was the importance of scholarship in the field of Chicana feminisms. We have placed our eggs in one basket: knowledge production in its full range of influence—artistic, written, ritualistic, spiritual, performative, applied, enacted in everyday life—will ultimately be the salvation of the planet. Not only for Chicanas, not only for women, not only for those who agree with us, but for all. Here are my remarks:

Aída Hurtado (AH): There is no greater pride for a teacher—

Unknown: Whoo!

AH:—than when a student exceeds the professor. (In reference to Carmen's generous introduction)

Crowd: (Cheers)

AH: Buenas tardes, gente de Nevada!

Crowd: (Cheers)

AH: This is what feminism looks like.

Crowd: (Cheers)

AH: So, let me begin with what has become a radical notion at this historical moment: I read books!

Crowd: (Cheers)

AH: I teach students to read books!

Crowd: (Cheers)

AH: I write books!

Crowd: (Cheers)

AH: So why does this matter? Because for a democracy to survive, we need an informed electorate. I come from a family of Mexican immigrants.

Crowd: (Cheers)

AH: My parents were migrant farmworkers and came to the United States not to get wealthy or because they did not love their country, but because they wanted their children to obtain an education.

Crowd: (Cheers)

AH: I was not only the first one in my family to go to college; I was the first one in my family to finish high school.

Crowd: (Cheers)

AH: And because I believe in chain migration, I helped my three siblings migrate to higher education and obtain degrees and help build this country.

Crowd: (Cheers)

AH: DACA students and their families only want that opportunity—

Crowd: (Cheers)

AH:—to become productive citizens and play a role in building this nation. Our efforts, our immigrant efforts, and those efforts of people of Color have been met with the hand. (Raises right hand, signaling "stop.") Yes, when we try to vote, they literally gave us the hand. How do they do this? One (from her open hand, she lowers one finger), by destroying our K through 12 system and not giving our young people a substantive education.

Crowd: (Cheers)

AH: And no, it is not the fault of the teachers.

Crowd: (Cheers)

AH: It is a systemic problem. Two (lowers a second finger), they pass laws to keeps us from voting by requiring extra identification, shortening voting hours, and by increasingly making it more difficult for working people to get to the polls. Three (lowers a third finger), they discourage candidates by making it impossible to run unless you have millions. Four (lowers a fourth finger), only the wealthy, mostly male, and mostly white are deemed worthy of holding office, regardless of qualifications.

Crowd: (Cheers)

AH: And five (lowers a fifth finger, closing the entire hand into a fist), they create a media narrative that constructs immigrants, people of Color, women, gays, lesbians, trans people, any kind of diversity, as felons, rapists, criminals, and as incompetent.

AH: (Raising a closed hand) That is the hand that they gave us.

Crowd: (Cheers)

AH: But this is going to change in 2018 with our vote!

Crowd: (Cheers)

AH: Every time I have voted, I cried as I filled out my ballot. The awesome privilege of participating in who is going to make decisions for me overwhelms me every single time. When I am in the voting booth, I reflect on the bloodshed, the courage, the struggle of our brothers and sisters in the civil rights movement, in the women's movement, in the Chicano movement—

Crowd: (Cheers)

AH:—clamoring for the right that I and others have inherited. But when we win, because as our sisters just said, we are going to win in 2018—

Crowd: (Cheers)

AH:—What will we offer? What will a feminist agenda in government offer? Instead of giving our opposition the hand (lifts hand in a signal to "stop"), we will extend an open invitation to participate. What will this extended feminist hand offer? (opening her hand to the crowd) One, truth! (lifts one finger) You never thought that would be a radical act. Two, equality for all! (lifts a second finger)

Crowd: (Cheers)

AH: Three, social justice! (lifts a third finger)

Crowd: (Cheers)

AH: Four, inclusivity! (lifts fourth finger)

Crowd: (Cheers)

AH: Five, an intersectional approach to participation so that all forms of inequality are considered simultaneously, rather than as separate silos (a full hand is opened and extended to the crowd), as so eloquently expressed by our organizers today!

Crowd: (Cheers)

AH: Ours will be a movement and a government of compassion, as Trayvon Martin's parents advocate in their book, *Rest in Power*.

Crowd: (Cheers)

AH: When they lost their son to gun violence, they did not retreat to revenge. They did not retreat to bitterness, and they did not withdraw from society, frozen in time. Instead, their compassion mobilized them to say, "Never again!"

Crowd: (Cheers)

AH: We do not want any parent of whatever race, ethnicity, gender, sexuality, or class to ever suffer this loss. We take their lessons of compassion, and we are fired up and ready to go.

Crowd: (Cheers)

AH: We embrace the audacity of hope, and as Dolores Huerta has reminded us for over fifty years, "Si, se puede! Yes we can!"

Crowd: (Cheers)

AH: May la Virgen de Guadalupe bless you all!

Crowd: (Cheers)

Conclusion

> Our goal should be to achieve joy.
>
> —Ana Castillo, *Massacre of the Dreamers*

In writing a theory of liberation, Chicana feminists put all their hopes in one basket—they had infinite faith that intellectual production inside and outside the academy would revolutionize ways of thinking and ultimately generate a differential consciousness that would reconstitute social reality and gain the traction necessary to change the world. And there is evidence that indeed they have. In 1977 when Martha Cotera published *The Chicana Feminist*, the 94th U.S. Congress (1975–77) only had 19 women in the House of Representatives and 0 women in the Senate. None of them were Latinas. In the 116th U.S. Congress (2019–21), there were 102 women in the House of Representatives and 25 in the Senate (Center for American Women and Politics n.d.). There were 41 Latinos in the House and 4 in the Senate (Cohen, Rundlett, and Wellemeyer, 2019). Forty-seven of the 127 women serving in Congress in 2019 were women of Color: 22 are Black, 13 Latina, 8 Asian American / Pacific Islander, 2 Native American, 1 Middle Eastern/North African, and 1 multiracial (Center for American Women and Politics 2019). A record number of women serve in the new legislature, with many breaking barriers: Muslim and Native American women for the first time, a record number of openly LGBT lawmakers, Texas sent the first Latina representatives to Congress, and Tennessee elected its first female senator (Claire 2019).

Among the new crop of elected Latinas is Puerto Rican congressperson Alexandria Ocasio-Cortez, who made the March 21, 2019 cover of *Time* magazine (Alter 2019). AOC, as she referred to in chants when she meets with her constituencies, represents what many Chicanas have written about—a person who challenges the boundaries of Latina womanhood and still remains legible to those in her community. AOC's outspokenness in social media as well as in traditional media outlets has spotlighted her progressive views that are up against the Republican right, as well as with moderate Democrats in her own party. As she is described in the *Time* profile:

> This is the daily reality for America's newest human Rorschach test. Wonder Woman of the left, Wicked Witch of the right, Ocasio-Cortez has become the second most talked-about politician in America, after the Presi-

dent of the United States. Since beating 10-term incumbent Joe Crowley in the Democratic primary to represent New York's 14th District last June, the 29-year-old former bartender has pressured 2020 presidential candidates into supporting her Green New Deal, made campaign-finance reform go viral and helped activists banish Amazon from Queens with a couple of tweets. No lawmaker in recent memory has translated so few votes into so much political and social capital so quickly. Her Twitter following has climbed from about 49,000 last summer to more than 3.5 million.

The description of AOC in the *Time* profile is reminiscent of the femme-macho subject position described in the introduction to this book. AOC is perceived as a "Wicked Witch" by her enemies and yet admired by many for her courage and equated with the "Wonder Woman" of the left. She is both feared and revered. Yet AOC has an internal guidance that was captured in her televised Town Hall interview with MSNBC's Chris Hayes, when she reflected on why she serves in Congress: "My life's calling is to serve people. I didn't know this would lead me to Congress." She continues that in the future she would go to "where and how can I do the most good for my community and my country." She is especially free as a potential femme-macho because she refuses funding from the patriarchy—no corporate funding or PAC money for her elections. AOC is not as tethered by her gender because she has refused the seduction of the patriarchal privileges that would give her access to wealth (Hurtado 1996). Her lifeline is the working-class community of the Bronx and Queens, where she grew up, and from which she derives her strength and defiance.

AOC's strategy is to organize at the grassroots level, as advocated by Chicana feminisms, to use her exposure to multiple social worlds as the daughter of a first-generation Puerto Rican immigrant mother and a Puerto Rican father born in the Bronx, to prevent the existing power structures from dictating her political positions and actions. Her working-class upbringing is combined with her educational experiences obtaining her BA in economics from Boston University. Like many working-class college graduates, she was saddled with substantial student debt that forced her to seek multiple low-wage restaurant jobs in the "gig" economy. At the same time, she worked as a community organizer after her father's death due to lung cancer. The recession forced her mother to clean houses to avoid losing their home, and AOC joined her mother as a house cleaner. These multiple life experiences make her fearless, in spite of the fact that at the age of

twenty-nine, she is the youngest congressperson in history. She knows what it is to lose everything in spite of doing everything right. From this lived experience (Trujillo 1998), she proposes bold initiatives, like the Green New Deal,[17] that are meant to disrupt the dominant discourses in Washington, D.C. Her purpose is to "debate not debase" by working on behalf of her community and finding wisdom and solace in returning to her childhood neighborhood in the Bronx and visiting her "bodega guy" (MSNBC 2019). In other words, AOC centers her cenote of wisdom not in the status quo of Washington, but in her lived experience that she trusts unconditionally, described as follows: "Despite Crowley's 10-to-1 fundraising advantage over Ocasio-Cortez, the latter carried out a smart and organized grassroots campaign, along with a powerful viral video ad that began with her stating: 'Women like me aren't supposed to run for office.' Ocasio-Cortez was the first opponent in the Democratic party to challenge Crowley's seat in 14 years" (Biography.com 2019).

As part of her campaign video, AOC was filmed putting on mascara—a decided counter-advised action when she is considered to be so young for a congressperson and a woman to boot. She denies neither her age nor her emphasis on what she considers a Latina aesthetic—wearing red lipstick, makeup, heels, long hair, gold hoop earrings, and clothes from sale racks. Her assertion of self *as a Latina woman* also speaks back to white feminisms that have long advised political candidates against feminine accoutrements. Within these complexities, AOC asserts her multipositioned feminisms that find considerable resonance with what is proposed in much of this book.

In spite of all the innovations in writing, art, and political organizing, much remains to be done within politics and the creation of a representative democracy. The new Congress has a record number of Latino/a members; however, the numbers fall far short of the share of the U.S. Latino population. Latinos make up approximately 17.8 percent of the U.S. population—57.5 million. If Latinos/as were fairly represented given their numbers, the 435-member House would have about 77 Latino/a house members. Similarly, the 100-member Senate would have about 18 Latino/a senators (Claire 2019). Chicana feminists would be the first to agree that there is still a long road ahead before there is adequate representation at all levels of government to make this country a true representative democracy.

Whatever still remains to be done, Chicana feminist writers have attained their goal of transformation, including the transformation for men

in their communities (Hurtado and Sinha 2016). These writers have trans-figured higher education through their writings, even while many of them composed outside the academy. Furthermore, their theory of liberation advocates changing consciousness through education and through nonvi-olent political engagement. Multiple testimonios created through multiple lenguas from multiple constituencies hailing from multiple sitios verify that the first part of their liberation theory has indeed succeeded. The next phase of Chicana feminisms will have to answer the question of whether the transformation of consciousness will lead to new forms of social relations that will result in liberation for all.

Discussion Exercise

For this exercise, find the videos of the women's marches held on Janu-ary 21, 2017, and January 21, 2018, on YouTube. Watch video clips for at least one hour by selecting speakers—for example, Angela Davis, Gloria Steinem, Melissa Harris Perry, or any of the speakers highlighted in this chapter. After you have viewed these videos, reflect on the content of this book and on the content of the speeches, and complete one or two of the following exercises.

1. Write a poem or poems.
2. Create an art piece.
3. Write an essay.
4. Begin a funding campaign for an issue.
5. Volunteer in an organization that speaks to your view of social justice.
6. Join an organization dedicated to social justice.
7. Volunteer in a political campaign.
8. Create a dance piece.
9. Write an op-ed piece for a local or national newspaper.
10. Take someone you know to an event that will expose them to a theme pre-sented in this book.
11. Volunteer in a school.
12. Present in an area of knowledge you feel comfortable in to a group of ele-mentary school, middle school, or high school students.
13. Compile an oral history with a family member or someone in your community.
14. Compose a photographic essay on one of the themes presented in this book.

This engagement should result in a concrete product that you can share with others—an essay, a film, an art exhibit, a dance performance. Remember that Chicana feminisms are about using every source of knowledge the body is capable of absorbing and returning a product back to a community or a constituency you care about.

Further Reading

Chira, Susan, and Yamiche Alcindor. "Defiant Voices Flood U.S. Cities as Women Rally for Rights." *New York Times*, January 21, 2017. https://www.nytimes.com /2017/01/21/us/women-march-protest-president-trump.html.

Hurtado, Aída. 2003. *Voicing Chicana Feminisms: Young Women Speak Out on Sexuality and Identity*. New York: New York University Press.

Romero, Mary. 2017. *Introducing Intersectionality*. Hoboken, N.J.: Wiley.

NOTES

Dedication

1. Dr. Stephanie Alvarez is an associate professor and the first-ever director of the Center for Mexican American Studies at the University of Texas Rio Grande Valley. Dr. Alvarez was the 2015 Carnegie Foundation for Teaching U.S. Professor of the Year. She also received the University of Texas System Board of Regents Outstanding Teaching Award. In 2011 she was recognized by the American Association of Hispanics in Higher Education as the Outstanding Latino/a Faculty in Higher Ed. As a professor, she has been instrumental in the implementation of testimonio as a signature pedagogy in the Mexican American Studies program, creating service learning courses for students to engage with the community, which has resulted in oral histories, murals in collaboration with the Smithsonian Institute in the City of San Juan, Texas, and multiple collaborations with Pharr San Juan Alamo ISD. Dr. Alvarez collaborates with the organization Mexican American Studies workshops for teachers and administrators in the Rio Grande Valley. Dr. Alvarez is a volunteer coach who oversees more than twenty youth teams. She has assisted more than a dozen Latinx students in reaching their goal of gaining entrance to PhD programs. She is the author of multiple research essays on the intersection of education, gender, language, identity, and culture. Dr. Alvarez is widely recognized as an important figure in the areas of research, practice, advocacy, and advancement of ethnic studies.

2. Emmy Pérez, Texas Poet Laureate 2020 and NEA Poetry Fellow 2017, is the author of the poetry collections *With the River on Our Face* and *Solstice*. She co-founded the Poets Against Walls collective in the Rio Grande Valley to help highlight borderland voices at activist events and in video work. She also serves on the organizing committee for CantoMundo, a national literary organization for Latinx poets, and is a professor of creative writing and associate director of the Center for Mexican American Studies at University of Texas Rio Grande Valley, where she has received a University of Texas Regents' Outstanding Teaching Award and a University Excellence Award in Student Mentoring.

3. Sister Norma Pimentel is a religious leader and a dedicated activist committed to caring for the people of the Rio Grande Valley of South Texas. At the onset of the "border crisis," Sister Norma was instrumental in organizing the Humanitarian Respite Center. The Center, under Sister Norma's direction, ensures that families released from ICE, who predominantly originated from Central America, were given the essentials like food, a place to rest, and clothing before they took buses to meet with U.S. family members to await the adjudication of their asylum cases. Sister Norma also chairs the community's Emergency Food and Shelter Program and is co-vicar of religious for the Diocese of Brownsville. Sister Norma has received national and international recognition for her exceptional efforts to uphold human dignity at the border and beyond. Sister Norma Pimentel earned her bachelor's degree in fine arts from Pan

American University (now University of Texas Rio Grande Valley), a master's degree in theology from St. Mary's University in San Antonio, Texas, and a master's degree in counseling psychology from Loyola University in Chicago, Illinois.

4. Juanita Valdez-Cox is an activist and prominent leader in the movement for the rights of farm workers. She is the executive director for the Rio Grande Valley chapter of the organization LUPE (La Unión del Pueblo Entero). Founded by labor rights activist César Chávez and Dolores Huerta, LUPE builds stronger, healthier communities where colonia residents use the power of civic engagement for social change. From fighting deportations to providing social services and English classes to organizing for streetlights and drainage, LUPE responds to the needs of the community and takes action that creates a chance for a better life. LUPE's strength derives from the more than eight thousand members throughout the Rio Grande Valley. Juanita has been passionately dedicated to fighting in the farm workers struggle since 1981 with the UFW and has been with LUPE since 2003. She brought LUPE to southern Texas because she saw the need for community organizing. Juanita come from a migrant family, making her intimately acquainted with the experience and challenges farm workers face in the United States. Juanita fights on behalf of low-income families by addressing their social and economic needs, cultivating cultural and political consciousness, and supporting their capacity to be advocates for themselves.

5. The Angry Tías y Abuelas of the Rio Grande Valley are eight women fiercely committed to providing support for migrant asylum seekers at bus stations and gathering places in and around McAllen, Texas, one of the sites for migrant detention centers only eleven miles from the U.S.-Mexico border. The group helps migrant asylum seekers by providing translation services, information on legal resources, and bus tickets to various U.S. destinations, in addition to providing essentials like food, diapers, water, and clothing. The group was called to action by the border crisis taking place close to their homes. From their perspective, they refused to ignore the crisis when people in their community are in need of help. The group was recently awarded the Robert F. Kennedy Human Rights Award for their efforts.

Introduction

1. In solidarity with many Chicana feminist writers, Professor D. Inés Casillas refuses to italicize Spanish phrases in her book *Sounds of Belonging: U.S. Spanish-language Radio and Public Advocacy* (2014). Given Chicanos/as' history of colonization, Professor Casillas does not consider Spanish a foreign language. Therefore, the Spanish phrases in this book are not italicized.

2. "La chingada" literally means in Spanish "the one who has been fucked." "El chingon" literally means in Spanish "the fucker," or the one who has the ability to fuck, implying the possession of a penis, which is the bodily organ used to fuck. La Malinche is often referred to as La Chingada because she was violated by Hernán

Cortez. The assumption in Paz's view of Mexican history is that the Spanish colonized the country through violation (rape).

3. "I complained; I talked back, I had a big mouth. I was indifferent to many of my culture's values. I fought back against men. I was not good nor obedient."

4. There is a great deal of internal variation and diversity in Chicanas' negotiations of the structural restrictions imposed on them by these subject positions. Chicana feminist writers have given us valuable and explicit information on these negotiations, inspiring other women to resist the cultural restrictions imposed on them.

5. The translation of this Spanish phrase into English is "the languages and spaces" and is taken from Emma Perez's 1998 chapter "Sexuality and Discourse: Notes from a Chicana Survivor" in Carla Trujillo's book *Chicana Lesbians: The Girls Our Mothers Warned Us About.*

Chapter 1

1. I use Pérez and Anzaldúa to elaborate the multiple meanings of using la lengua(s) (tongues/languages) para crear sitios fronterizos (to create borderland spaces).

2. In *The Souls of Black Folks* (1903), Du Bois wrote about the Black people of the United States and their experience of a "double consciousness," as follows: "It is a peculiar sensation, this double-consciousness, this sense of always looking at one's self through the eyes of others, of measuring one's soul by the tape of a world that looks on in amused contempt and pity. One ever feels his two-ness, an American, a Negro; two souls, two thoughts, two unreconciled strivings; two warring ideals in one dark body, whose dogged strength alone keeps it from being torn asunder. The history of the American Negro is the history of this strife—this longing to attain self-conscious manhood, to merge his double self into a better and truer self. In this merging he wishes neither of the older selves to be lost. He does not wish to Africanize America, for America has too much to teach the world and Africa. He wouldn't bleach his Negro blood in a flood of white Americanism, for he knows that Negro blood has a message for the world. He simply wishes to make it possible for a man to be both a Negro and an American without being cursed and spit upon by his fellows, without having the doors of opportunity closed roughly in his face" (2–3).

3. They will no longer steal my space and my language.

4. My sisters of the Third World.

Chapter 2

1. I Feel Myself Continent.

2. The Spanish for Spanish Speakers Program at the University of California, Santa Cruz, was an innovative intervention at designing a language program for native speakers of Spanish who had not been formally educated in their language but

were verbally fluent. Much of the pedagogy was based on teaching Spanish speakers about their history, culture, and literature, and affirming the knowledge they already possessed but had not been formally taught.

3. The contents of the colloquium presentation and chapter overlap considerably. However, the lecture contains commentary by Sánchez and a question-and-answer session held after the talk, which were not included in the chapter. I use both the lecture and published chapter to discuss Sánchez's work and its relationship to Chicana feminist methodologies.

4. Firm ground.

5. The surface of my skin.

6. Firm land.

7. Because my writing has been a way of mapping a life, I had to partake of several words and concepts to name the process.

8. In the sense of relating episodes and happenings worth remembering.

9. I also reclaim histo- from history in the sense of the development of humanity. In this case, the development of my own humanity.

10. "The last part of this constructed term consiste de la palabra: grafía [consists of the word graph], del griego [from the Greek], graphé, acción de escribir [graphé, the action of writing]. Significa un sistema de escritura [it means a system of writing], o el empleo de signos determinados para expresar las ideas [or the employment of symbols used to express ideas]."

11. "Documentación de una historia o experiencia individual por medio de escritos, dibujos, u otra representación cuyos signos y significados son compartidos [Documentation of a history or individual experience through their writings, drawings, or any other representation that have a shared meaning]; amplía la geografía del espacio individual al espacio comunal [the purpose is to amplify the geography from an individual space to a communal space]."

12. "I wanted to write porque en mi familia, yo no hablaba [because in my family, I did not speak], unless I was spoken to."

13. More than anything, I hope my work demonstrates a conscious and a voice in development. As a cartohistoriographer I make an effort to unite territories previously separated, especially those than can potentially become common territories, sister lands through our literature. Through our writings, we reflect, analyze, create consciousness and we create the next stage of our development. As writers and cartohistographers we outline the common threads of our woman continent.

14. As cartohistoriographer, I am observing and defining scientifically and sensibly everything that fills my space.

15. I say pueblos or communities because my geography moves, expands, it is flexible.

16. For example, I belong to Chicana and Latina communities, I come from a working class family, woman, educator, mother, cultural worker, and I add other communities.

17. Our writings consider, measure and explain individual experiences that are part of our community puzzle. By publishing these writings, we are demanding acknowledgement of our realities.

18. "Aprendí a cantar en español [I learned to sing in Spanish], play adivinanzas [to play a game of riddles] and other games."

19. In my mind, my voice screamed in Spanish, while I tried to control the multitude of sounds that seemed like scribblings, for the first time I was mute, without language.

20. Sánchez is referring to California, where a formal law was passed in 1986 marking English as the official language of the state.

21. "When books disappear, tongues will recount history." That's what my grandmother told me once. I have carried her words and advice tucked in my shawl, ever since I felt them, or in other words, since I understood them. Spanish is and has been my first language. It is my conscious resistance in this English-only state. Spanish is another consciousness, another world. Spanish is the language of my cognitive self, of my dreams y recuerdos [and memories]. I learned to sing in Spanish, to answer riddles and other games. As a child I learned to invent stories to finally put my little sister to sleep at night. When I finished fifth grade, at the age of eleven, I already had the ability to count, multiply, divide, add, and solve mathematical problems in Spanish. English? That came afterward, when I came to the United States.

22. "I could not do justice a la realidad de la palabra [to the reality of the word]."

23. "I am talking about an audience que vive una realidad mestiza, en el sentido de mezclada [that lives a mestiza reality, in the sense of mixture], que se ha expuesto a varias culturas y gentes [that have been exposed to several cultures and peoples], one that eats, breathes, dreams, and lives every day en diferentes y múltiples mundos y habla en code-switching, multilingual conciencias [in different and multiple worlds and speaks in code-switching, multilingual conciousness]."

24. The term "race" should be in quotation marks. There is extensive scientific documentation that there are no absolute biological markers of race. Race is socially constructed, and the specific contours of who belongs to what "race" vary from society to society. However, in the popular understanding and categorization of race, phenotype is used as s very strong proxy—if you "look" Black, you are Black. If you "look" Latina, you are Latina. Because phenotype is largely biological, "race" is thought of as an immutable characteristic.

25. "My English, Spanish, Spanglish, and other lengualidades [languaging] have danced around each other and together en mi boca [in my mouth], casi forever [almost forever], like seasoned partners on the dance floor, se siguen bien [they follow each other], sus vueltas y pasos bien coreografiados [their turns and steps well choreographed]."

26. Other times, they clash and even stumble, one language over another.

27. "As a Chicana, mis lengualidades [my languaging] y sus hermanas culturas and their sister cultures] have been energized and expanded by the urgency, the positive,

heart-pulsing beats and spoken word world of hip-hop culture that is a part of my son and daughter."

28. "My life has been enriched by these constant encuentros con otras y otros [encounters with others] whose español y cultura [Spanish and culture] are distinctly different from my own."

29. The dialogue that we have shared has expanded not only my linguistic horizons but my own sense and understanding of the world, of my people and of myself.

30. "Through this encuentro [encounter] I found that my reality is in some significant way a part of theirs too, que compartimos una esencia humana [that we share a human essence]."

31. My work, "our work" affirms me and us.

32. "Es una expresión de quienes somos [It is an expression of who we are], de nuestro ollín o movimiento [of our movement], our sociopolitical, cultural, and human development."

33. Consciousness.

34. "Al escribir mi cartohistografía [by writing my cartohistography], what I once believed were individual relatos [tales] have become encuentros [encounters] of shared emotion(s), a link that forms and connects my path with the meeting and merging of others."

35. "In this encuentro [encounter] between writer and reader/listener, ser a ser [being to being], there occurs the possibility of a powerful process."

36. As a writer and poet, it is my tongue, the most powerful one, the one that does and undoes.

37. "My polylingual lengua habla mi realidad, es mi realidad [tongue speaks my truth, my reality]. Cuando digo cilantro, lo pruebo [When I say cilantro, I taste it]."

38. "Mi lengua es como una metáfora [My tongue is like a metaphor], viste colores vibrantes [it is adorned with vibrant colors], define mi identidad en español [it defines my identity in Spanish], en English y en espanglish [in English and in Spanglish], y sprinkled with other stuff, my tongue questions and explains my pocha reality, da voz a mi conciencia, protesta en las marchas [it gives voice to my consciousness, my protests when I march]."

39. It is my tongue that passionately kisses in several languages (so that the translation can be understood).

40. "Nuestros hogares [our homes] were filled with the sounds of children, español [Spanish], y música [and music]."

41. My consciousness awakened and embraced the reality of their struggle, a struggle that was also mine.

42. These were my people and I belonged to them.

43. I arrived as a pure Mexican.

44. Here people think that Mexicans are dirty and lazy. You must always dress and behave well when you are out. I don't ever want anyone to say anything to you!

45. I started to write letters to my family in Mexico shortly after I arrived. They were my linkage, my only connection to the family, the birthday parties, to the rituals and celebrations that used to be part of my daily life.

46. The separations of months and years.

47. And everyday small successes in our new lives.

48. "Crossing Borders"

> For my mother, who waited for the letters
> from Chicago, where her "old man" was residing
>
> pursued by your absence
> the whistle of the mailman makes me run
> my hands get ahead of me
> flying
> extending themselves like a runway
> so they can serve as a landing strip
> for the desired envelope to land
> the familiar writing
> perhaps there is a stain
> a thread
> a string of hair
> a photo
> something that will bring me
> closer to you
> on the other side
> you sweat buckets full
> you get woken up and they put you to sleep
> contortions
> of your insides
> from hunger
> some mornings
> and many nights
> you feel like you are dying
> so far from your land
> from your people
> I try to find your breath
> in these letters
> perhaps as I unfold
> the sheets
> I will feel the warmth
> of your hands
> perhaps

that way I will
smell the odor of your sweat
the flavor of your words
laughter kisses
via airmail
via airmail
via airmail

49. UCSC graduate students Aracely Garcia-Gonzalez, Paulina Ramirez Niembro, Alejandro Prado, and Mariano Nava identified this circular process of knowledge production in Chicana/o Studies as a tree that is fed by the Chicano community, which in turn bears fruits in the academy and is then returned to the community for nurturance (class presentation, Chicano Studies 200C, Social Processes, spring quarter 2016).

50. "My tongue names injustices I witness, a veces en voz de poeta [sometimes in my poet's voice], a veces en mi native lengua pocha [sometimes in my native pocha tongue], from my pocha perspective."

51. My tongue retells in color and odor of my own flesh.

52. So they understand—for those who do not live them or for those who are myopic and cannot see them.

53. My tongue is a vital organ.

54. "La palabra [the word] has been a way to channel my reflections, to question myself, to give shape to the unknown, to honor my roots y mis lengualidades [my languaging]."

55. With words I can make or unmake worlds, reclaim and define my humanity, and speak of my woman being.

Chapter 3

1. Ester Hernández's work is available at http://www.esterhernandez.com.

2. To review the extensive details of the controversy, see http://www.almalopez.com.

3. Cyber Arte "features computer-inspired work by contemporary Hispana/Chicana/Latina artists, all of whom intentionally combine elements traditionally defined as 'folk' with current computer technology to create a new aesthetic. Artists include Elena Baca, Marion Martínez, and Teresa Archuleta Sagel" (López 2001).

4. In 2018 Sandoval passed her qualifying exam for her doctoral degree in creative writing at Washington State University, and she is currently working on her dissertation.

5. The lottery game originated in Italy in the fifteenth century and was brought to New Spain (Mexico) in 1769. The current Mexican version of lotería was first published in 1887, and the images have become iconic in Mexican/Chicana/o culture, gaining popularity in the United States and Europe.

Chapter 4

1. According to Crenshaw's (1989) analysis, historically there were no institutional efforts to regulate Black women's chastity because they were not perceived as "true women" but rather as "licentious" women, always desirous of sexual encounters (35). In contrast, laws were developed to protect white women's chastity, and rape by Black men was the ultimate violation, often punishable by lynching (Wriggins 1983). Because the legal system's underlying assumptions about who possessed chastity and who did not, "black women could not be victims of forcible rape" (Crenshaw 1989, 35).

2. Castillo expands Freire's (1970) notion of conscientización to include gender. In the 1970s Paulo Freire proposed that the genesis of individual behavior is not in the intrapsychic processes of the mind, but rather that behavior emanates from individuals operating within oppressive and alienating social structures. Liberation theology was also central to the process of conscientización.

3. Ting Ting Cheng is a Shanghai-born, University of Cape Town–educated lawyer. She is an attorney at the New York City Commission on Human Rights and legal director for the Women's March on Washington.

4. Tabitha St. Bernard is a Trinidadian American zero-waste fashion designer and the youth initiative coordinator for the Women's March on Washington.

5. Janaye Ingram is a Washington, D.C., consultant on issues of civil rights, voting rights, and women's rights. She is head of logistics for the Women's March on Washington.

6. Paola Mendoza is a Colombian-American writer and director whose work centers on the experiences of immigrant Latina women. She serves as artistic director for the Women's March on Washington.

7. Cassady Fendlay is a writer and communications strategist who has worked for the Gathering for Justice. She is the communications director for the Women's March on Washington.

8. Linda Sarsour is the former executive director of the Arab American Association of New York and an organizer of the 2017 Day Without a Woman strike. She serves as one of the national co-chairs of the Women's March on Washington.

9. Bob Bland is a fashion designer and activist. She serves as one of the national co-chairs for the Women's March on Washington.

10. Nantasha Williams is a political strategist and former executive director of the New York Black, Puerto Rican, Hispanic, and Asian Legislative Caucus. She serves as an advisor to the Women's March on Washington.

11. Breanne Butler is a New York City pastry chef and CEO of "by Breanne," a company specializing in "fashionable confections." She serves as a board member and director of capacity building for the Women's March on Washington.

12. Ginny Suss is a producer for the Women's March on Washington. She is the former vice president of OkayPlayer.com and co-founder of OkayAfrica.com, two music and culture-based media companies.

13. Sarah Sophie Flicker is a creative director at the progressive media company Art Not War and also of the Citizens Band. She serves as a team member on the board of the Women's March on Washington.

14. Tamika Mallory is a lifelong activist and founder of Mallory Consulting, a strategic planning firm in New York City. She is the co-president of the board for the Women's March on Washington.

15. Carmen Pérez is a longtime advocate for civil rights issues and executive director of the Gathering for Justice. She is a national co-chair of the Women's March on Washington.

16. Vanessa Wruble is co-founder of OkayAfrica, a digital media platform centered on African culture, music, and politics. She serves as head of campaign operations for the Women's March on Washington and brought on three national co-chairs, Carmen Perez, Linda Sarsour, and Tamika Mallory, to bring diversity to the leadership of the Women's March.

17. The Green New Deal Resolution proposed by AOC and Massachusetts senator Ed Markey is described as follows: "The resolution proposed the switch to renewable energy sources for the entire country, with the goal of achieving net-zero greenhouse gas emissions by 2030. Additionally, the plan called for major investments in clean energy technology research and development, with Ocasio-Cortez also aiming to include a federal jobs guarantee, basic income and universal health care under the umbrella of the Green New Deal" (Biography.com 2019).

REFERENCES

Alarcón, Norma. 1989. "*Traductora, traidora*: A Paradigmatic Figure of Chicana Feminism." *Cultural Critique* 13 (Fall): 57–87.

Alarcón, Norma. 1990a. "Chicana Feminism: In the Tracks of 'the' Native Woman." *Cultural Studies* 4 (3): 248–56.

Alarcón, Norma. 1990b. "The Theoretical Subject(s) of *This Bridge Called My Back* and Anglo-American Feminism." In *Making Face, Making Soul/Haciendo Caras: Creative and Critical Perspectives by Feminists of Color*, edited by Gloria Anzaldúa, 356–69. San Francisco: Aunt Lute Books.

Alarcón, Norma, ed. 1993. *Chicana Critical Issues*. Berkeley: Third Woman Press.

Almaguer, Tomás. 1974. "Historical Notes on Chicano Oppression: The Dialectics of Racial and Class Domination in North America." *Aztlán: A Journal of Chicano Studies* 5 (1–2): 27–56.

Almaguer, Tomás. 1991. "Chicano Men: A Cartography of Homosexual Identity and Behavior." *Differences: A Journal of Feminist Cultural Studies* 3 (2): 75–100.

Alter, Charlotte. 2019. "'Change Is Closer Than We Think.' Inside Alexandria Ocasio-Cortez's Unlikely Rise." *Time*, March 21, 2019. https://time.com/longform/alexandria-ocasio-cortez-profile/.

Anzaldúa, Gloria. 1981. "La Prieta." In *This Bridge Called My Back: Writings by Radical Women of Color*, 1st ed., edited by Cherríe Moraga and Gloria Anzaldúa, 198–209. London: Persephone Press.

Anzaldúa, Gloria. 1987. *Borderlands / La Frontera: The New Mestiza*. San Francisco: Spinsters / Aunt Lute Press.

Anzaldúa, Gloria. 2002. "Now Let Us Shift . . . The Path of Conocimiento . . . Inner Work, Public Acts." In *This Place We Call Home: Radical Visions for Transformation*, edited by Gloria Anzaldúa and AnaLouise Keating, 540–78. New York: Routledge.

Anzaldúa, Gloria. 2015. *Light in the Dark / Luz en lo Oscuro: Rewriting Identity, Spirituality, Reality*. Durham, N.C.: Duke University Press.

Arce, Carlos H., Edward Murguía, and W. Parker Frisbie. 1987. "Phenotype and Life Chances Among Chicanos." *Hispanic Journal of Behavioral Sciences* 9 (1): 19–32.

Arredondo, Gabriela F., Aída Hurtado, Norma Klahn, Olga Nájera-Ramírez, and Patricia Zavella, eds. 2003. *Chicana Feminisms: A Critical Reader*. Durham, N.C.: Duke University Press.

Asante, Molefi K. 2009. *It's Bigger than Hip Hop*. New York: St. Martin's Press.

Baca, Judith F. 1994. "World Wall: A Vision of the Future Without Fear." *Frontiers: A Journal of Women's Studies* 14 (2): 81–85.

Baca Zinn, Maxine. 1975. "Political Familism: Toward Sex Role Equality in Chicano Families." *Aztlán: A Journal of Chicano Studies* 6 (1): 13–26.

Ballet Nepantla. n.d. "About Ballet Nepantla." Accessed May 28, 2019. https://www
.balletnepantla.com/about.

Barvosa, Edwina. 2008. *Wealth of Selves. Multiple Identities Mestiza Consciousness and
the Subject of Politics*. College Station: Texas A&M University Press.

Barvosa, Edwina . 2011. "Mestiza Consciousness in Relation to Sustained Political
Solidarity: A Chicana Feminist Interpretation of the Farmworker Movement."
Aztlán: A Journal of Chicano Studies 36 (2): 121–54.

Battersby, Sarah-Joyce. 2017. "How Six-Year-Old Sophie Cruz Became the 2017 Face
for Immigration Reform." *Brit + Co*, November 20, 2017. https://www.brit.co
/sophie-cruz-year-in-women/.

Bell, Derrick. 1993. *Faces at the Bottom of the Well: The Permanence of Racism*. New
York: Basic Books.

Benke, Richard. 2001a. "'Bikini Virgin' Prompts Debate." *Santa Cruz Sentinel*, April 17,
2001.

Benke, Richard. 2001b. "Speakers Demand Museum Remove Bare-Midriff." *San Jose
Mercury*, April 17, 2001.

Biography.com. 2019. "Alexandria Ocasion-Cortez: Biography," June 17, 2019. https://
www.biography.com/political-figure/alexandria-ocasio-cortez.

Blackwell, Maylei. 2011. *Chicana Power!: Contested Histories of Feminism in the Chicano
Movement*. Austin: University of Texas Press.

Blackwell, Maylei. 2018. "Women Who Make Their Own Worlds: The Life and Work
of Ester Hernández." In *Chicana Movidas: New Narratives of Activism and Femi-
nism in the Movement Era*, edited by Dionne Espinoza, Maria Eugenia Cotera, and
Maylei Blackwell, 138–58. Austin: University of Texas Press.

Bowerman, Mary. 2017. "Watch 6-Year-Old Sophie Cruz Capture Hearts at Massive
Women's March." *USA Today*, January 21, 2017. https://www.usatoday.com/story
/news/politics/onpolitics/2017/01/21/watch-6-year-old-sophie-cruz-capture-hearts
-massive-womens-march/96889558/.

Broyles, Yolanda. 1986. "Women in El Teatro Campesino: ¿Apoco Estaba Molacha
La Virgen de Guadalupe?" In *Chicana Voices: Intersections of Class, Race, and Gen-
der*, edited by Teresa Córdova, Norma Cantú, Gilberto Cardenas, Juan García, and
Christine M. Sierra, 162–87. Austin: Center for Mexican American Studies.

Broyles-Gonzalez, Yolanda. 1994. *El Teatro Campesino: Theater in the Chicano Move-
ment*. Austin: University of Texas Press.

Caballero, Cecilia, Yvette Martínez-Vu, Judith Pérez-Torres, Michelle Téllez, and
Christine Vega. 2019. *The Chicana Motherwork Anthology*. Tucson: University of
Arizona Press.

Cantú, Norma Elia. 1995. *Canícula: Snapshots of a Girlhood en la Frontera*. Albuquer-
que: University of New Mexico Press.

Casillas, Dolores Ines. 2014. *Sounds of Belonging: U.S. Spanish-Language Radio and
Public Advocacy*. New York: New York University Press.

Castañeda, Antonia I. 1990. "The Political Economy of Nineteenth-Century Stereo-types of Californianas." In *Between Borders: Essays on Mexicana/Chicana History*, edited by Adelaida Del Castillo, 213–36. Moorpark, Calif.: Floricanto Press.

Castañeda, Antonia I. 1993. "Sexual Violence in the Politics/Policies of Conquest: Am-erindian Women in the Spanish Conquest of Alta California." In *Building with Our Hands: New Directions in Chicana Studies*, edited by Beatríz M. Pesquera and Adela de la Torre, 15–33. Berkeley: University of California Press.

Castillo, Ana. 1992. *The Mixquiahuala Letters*. New York: Doubleday/Anchor Books.

Castillo, Ana. 1995. *Massacre of the Dreamers: Essays on Xicanisma*. Albuquerque: Uni-versity of New Mexico Press.

Castillo, Ana, ed. 1997. *Goddess of the Americas / La Diosa de las Américas: Writings on the Virgin of Guadalupe*, 46–51. New York: Riverhead Books.

Castillo, Ana. 2016. *Black Dove. Mamá, Mi'jo and Me*. New York: Feminist Press.

Cuádraz, Gloria Holguín, and Yolanda Flores. 2017. *Claiming Home, Shaping Commu-nity: Testimonios de los Valles*. Tucson: University of Arizona Press.

Center for American Women and Politics. n.d. "History of Women in the U.S. Con-gress." Rutgers University website. Accessed June 21, 2019. https://cawp.rutgers .edu/history-women-us-congress.

Center for American Women and Politics. 2019. "Women in the U.S. Congress 2019." Rutgers University website. Accessed June 21, 2019. https://cawp.rutgers.edu /women-us-congress-2019.

Cervantes, Lorna Dee. 1981. *Emplumada*. Pittsburgh: University of Pittsburgh Press.

Chabram-Dernersesian, Angie. 1996. "The Spanish Colón-ialista Narrative: Their Prospectus for US in 1992." In *Mapping Multiculturalism*, edited by Avery F. Gordon and Christopher Newfield, 215–37. Minneapolis: University of Minnesota Press.

Chabram-Dernersesian, Angie, ed. 2007. *The Chicana/o Cultural Studies Forum: Criti-cal and Ethnographic Practices*. New York: New York University Press.

Chávez-García, Miroslava. 2018. *Migrant Longing: Letter Writing Across the U.S.-Mexico Borderlands*. Chapel Hill, N.C.: University of North Carolina Press.

Chenoweth, Erica, and Jeremy Pressman. 2017. "This Is What We Learned by Count-ing the Women's Marches." *The Washington Post*, February 7, 2017. https://www .washingtonpost.com/news/monkey-cage/wp/2017/02/07/this-is-what-we-learned -by-counting-the-womens-marches/?noredirect=on&utm_term=.69bdd0451881.

Cisneros, Sandra. 1991. *Woman Hollering Creek and Other Stories*. New York: Random House.

Cisneros, Sandra. 1994. *Loose Woman*. New York: Alfred A. Knopf.

Cisneros, Sandra. 1996. "Guadalupe the Sex Goddess." In *Goddess of the Americas / La Diosa de las Américas: Writings on the Virgin of Guadalupe*, edited by Ana Castillo, 46–51. New York: Riverhead Books.

Cohen, Rachel, Madeline Rundlett, and James Wellemeyer. 2019. "116 Congress Breaks Records for Women, Minority Lawmakers." The Hill, January 9, 2019.

https://www.thehill.com/homenews/house/424449-116th-congress-breaks-records
-for-women-minority-lawmakers.

Collins, Patricia Hill. 1991, 2000. *Black Feminist Thought: Knowledge, Consciousness, and the Politics of Empowerment*. New York: Routledge.

Collins, Patricia Hill, and Sirma Bilge. 2016. *Intersectionality*. Cambridge, UK: Polity Press.

Córdova, Teresa. 1994. "The Emergent Writings of Twenty Years of Chicana Feminist Struggles: Roots and Resistance." In *The Handbook of Hispanic Cultures in the United States*, edited by Félix Padilla, 175–202. Houston: Arte Público Press.

Cotera, Marta. 1976. *Diosa y Hembra: The History and Heritage of Chicanas in the U.S.* Austin: Information Systems Development.

Cotera, Marta. 1977. *The Chicana Feminist*. Austin: Information Systems Development.

Crenshaw, Kimberlé Williams. 1989. "Demarginalizing the Intersection of Race and Sex: A Black Feminist Critique of Anti-discrimination Doctrine, Feminist Theory, and Anti-racist Politics." In *Feminist Legal Theory: Foundations*, edited by D. Kelly Weisberg, 383–95. Philadelphia: Temple University Press.

Crenshaw, Kimberlé Williams. 1991. "Mapping the Margins: Intersectionality, Identity Politics, and Violence Against Women of Color." *Stanford Law Review* 43 (6): 1241–99.

Crenshaw, Kimberlé Williams. 1995. "Mapping the Margins: Intersectionality, Identity Politics, and Violence Against Women of Color." In *Critical Race Theory: The Key Writings That Formed the Movement*, edited by Kimberlé Williams Crenshaw, Neil T. Gotanda, Gary Peller, and Kendall Thomas, 357–83. New York: The New Press.

Crenshaw, Kimberlé Williams. 2016. "The Urgency of Intersectionality." TED Talk, November 2016. https://www.ted.com/talks/kimberle_crenshaw_the_urgency_of_intersectionality?language=en.

Cucher, Michael. 2018. "Picturing Fictional Autobioethnography in Norma Elia Cantú's *Canícula: Snapshots of a Girlhood en la Frontera*." *MELUS* 43 (1): 91–114.

Davalos, Karen Mary. 2008. *Yolanda M. López*. Los Angeles: UCLA Chicano Studies Research Center Press.

De la Torre, Adela, and Beatríz M. Pesquera, eds. 1993. *Building with Our Hands: New Directions in Chicana Studies*. Berkeley: University of California Press.

Del Castillo, Adelaida. 1974. "Malintzín Tenepal: A Preliminary Look into a New Perspective." *Encuentro Femenil* 1 (2): 58–77.

Del Castillo, Adelaida, ed. 1990. *Between Borders: Essays on Mexicana/Chicana History*. Moorpark, Calif.: Floricanto Press.

Delgado Bernal, Dolores. 1998. "Using a Chicana Feminist Epistemology in Educational Research." *Harvard Educational Review* 68 (4): 555–79.

Delgado Bernal, Dolores. Rebeca Burciaga, and Judith Flores Carmona, eds. 2018. *Chicana/Latina Testimonios as Pedagogical, Methodological, and Activist Approaches to Social Justice*. New York: Routledge.

Díaz-Sánchez, Micaela. 2012. "Body As Codex-ized Word / *Cuerpo Como Palabra (en-) Códice-ado*: Chicana/Indígena and Mexican Transnational Performative Indigeneities." In *Performing the U.S. Latina & Latino Borderlands*, edited by Arturo J. Aldama, Chela Sandoval, and Peter García, 31–50. Bloomington: Indiana University Press.

Díaz-Sánchez, Micaela, and Alexandro D. Hernández. 2013. "The *Son Jarocho* as Afro-Mexican Resistance Music." *The Journal of Pan African Studies* 6 (1): 187–209.

Du Bois, W. E. B. 1903. *The Souls of Black Folk*. Mineola, N.Y.: Dover Publications.

Escher, M. C. 2018. *Drawing Hands* (1948 lithograph). M. C. Escher Company. Accessed June 21, 2019. https://www.mcescher.com/gallery/back-in-holland/drawing-hands/.

Espín, Oliva M. 1996. "Leaving the Nation and Joining the Tribe: Lesbian Immigrants Crossing Geographical and Identity Borders." *Women and Therapy* 19 (4): 99–107.

Espino, Viginia, producer. 2015. *No Mas Bebes (No More Babies)*. Film directed by Renee Tajima-Peña.

Espinoza, Dionne, Maria Eugenia Cotera, and Maylei Blackwell, eds. 2018. *Chicana Movidas: New Narratives of Activism and Feminism in the Movement Era*. Austin: University of Texas Press.

Facio, Elisa, and Irene Lara, eds. 2014. *Fleshing the Spirit: Spirituality and Activism in Chicana, Latina, and Indigenous Women's Lives*. Tucson: University of Arizona Press.

Felsenthal, Julia. 2017. "These Are the Women Organizing the Women's March on Washington." *Vogue*, January 10, 2017. https://www.vogue.com/article/meet-the-women-of-the-womens-march-on-washington.

Fine, Michelle. 1997. "Witnessing Whiteness." In *Off White: Readings On Race, Power, and Society*, edited by Michelle Fine, Lois Weis, Linda C. Powell, and Mun Wong, 57–65. New York: Routledge.

Forbes, Jack. 1968. "Race and Color in Mexican-American Problems." *Journal of Human Relations* 16 (1): 55–68.

Frankenberg, Ruth. 1993. *White Women, Race Matters: The Social Construction of Whiteness*. Minneapolis: University of Minnesota Press.

Fregoso, Rosa Linda. 1993a. *The Bronze Screen: Chicana and Chicano Film Culture*. Minneapolis: University of Minnesota Press.

Fregoso, Rosa Linda. 1993b. "The Mother Motif in *La Bamba* and *Boulevard Nights*." In *Building with Our Hands: New Directions in Chicana Studies*, edited by Adelaida de la Torre and Beatriz M. Pesquera, 130–48. Berkeley: University of California Press.

Fregoso, Rosa Linda. 2000. "Voices Without Echo: The Global Gendered Apartheid." *Emergences: Journal for the Study of Media and Composite Cultures* 10 (1): 137–55.

Fregoso, Rosa Linda. 2003a. "Reproduction and Miscegenation on the Borderlands: Mapping the Maternal Body of Tejanas." In *Chicana Feminisms: A Critical Reader*, edited by Gabriela F. Arredondo, Aída Hurtado, Norma Klahn, Olga Nájera-Ramírez, and Patricia Zavella, 306–30. Durham, N.C.: Duke University Press.

Fregoso, Rosa Linda. 2003b. *meXicana Encounters. The Making of Social Identities on the Borderlands*. Berkeley: University of California Press.

Freire, Paolo. 1970. *Pedagogy of the Oppressed*. New York: Continuum.

García, Alma M. 1989. "The Development of Chicana Feminist Discourse, 1970–1980." *Gender and Society* 3 (2): 217–38.

García, Alma M., ed. 2014. *Chicana Feminist Thought: The Basic Historical Writings*. New York: Routledge.

García, Chris F. 1973. *Political Socialization of Chicano Children: A Comparative Study with Anglos in California Schools*. Santa Barbara, Calif.: Praeger Publishers.

Gaspar de Alba, Alicia. 1998. "The Politics of Location of the Tenth Muse of America: An Interview with Sor Juana Inés de la Cruz." In *Living Chicana Theory*, edited by Carla Mari Trujillo, 136–65. Berkeley: Third Woman Press.

Gaspar de Alba, Alicia, and Alma López, eds. 2011. *Our Lady of Controversy: Alma López's Irreverent Apparition*. Austin: University of Texas Press.

González, María R. 1990. "El Embrín Nacionalista Visto a Través de la Obra de Sor Juana Inés de la Cruz." In *Between Borders: Essays on Mexicana/Chicana History*, edited by Adelaida del Castillo, 237–56. Moorpark, Calif.: Floricanto Press.

González, Martha. 2014. "Mixing in the Kitchen: Entre Mujeres ('Among Women') Translocal Musical Dialogues." In *Performing Motherhood. Artistic, Activist, and Everyday Enactments*, edited by Amber E. Kinser, Kryn Freehling-Burton, and Terri Hawkes, 69–87. Ontario, Canada: Demeter Press.

González, Martha. 2015. "King County Juvenile Detention—Sounds Beyond Barriers." YouTube video, uploaded by Scott Macklin, September 14, 2015. https://www.youtube.com/watch?v=s3kOzhGJshc.

González, Jennifer A., and Michelle Habell-Pállan. 1994. "Heterotopias and Shared Methods of Resistance: Navigating Social Spaces of Identity." *Inscriptions* 7: 80–104.

Guerin-Gonzalez, Camille. 1994. *Mexican Workers and American Dreams: Immigration, Repatriation, and California Farm Labor, 1900–1939*. New Brunswick, N.J.: Rutgers University Press.

Guinier, Lani. 1998. *Lift Every Voice: Turning a Civil Rights Setback into a New Vision of Social Justice*. New York: Simon & Schuster.

Gurin, Patricia, Arthur H. Miller, and Gerald Gurin. 1980. "Stratum Identification and Consciousness." *Social Psychology Quarterly* 43 (1): 30–47.

Gutiérrez, Elena. 2008. *Fertile Matters: The Politics of Mexican-Origin Women's Reproduction*. Austin: University of Texas Press.

Gutiérrez, Ramón A. 1993. "Community, Patriarchy and Individualism: The Politics of Chicano History and the Dream of Equality." *American Quarterly* 45 (1): 44–72.

Habell-Pallan, Michelle. 2005. *Loca Motion: The Travels of Chicana and Latina Popular Culture*. New York: New York University Press.

Hansen, Claire. 2019. "116th Congress by Party, Race, Gender, and Religion." *U.S. News & World Report*, January 3, 2019. https://www.usnews.com/news/politics/slide shows/116th-congress-by-party-race-gender-and-religion.

Harris-Perry, Melissa. 2017. "How I Came to Love the March Even Though I Still Hate the Safety Pin." *ELLE*, January 19, 2017. https://www.elle.com/culture/career -politics/a42280/mhp-march-on-dc/.

Hayes, Chris. 2018a. *All In with Chris Hayes*. September 28, 2018.

Hayes, Christal. 2018b. "Read Christine Blasey Ford's Letter Detailing the Alleged Assault by Brett Kavanaugh." *USA Today*, September 23, 2018. https://www.usa today.com/story/news/politics/2018/09/23/christine-blasey-ford-letter-alleged -assault-brett-kavanaugh/1406932002/.

Hughes, Everett C. 1945. "Dilemmas and Contradictions of Status." *American Journal of Sociology* 50 (5): 353–59.

Hurtado, Aída. 1989. "Reflections on White Feminism: A Perspective from a Woman of Color." In *Social and Gender Boundaries in the United States*, edited by Sucheng Chan. Lewiston, N.Y.: Edwin Mellen Press.

Hurtado, Aída. 1996a. *The Color of Privilege: Three Blasphemies on Race and Feminism*. Ann Arbor: University of Michigan Press.

Hurtado, Aída. 1996b. "Strategic Suspensions: Feminists of Color Theorize the Pro- duction of Knowledge." In *Knowledge, Difference and Power: Essays Inspired by Women's Ways of Knowing*, edited by Nancy Goldberger, Jill Tarule, Blythe Clinchy, and Mary Belenky, 372–92. New York: Basic Books.

Hurtado, Aída. 1997a. Introduction to Elba Sánchez's "Me Siento Continente" lecture, presented at Chicana Feminisms Colloquium Series, April 4, 1997, University of California, Santa Cruz.

Hurtado, Aída. 1997. "Understanding Multiple Group Identities: Inserting Women into Cultural Transformations." *Journal of Social Issues* 53 (2): 299–338.

Hurtado, Aída. 1998. "Sitios y Lenguas: Chicanas Theorize Feminisms." *Hypatia* 13 (2): 134–59.

Hurtado, Aída. 2003a. "Theory in the Flesh: Toward an Endarkened Epistemology." *International Journal of Qualitative Studies in Education* 16 (2): 215–25.

Hurtado, Aída. 2003b. "Underground Feminisms: Inocencia's Story." In *Chicana Fem- inisms: A Critical Reader*, edited by Gabriela F. Arredondo, Aída Hurtado, Norma Klahn, Olga Nájera-Ramírez, and Patricia Zavella, 260–90. Durham, N.C.: Duke University Press.

Hurtado, Aída. 2003c. *Voicing Chicana Feminisms: Young Women Speak Out on Sexuality and Identity*. New York: New York University Press.

Hurtado, Aída. 2005. "Multiple Subjectivities: Chicanas and Cultural Citizenship." In *Women and Citizenship*, edited by Marilyn Friedman, 111–29. Oxford: Oxford University Press.

Hurtado, Aída. 2011. "Making Face, Rompiendo Barreras (Breaking Barriers): The Activist Legacy of Gloria E. Anzaldúa." In *Bridging: How and Why Gloria Evangelina Anzaldúa's Life and Work Transformed Our Own. Academics, Activists, and Artists Share Their Testimonios*, edited by Gloria González-López and AnaLouise Keating, 49–62. Austin: University of Texas Press.

Hurtado, Aída. 2015. "Gloria Anzaldúa's Seven Stages of Conocimiento in Redefining Latino Masculinity: José's Story." *Masculinities and Social Change* 4 (1): 44–84.

Hurtado, Aída. 2016. "The Social Psychology of Spanish/English Bilingualism in the United States." In *Handbook of Advances in Culture and Psychology*, vol. 6, edited by Michele J. Gelfand, Chi-yue Chiu, and Ying-yi Hong, 157–208. Oxford: Oxford University Press.

Hurtado, Aída, producer. 2017. Video of Carmen Pérez on Intersectionality. Washington, D.C., January 21, 2017.

Hurtado, Aída. 2018. "Intersectional Understandings of Inequality." In *Oxford Handbook of Social Psychology and Social Justice*, edited by Phillip L. Hammack, 157–72. Oxford: Oxford University Press.

Hurtado, Aída. 2019. "Intersectionality." In *The Bloomsbury Handbook of 21st-Century Feminist Theory*, edited by R. T. Goodman, 159–70. London: Bloomsbury Publishing.

Hurtado, Aída, and Norma E. Cantú. 2020. "Introduction." In *MeXicana Fashion: Self-Adornment, Identity Construction, and Political Self-Presentation*, edited by Aída Hurtado and Norma Elia Cantú.

Hurtado, Aída, and Karina Cervantez. 2009. "A View from Within and from Without: The Development of Latina Feminist Psychology." In *The Handbook of U.S. Latino Psychology: Developmental and Community-Based Perspectives*, edited by Francisco A. Villarruel, Josefina M. Grau, Gustavo Carlo, Natasha J. Cabrera, Margarita Azmitia, and T. Jaime Chahin, 171–90. Thousand Oaks, Calif.: Sage Publications.

Hurtado, Aída, and Patricia Gurin. 2004. *Chicano/a Identity in a Changing U.S. Society ¿Quién Soy? ¿Quiénes Somos?*. Tucson: University of Arizona Press.

Hurtado, Aída, and Mrinal Sinha. 2016. *Beyond Machismo: Intersectional Latino Masculinities*. Austin: University of Texas Press.

Hurtado, Aída, and Raúl Rodríguez. 1989. Language as a Social Problem: The Repression of Spanish in South Texas. *Journal of Multilingual Multicultural Development* 10 (5), 401–19.

Jaggar, Alison M. 1983. *Feminist Politics and Human Nature*. Totowa, N.J.: Rowman & Allanheld.

Janofsky, Michael. 2001. "Santa Monica Artist's Image of Mary Rouses Ire at New Mexico Museum." *San Jose Mercury News*, April 6, 2001.

Klahn, Norma. 1994. "Writing the Border: The Languages and Limits of Representation." *Journal of Latin American Studies* 3 (1–2): 29–55.

Lady Mariposa. 2011. "Chicana Poet Lady Mariposa 'Spoken Word and Borderland Beats.'" YouTube video, uploaded by Writers of the Rio Grande, May 12, 2011. https://www.youtube.com/watch?v=Qph9TIXfkbY.

The Latina Feminist Group. 2001. *Telling to Live: Latina Feminist Testimonios*. Durham, N.C.: Duke University Press.

Lewis-Beck, Michael S., Alan Bryman, and Tim Futing Liao, eds. 2004. *The SAGE Encyclopedia of Social Science Research Methods*, vol. 3. Thousand Oaks, Calif.: Sage Publications.

Lopez, Alma. 2001. "Chicana Artist Needs Our Support!" Accessed July 19, 2010. http://www.almalopez.com.

Lopez, Alma. 2011. "It's Not About the Santa in My Fe, but the Santa Fe in My Santa." *Our Lady of Controversy: Alma López's Irreverent Apparition*, edited by Alicia Gaspar de Alba and Alma López, 249–92. Austin: University of Texas Press.

Lugones, Maria. 2003. *Pilgrimages/Peregrinajes: Theorizing Coalition Against Multiple Oppressions*. Lanham, Md.: Rowman and Littlefield.

MacKinnon, Catherine A. 1982. "Feminism, Marxism, Method, and the State: An Agenda for Theory." *Signs: Journal of Women in Culture and Society* 7 (31): 515–44.

Martínez, Elizabeth. 1989. "That Old (White) Male Magic." *Z Magazine* 27 (8): 48–52.

Méndez-Negrete, Josephine. 1995. "¡No es lo que haces!": A Sociohistorical Analysis of Relational Leadership in a Chicana/Latino Community." PhD diss., University of California, Santa Cruz.

Mora, Magdalena, and Adelaida R. Del Castillo. 1980. *Mexican Women in the United States: Struggles Past and Present*. Los Angeles: Chicano Studies Research Center.

Mora, Pat. 1993. *Nepantla: Essays from the Land in the Middle*. Albuquerque: University of New Mexico Press.

Mora, Pat. 1996. "Coatlique's Rules: Advice from an Aztec Goddess." In *Goddess of the Americas / La Diosa de las Americas: Writings on the Virgin of Guadalupe*, edited by Ana Castillo, 88–89. New York: Riverhead Books.

Moraga, Cherríe. 1983. *Native Country of the Heart: A Memoir*. New York: Farrar, Straus and Giroux.

Moraga, Cherríe. 2019. *Loving in the War Years: Lo que nunca pasó por sus labios*. Boston: South End Press.

Moraga, Cherríe, and Gloria Anzaldúa, eds. 1981. *This Bridge Called My Back: Writings by Radical Women of Color*. London: Persephone Press.

MSNBC. 2019. "Alexandria Ocasio-Cortez Contemplates What's Next." MSNBC.com, March 29, 2019. https://www.msnbc.com/all-in/watch/alexandria-ocasio-cortez-contemplates-what-s-next-1468184131741.

Mujeres Activas en Letras y Cambio Social (MALCS). n.d. "About." Accessed June 18, 2019. http://www.malcs.org/about/.

Murray, Pauli, and Mary O. Eastwood. 1965. "Jane Crow and the Law: Sex Discrimination and Title VII." *George Washington Law Review* 34: 232.

Nájera-Ramírez, Olga. 2012. "Ballet Folklórico Mexicano: Choreographing a National Identity in a Transnational Context." In *Dancing Cultures: Globalization, Tourism and Identity in the Anthropology of Dance*, edited by Hélène Neveu Kringelback and Jonathon Skinner. New York: Berghahn Books.

Nájera-Ramírez, Olga, Norma E. Cantú, and Brenda M. Romero, eds. 2009. *Dancing Across Borders: Danzas y Bailes Mexicanos*. Champaign: University of Illinois Press.

Neumaier, Diane. 1990. "Judy Baca: Our People Are the Internal Exiles." In *Making Face, Making Soul / Haciendo Caras: Creative and Critical Perspectives by Women of Color*, edited by Gloria Anzaldúa. San Francisco: Aunt Lute Books.

Nieto, Consuelo. 1974. "The Chicana and the Women's Rights Movement: A Perspective." *Civil Rights Digest* 6 (3): 36–42.

Nieto-Gómez, Anna. 1974. "La Feminista." *Encuentro Femenil* 1 (2): 34–37.

Ochoa, Maria, and Teresía Teaiwa, eds. 1994. "Enunciating Our Terms: Women of Color in Collaboration and Conflict." *Inscriptions* 7: 1–155.

Ortega, Mariana. 2016. *In-Between: Latina Feminist Phenomenology, Multiplicity, and the Self*. Albany, N.Y.: State University of New York Press.

Ostrander, Susan. 1984. *Women of the Upper Class*. Philadelphia: Temple University Press.

Pacheco, Sandra. 2018. "'Para Servir': Chicana Feminist Methodology in Studying Curanderas." Class presentation, Introduction to Chicana/o Studies: Gender, University of California, Santa Barbara, February 14, 2018.

Pastor, Jennifer, Jennifer McCormick, Michelle Fine, Ruth Andolsen, Nora Friedman, Nikki Richardson, Tanzania Roach, and Marina Tavarez. 2007. "Making Homes: An Urban Girl Thing." In *Urban Girls Revisited: Building Strengths*, edited by B. J. Ross Leadbeater and Niobi Way, 75–96. New York: New York University Press.

Paz, Octavio. 1985. *The Labyrinth of Solitude*, translated by Lysander Kemp, Yara Milos, and Rachel Phillips Belash. New York: Grove Press.

Pérez, Domino R. 2008. *There Was a Woman: La Llorona from Folklore to Popular Culture*. Austin: University of Texas Press.

Peréz, Emma. 1991. "Sexuality and Discourse: Notes from a Chicana Survivor." In *Chicana Lesbians: The Girls Our Mothers Warned Us About*, edited by Carla Trujillo, 159–84. Berkeley: Third Woman Press.

Peréz, Emma. 1993. "Speaking from the Margin: Uninvited Discourse on Sexuality and Power." In *Building with Our Hands: New Directions in Chicana Studies*, edited by Adela de la Torre and Beatríz M. Pesquera, 51–71. Berkeley: University of California Press.

Peréz, Emma. 1996. *Gulf Dreams*. Berkeley: Third Woman Press.

Pérez, Emma. 1998. "Sexuality and Discourse: Notes from a Chicana Survivor." In *Chicana Lesbians: The Girls Our Mothers Warned Us About*, edited by Carla Trujillo, 159–84. Berkeley, Calif.: Third Woman Press.

Peréz, Emma. 1999. *The Decolonial Imaginary: Writing Chicanas into History*. Bloomington: Indiana University Press.

Pérez, Laura E. 2007. *Chicana Art: The Politics of Spiritual and Aesthetic Altarities*. Durham, N.C.: Duke University Press.

Pesquera, Beatríz M. 1991. "Work Gave Me a Lot of Confianza: Chicanas' Work Commitment and Work Identity." *Aztlán: A Journal of Chicano Studies* 20 (1–2): 97–118.

Pesquera, Beatríz M., and Denise A. Segura. 1993. "There Is No Going Back: Chicanas and Feminism." In *Chicana Critical Issues*, edited by Norma Alarcón. Berkeley: Third Woman Press.

Quintana, Alvina E. 1989. "Challenge and Counter-challenge: Chicana Literary Motifs." In *Social and Gender Boundaries in the United States*, edited by Sucheng Chan, 187–203. Lewiston, N.Y.: Edwin Mellen Press.

Quintana, Alvina E. 1996. *Home Girls: Chicana Literary Voices*. Philadelphia: Temple University Press.

Reilly, Katie. 2018. "How Sexual Assault Survivors Reacted to Christine Blasey Ford's Testimony: 'She's Doing It for All of Us.'" *Time*, September 27, 2018. http://www.time.com/5408773/christine-blasey-ford-sexual-assault-survivors-testimony/.

Rendón, Laura I. 2008. *Sentipensante (Sensing/Thinking) Pedagogy: Educating for Wholeness, Social Justice and Liberation*. Sterling, Va.: Stylus Publishing.

Reston, Maeve. 2018. "'I Will Never Forget:' Christine Blasey Ford Recounts Her Trauma in Raw Testimony." CNN Politics, September 27, 2018. https://www.cnn.com/2018/09/27/politics/christine-blasey-ford-raw-testimony/.

Reti, Irene H., Elba R. Sánchez, and Susy Zepeda. 2014. "A Lifetime Commitment to Giving Voice: An Oral History of Elba R. Sánchez." UC Santa Cruz, April 4, 2014. https://www.escholarship.org/uc/item/2xg7k0gz.

Roberts, Rosiemarie A. 2005. "Radical Movements: Katherine Dunham and Ronald K. Brown Teaching Toward Critical Consciousness. PhD diss., City University of New York." *Dissertation Abstracts International* 65 (12-B): 6710.

Romero, Mary. 1992. *Maid in the U.S.A.* New York: Routledge.

Romero, Mary. 2017. *Introducing Intersectionality*. Hoboken, N.J.: Wiley.

Ruíz, Vicki L. 1987. *Cannery Women, Cannery Lives: Mexican Women, Unionization, and the California Food Processing Industry, 1930–1950*. Albuquerque: University of New Mexico Press.

Ruíz, Vicki L. 1998. *From Out of the Shadows: Mexican Women in Twentieth-Century America*. New York: Oxford University Press.

Saldívar-Hull, Sonia. 1991. "Feminism on the Border: From Gender Politics to Geopolitics." In *Criticism in the Borderlands: Studies in Chicano Literature, Culture, and Ideology*, edited by Hector Calderón and Jose David Saldívar, 203–20. Durham, N.C.: Duke University Press.

Saldívar-Hull, Sonia. 2000. *Feminism on the Border: Chicana Gender Politics and Literature*. Berkeley: University of California Press.

Sánchez, Elba. 1997. "Me Siento Continente" lecture, presented at Chicana Feminisms Colloquium Series, April 4, 1997. University of California, Santa Cruz.

Sánchez, Elba. 2003. "Cartohistografía: Continente de Una Voz. Cartohistography: One Voice's Continent." In *Chicana Feminisms: A Critical Reader*, edited by Gabriela F. Arredondo, Aída Hurtado, Norma Klahn, Olga Nájera-Ramírez, and Patricia Zavella, 19–51. Durham, N.C.: Duke University Press.

Sandoval, Chéla. 1990. "The Struggle Within: A Report on the 1981 N.W.S.A. Conference." In *Making Face, Making Soul / Haciendo Caras: Creative and Critical Perspectives by Women of Color*, edited by Gloria Anzaldúa, 1–38. San Francisco: Aunt Lute Books.

Sandoval, Chéla. 1991. "U.S. Third World Feminism: The Theory and Method of Oppositional Consciousness in the Postmodern World." *Genders* 10 (Spring): 1–24.

Sandoval, Chéla. 2000. *Methodology of the Oppressed*. Minneapolis: University of Minnesota Press.

Sandoval, Chéla, and Guisela Latorre. 2008. "Chicana/o Artivism: Judy Baca's Digital Work with Youth of Color." In *Learning Race and Ethnicity: Youth and Digital Media*, edited by Anna Everett, 81–108. The John D. and Catherine T. MacArthur Foundation Series on Digital Media and Learning. Cambridge: MIT Press.

Schaeffer, Felicity Amaya. 2018. "Spirit Matters: Gloria Anzaldúa's Cosmic Becoming Across Human/Nonhuman Borderlands." *Signs: Journal of Women in Culture and Society* 43, no. 4 (Summer): 1005–29.

Segura, Denise. 1994. "Beyond Machismo: Chicanas, Work, and Family." Paper presented at the Sixth European Conference on Latino Cultures in the United States, July 7–10, 1994. Bordeaux, France.

Segura, Denise, and Beatriz M. Pesquera. 1992. "Beyond Indifference and Antipathy: The Chicana Movement and Chicana Feminist Discourse." *Aztlan* 19 (2): 69–91.

Serna, Cristina. 2011. "It's Not About the Virgins in My Life, It's About the Life in My Virgins." *Our Lady of Controversy: Alma López's Irreverent Apparition*, edited by Alicia Gaspar de Alba and Alma López, 164–94. Austin: University of Texas Press.

Serros, Michele M. 1993. *Chicana Falsa: And Other Stories of Death, Identity, and Oxnard*. Valencia, Calif.: Lalo Press.

Sisneros, Maya. 2017. "A Time for Making: An Interview with Poets in the Borderlands." *Medium*, May 4, 2017. https://medium.com/@maya.sisneros13/a-time-for-making-an-interview-with-poets-in-the-borderlands-90ccbccaaa05.

Smith, Amy Nichol. 2010. "How Border Poet Lady Mariposa Found Her Wings." *The Monitor*, August 25, 2010. https://www.themonitor.com/entertainment/article_fb5d358f-edb8-53b6-9c15-9fc0e6aeecfd.html.

Sosa-Riddell, Ada. 1993. "The Bioethics of Reproductive Technologies: Impacts and Implications for Chicanas/Latinas." In *Chicana Critical Issues*, edited by Norma Alarcon, 183–96. Berkeley: Third Woman Press.

"Spoken Word." 2018. *Poetry Foundation*. Accessed June 21, 2019. https://www.poetry foundation.org/learn/glossary-terms/spoken-word.

Sternbach, Nancy Saporta, Marysa Navarro-Aranguren, Patricia Chuchryk, and Sonia E. Alvarez. 1992. "Feminisms in Latin America: From Bogotá to San Bernardo." *Signs* 17 (2): 393–434.

Stockman, Farah. 2017. "Women's March on Washington Opens Contentious Dialogues About Race." *New York Times*, January 9, 2017. https://www.nytimes.com /2017/01/09/us/womens-march-on-washington-opens-contentious-dialogues-about -race.html.

Tajfel, Henri. 1981. *Human Groups and Social Categories: Studies in Social Psychology*. Cambridge: Cambridge University Press.

Telles, Edward E, and Edward Murguia. 1992. "The Continuing Significance of Phenotype Among Mexican-Americans." *Social Science Quarterly* 73 (1): 120–22.

Telles, Edward E., and Edward Murguia. 1990. "Phenotypic Discrimination and Income Differences Among Mexican-Americans." *Social Science Quarterly* 71 (4): 682–96.

Torre, María Elena, and Jennifer Ayala. 2009. "Envisioning Participatory Action Research Entremundos." *Feminism & Psychology* 19 (3): 387–93.

Trujillo, Carla, ed. 1991. *Chicana Lesbians: The Girls Our Mothers Warned Us About*. Berkeley: Third Woman Press.

Trujillo, Carla. 1998. *Living Chicana Theory*. Berkeley: Third Woman Press.

Tyx, Daniel Blue. 2017. "Dance Without Borders." *Texas Observer*, December 8, 2017. https://www.texasobserver.org/dance-without-borders/.

Vásquez, Melba J., and Anna M. González. 1981. "Sex Roles Among Chicanos: Stereotypes, Challenges, and Changes." In *Explorations in Chicano Psychology*, edited by Augustine Baron Jr., 215–34. New York: Praeger.

Viramontes, Helena Maria. 1995. *The Moths and Other Stories*. Houston: Arte Publico Press.

White, Aaronette M. 2008. *Ain't I a Feminist? African American Men Speak Out on Fatherhood, Friendship, Forgiveness, and Freedom*. Albany: State University of New York Press.

"Women Within the La Raza Unida Party and the Rights They Fought For." University of Michigan student interview with Martha Cotera, October 27, 2005. http:// www.umich.edu/~ac213/student_projects05/cf/interview.html.

Wriggins, Jennifer. 1983. "Rape, Racism, and the Law." *Harvard Women's Law Journal* 6: 103–41.

Yarbro-Bejarano. 1986. "The Female Subjects in Chicano Theater: Sexuality, 'Race,' and Class." *Theater Journal* 38 (1): 389–407.

Ybarra-Frausto, Tomás. 1989. "Rasquachismo: A Chicano Sensibiity." In *Chicano Aesthetics: Rasquachismo*, exhibition catalog, 5–8 (Phoenix: MARS Artspace).

York, Jessica A. 2017. "Santa Cruz Mural Artists, Youth Examine Discrimination." *Santa Cruz Sentinel*, August 2, 2017. https://www.santacruzsentinel.com/2017/08/02 /santa-cruz-mural-artists-youth-examine-discrimination/.

Zavella, Patricia. 1987. *Women's Work and Chicano Families: Cannery Workers of the Santa Clara Valley*. Ithaca, N.Y.: Cornell University Press.

Zavella, Patricia. 1994. "Reflections on Diversity Among Chicanas." In *Race*, edited by Steven Gregory and Roger Sanick, 199–212. New Brunswick, N.J.: Rutgers University Press.

Zavella, Patricia. 1997. "Playing with Fire: The Gendered Construction of Chicano/Mexican Sexuality." In *The Gender/Sexuality Reader: Culture, History, Political Economy*, edited by Roger N. Lancaster and Maraela di Leonardo, 392–408. New York: Routledge.

Zavella, Patricia. 2003. "Talkin' Sex: Chicanas and Mexicanas Theorize About Silences and Sexual Pleasures." In *Chicana Feminisms: A Critical Reader*, edited by Gabriela F. Arredondo, Aída Hurtado, Norma Klahn, Olga Nájera-Ramírez, and Patricia Zavella, 210–352. Durham, N.C.: Duke University Press.

Zavella, Patricia. 2011. *I'm Neither Here nor There: Mexicans' Quotidian Struggles with Migration and Poverty*. Durham, N.C.: Duke University Press.

Zavella, Patricia. 2020. *The Movement for Reproductive Justice: Empowering Women of Color Through Social Activism*. New York: New York University Press.

INDEX

Page numbers in italic indicate figures.

physical ableness, 8, 9, 27, 28, 132, 148, 167; ableism, 171
politics, 13, 52, 80, 85, 114, 115, 146
power, 19, 59
Prado, Alejandro, 192
Pressman, Jeremy, 141
privilege, 9, 36, 38, 145, 148, 160, 174, 176, 180, 183; white privilege, 31, 32

Quintana, Alvina, 50, 92

race, 8, 9, 11, 12, 20, 27, 28, 29, 32, 52, 59, 66, 69, 77, 84, 92, 93, 96, 97, 114, 120, 126, 128, 132, 147, 147, 148, 150, 170 178, 181; internal racism: 44, 45, racism, 4, 17, 27, 29, 31, 32, 37, 44, 45, 166, 167, 171
Ramirez Niembro, Paulina, 192
Reilly, Katie, 175
Religion, 98, 132; Catholicism, 98, 107, 131
Rendón, Laura I, 97
reproductive rights: abortions, 9, 15, 175; birth control: 15, 30; contraception: 175; sterilization: 30
Roberts, Rosiemarie A., 97
Rodríguez, Celia Herrera, 126
Rodriguez, Chipita, 13
Rodríguez, Faviana, 96
Rodriguez, Martin, 118, 119, 120, 121, 127
Rodríguez, Raúl, 47
Rodríguez, Roberto, 130, 131
Romero, Brenda M, 140
Romero, Mary , 12, 92, 144, 186
Ruíz, Vicki L., 12

Sagel, Teresa Archuleta, 193
Saldívar-Hull, Sonia, 14, 19, 31, 33, 44, 46, 47, 48, 50, 61, 148
Salinas, Raquel, 26, 27, 108, 129, 130

Sánchez, Elba Rosario, 51, 53, 59, *60, 61*, 62, 63, 64, 65, 66, 67, 68, 69, 70, 72, 73, 74, 75, 76, 78, 79, 80, 81, 82, 83, 84, 85, 86, 88, 89, 90, 91, 92, 93, 111, 115, 131, 139, 188, 189; on César Chávez, 88; Francisco X. Alarcón, 61; her son, 87; her Mother: 88, 90; Isaías Mata: 60, 61
Sandoval, Chéla, 15, 28, 32, 50, 51, 69, 96, 98, 148, 193
Sarsour, Linda, 151, 154, 155, 169, 194; Basemah Atweh, 155
Schaeffer, Felicity Amaya, 85
Segura, Denise, 12, 26, 69, 92
Serna, Cristina, 98
Serros, Michele M., 51
Sexuality, 8, 11, 12, 18, 20, 21, 25, 27, 28, 32, 38, 49, 53, 55, 59, 64, 66, 79, 96, 97, 107, 126, 128, 132, 147, 148, 150, 181; heterosexuality, 17; homophobia, 17, 25; LGBTQ community, 37, 55, 69, 110, 154, 159, 183; bisexuality, 55; gay community and gayness, 55, 145, 180; lesbian community and lesbianism, 17, 20, 24, 25, 26, 27, 28, 32, 37, 55, 69, 79; queer community and queerness, 17, 20, 25, 26, 27, 32, 55, 99, 107, 109, 111, 144, 180; trans community, 17, 20, 25, 28, 163, 166, 167, 174, 180; transsexuality, 55; transphobia, 25
Shook, Teresa, 152, 153
Sinha, Mrinal, 62, 148, 185
Smith, Amy Nichol, 116
Sosa-Riddell, Ada, 30
St. Bernard, Tabitha, 151, 193
Steinem, Gloria, 146, 185
Sternbach, Nancy Saporta, 31
Stockman, Farah, 170
Suss, Ginny, 151, 194

ABOUT THE AUTHOR

Professor **Aída Hurtado** is a social psychologist who holds the Luis Leal Endowed Chair in the Department of Chicana and Chicano Studies at the University of California, Santa Barbara. Professor Hurtado's work combines the feminist writings of African American scholars with Chicana feminisms, social identity theory, and Anzaldúa's borderlands theory to delineate the applicability of intersectionality to different ethnic, racial, and gender formations. Her books include *Relating to Privilege: Three Blasphemies on Race and Feminism* (University of Michigan, 1996), *Voicing Chicana Feminisms: Young Women Speak Out on Sexuality and Identity* (New York University Press, 2003), *Chicana/o Identity in a Changing U.S. Society: ¿Quién soy? ¿Quiénes somos?* (co-authored, University of Arizona Press, 2004), and the co-edited books *Chicana Feminisms: A Critical Reader* and *Invisible No More: Understanding the Disenfranchisement of Latino Men and Boys* (Routledge, 2012). Her most recent book, *Beyond Machismo: Intersectional Latino Masculinities* (University of Texas Press, 2016), is a feminist analysis of Latino men in higher education and their views on gender. Dr. Hurtado is the recipient of the Women of Color Psychologies Award (from the Association of Women in Psychology), the SAGE Award for Distinguished Contributions to Gender Equity in Education Research (from the American Educational Research Association), and the Outstanding Latino/a Faculty in Higher Education Award (from the American Association of Hispanics in Higher Education). Professor Hurtado spoke at the 2017 and 2018 Women's March and serves on the Women's March Steering Committee. Professor Hurtado has served as a consultant on educational and gender issues for the Ford Foundation, the Rockefeller Foundation, the Kellogg Foundation, the federal program GEAR UP, and the University of California's Office of the President, among other local, state, and national organizations.